ARTS
&
CRAFTS
of
MOROCCO

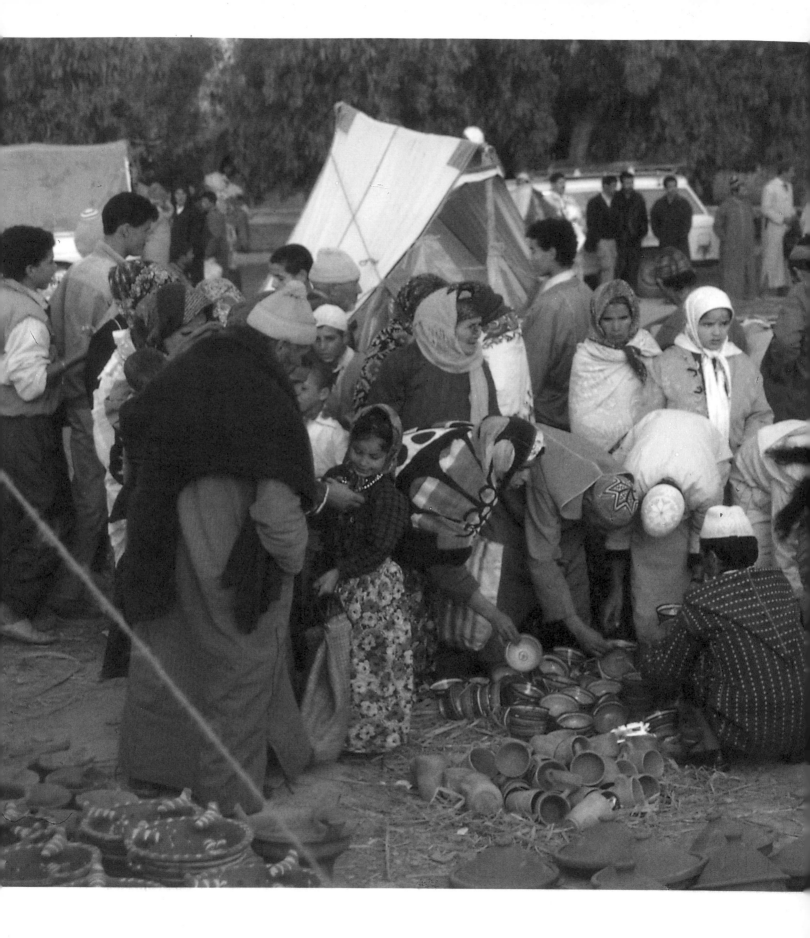

ARTS
&
CRAFTS
of
MOROCCO

JAMES F. JEREB

CHRONICLE BOOKS

SAN FRANCISCO

For Mary and Don, my lifelong mentors

Editor Mary Daniels

AUTHOR'S NOTE

A book of this scope could not have been possible without the support and co-operation of a large number of people and institutions. A very special thanks goes to my editor, Mary Daniels, and my translator, Rebecca Romani, who kept me going in my pursuit of clarity in the manuscript. Without their help, I could not have completed this book. I would also like to offer heartfelt thanks to the writer Paul Bowles, who inspired me to keep on writing and traveling, no matter what the obstacles to my quest.

I wish to acknowledge the assistance of the Moroccan officials here and abroad who were helpful to me in my research and in my obtaining access to collections in Moroccan museums. The late Mohamed Belkhyat and Mohamed Ben Aissa at the Embassy of Morocco in Washington, D.C. were particularly helpful, but I am also grateful for the assistance of Dr. Ali Amahan and Dr. Driss Dkissi in the Ministry of Patrimony, and the Ministry of Moroccan Tourism and Artisanry, both in Rabat.

In Europe, Marie France Vivier at the Museum of African and Oceanic Art in Paris, Angelika Tunis in Berlin at the Museum für Völkerkunde, and Julie Hudson and John Mack at the British Museum in London were of invaluable help, as was Rachel Hasson at the L.A. Mayer Memorial Museum of Islamic Art in Jerusalem.

I am particularly indebted to Farid Moussaoui and Mustopha Benidrane of Royal Air Maroc for their assistance with travel arrangements to Morocco.

The visual beauty of this book could not have been attained without the financial assistance of the Near Eastern Art Research Council in Washington, D.C., or the contributions of my dear photographer friends Athi Mara Magadi, Lynn Lown, Michael Tropea and Joel Rubiner, and my illustrator, Elaine Feldman.

I would also like to thank my good friends Boubker Temli, Mustapha Ouizid, Benane Rhadir, and Mustapha Boumazzough, all of whom gave me their assistance and support and opened their hearts and minds to me in my personal quest of understanding their country and their artistic traditions.

Above all, I wish to give special thanks to the countless Moroccan artists, craftsmen, scholars and dealers, both men and women, who opened their homes, ateliers, and hearts, to me during my years of travel in Morocco. And lastly, but not least, I would like to express my gratitude to all the private collectors and institutions, here and abroad, who lent objects and textiles, and to the staff of Thames and Hudson, for the production of this book.

FRONTISPIECE
Potters' market at a souk at Imin Tanout in the south of Morocco

First published in the United States in 1996 by Chronicle Books.

ISBN: 0-8118-1157-3

First published in Great Britain in 1995 by Thames and Hudson Ltd., London.

© 1995 James F. Jereb

Printed and bound in Singapore.

Library of Congress Cataloging-in-Publication Data available.

Cover design by Sarah Bolles.

Distributed in Canada by
Raincoast Books
8680 Cambie Street
Vancouver, B.C. V6P 6M9

10 9 8 7 6 5 4 3 2 1

Chronicle Books
275 Fifth Street
San Francisco, California 94103

CONTENTS

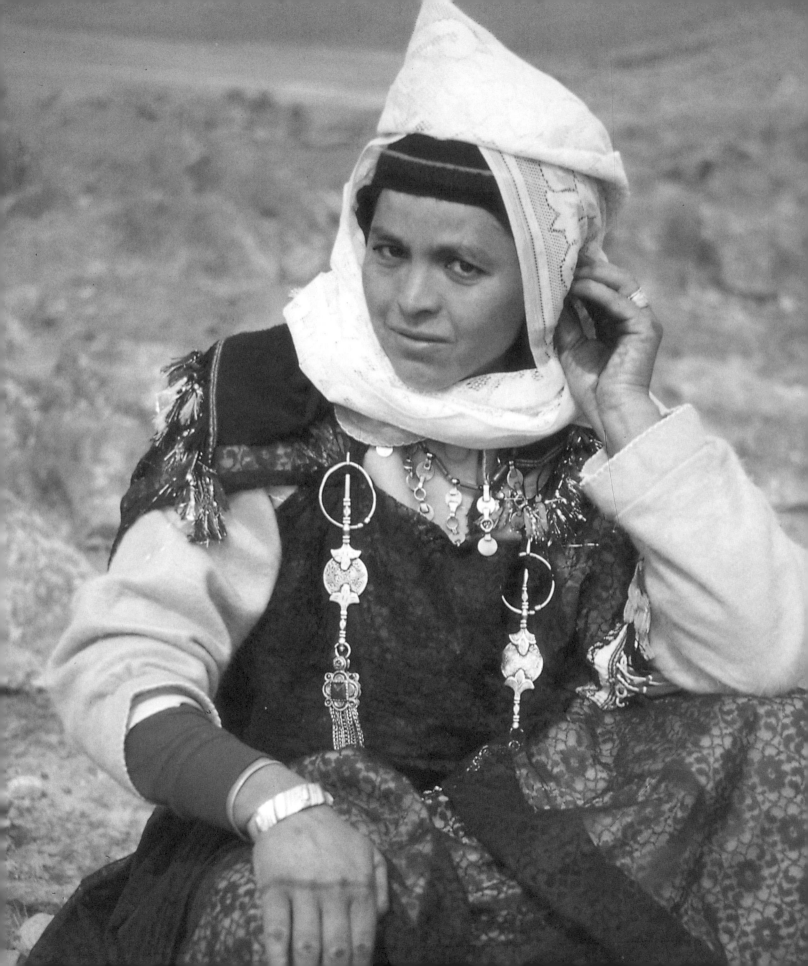

INTRODUCTION

Morocco is a word that conjures up fabulous images imprinted upon our very souls by tales told in storybooks and on the screen. It evokes images of blue-robed warriors on thoroughbred racing camels crossing bleakly beautiful desert sands, nomad chieftains racing swift Berber stallions at tribal celebrations, mysterious high-walled mountain fortresses, palace harems housing pampered captives, intrigue-filled *souks* where one can find everything from bejewelled scimitars to magicians' spells and wild animals.

Reality is in fact more exotic than legend when it comes to the 'land of the Moors'. The name was originally taken by the sixteenth-century European map-makers from the territory surrounding the Kingdom of Marrakesh, an imperial city in the south known as the Baghdad of the West because of its luxurious lifestyle, which they applied to the entire country. Arab geographers, however, called this land *El Maghreb El Aksa* – 'the land farthest west' – meaning the westernmost portion of the Islamic world. Maghreb has since come to be used as a blanket term for the whole of North Africa, including Morocco, Algeria, Tunisia and part of Libya. Many historical accounts use the term for Morocco alone, and both usages are correct.

Since ancient times, Morocco has been a strategic crossroads of trade, with Spain to the north, the Atlantic Ocean to the west, Algeria to the east and the Saharan desert to the south. The most important influences from contact with these countries were those brought about by the gold and slave trades with inner Black Africa, the conversion to Islam in the seventh century and the alliance with Moorish Spain.

The Sahara has not always been a barrier: it was once a filter for many cultures and peoples moving back and forth across the borders. In particular, the trade in slavery and gold from the south along the trans-Saharan routes made the whole of Africa accessible, benefitting both the Maghreb in the north and the Negro kingdoms of the south. This constant flow of people and the consequent exchange of ideas, beliefs and traditions – including art forms, designs, colours and music – have contributed greatly not only to Morocco's history, diverse population and rich cultural heritage, but also to its considerable impact on the traditions of sub-Saharan Africa. Islam, too, had ramifications that were not solely religious: the whole culture, and even the economy, of Morocco would change – along with all of North Africa and parts of West Africa.

LEFT *Woman in the Anti Atlas wearing jewelry.*

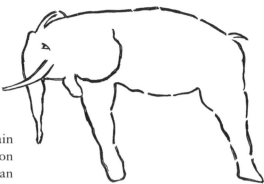

Outline of a petroglyph depicting an elephant from the Anti Atlas, c. 3–5000 BC.

Between the tenth and twelfth centuries, the Moorish empire in Spain extended its influence over much of the known world, finding cultural expression in music, literature, philosophy, art and mathematics. Morocco was more than ever a bridge between Africa and Europe – a vital link between the trade, economy, religions and artistic traditions of East and West. This was ensured by a steady movement between al-Andalus and Morocco (and beyond) of scholars, merchants, craftsmen, agriculturalists, musicians and poets. After the fall of Granada in 1492, as the Spanish Inquisition carried out its self-appointed task of wiping out the philosophy and culture that had reigned for seven hundred years in Moorish Spain, many of these people fled the country and found refuge in Morocco, where their artistic traditions had long been adopted and perpetuated.

Unlike other parts of the world, where indigenous, or at least the earliest-known, traditions have long since disappeared, Morocco's arts and crafts have kept their identity for thousands of years and retain it to this day.

Who were the first inhabitants of Morocco, before the waves of invaders came? No one knows their ethnic origins for sure. Cave paintings attest to an early hunter-gatherer group, replaced by or absorbed into agrarian and pastoralist populations around 5000 BC. Most scholars agree that these settlers migrated from the East, possibly from the Mediterranean Crescent. One group travelled westwards from Egypt across North Africa, another migrated south-east across the Sahara, which at that time was probably more of a semi-jungle than a desert. The same cave paintings depict an era when elephants, hippopotamuses, giraffes, crocodiles and other wild beasts were hunted far to the north of their modern habitat. While their actual point of origin is still a mystery, it is widely thought that the first settlers were semi-nomadic, pale-skinned and blond or brown-haired. Warlike and much feared, they were called 'Libyans' by the Egyptians; Libya was to become the name for the whole of the African continent. These Libyans were the same race that in antiquity the invading forces of Phoenicians, Carthaginians, Vandals, Greeks and Romans would encounter and – regarding them an uncivilized race – would call *barbari* (barbarians), evolving eventually into 'Berbers' after the Arab invasion of the seventh century. The Berbers, who constitute the majority of Morocco's population, live today much as they did in ancient times. Some wandered the desert, tending their flocks and herds, carrying the sum of their wealth with them as they migrated seasonally; some grew dates in the oasis gardens and others lived in the villages of the mountains and valleys of the Atlas range.

Early exposure to the Carthaginian civilization provided the Berbers with an alphabet, as well as sophisticated agricultural skills in the cultivation of olives and pomegranates. They also learned to work iron, use a pottery wheel, create ceramics and tile, as well as improve weaving techniques. The destruction of Carthage in 146 BC was followed by the Roman domination of North Africa.

The Romans categorized the Berbers according to their geographic location: they called the Berbers from Mauritania (the Roman name for Morocco) 'Maurs', and those from Numidia (now Tunisia) 'Numidians'. Its European derivative, 'Moor', was sometimes used as a synonym for 'black', as in Shakespeare's *Othello*. In fact, historical and travellers' accounts, beginning with the Arab invasion, have called Arab, Jew, Berber or African 'Moor' whatever the colour of skin, the only prerequisite being to live in North Africa and profess the Islamic faith. However, the Berbers called themselves *Imazighen* – free men, or nobles. An especially free-spirited people, their resistance was never totally vanquished in the early years of the Islamic invasion. An old Berber man in the High Atlas Mountains told me a parable about how the Berbers perceive themselves as a free and noble people, and their resistance against all invaders. The story is of a ram banging his head against a wall. Many different civilizations (the Phoenicians, Romans, Arabs and Europeans), like the ram, tried to invade and occupy Berber territory and change their beliefs and way of life. But the Berbers are like the wall, and although some have adapted to Islamic culture, they have preserved their traditions throughout the centuries. Parts of the wall collapse, but it stands firm, and the ram's horns are broken or shattered against it. Despite the countless invasions throughout Morocco's tumultuous history (it finally gained independence from France and Spain in 1956 and is now a constitutional monarchy), the Berbers have held strong and made a significant contribution to the history of Western civilization, as well as to the Islamic world.

Some Berbers speak and write Arabic, and some have their own dialects. Probably only ten per cent of the population are pure Arab. However, all are Moslem, professing Islam, attending Arab-built mosques and adhering to most of its teachings, although this is coupled with their animistic traditions, the pantheons of saints and the *marabouts*, the holy men and religious brotherhoods. The history of the Pueblo Indians in the American Southwest is in many ways analogous: they accepted Christianity and attended the Spanish missions, but they also held on to their own religious beliefs and dances, which they practise to this day. Just as some Pueblo peoples have held on to more of their ancient ways than others, so too have some Berbers been less Arabicized than others.

Morocco's artistic traditions can be divided into two seemingly distinct areas of activity: the rural and the urban. The traditions of weaving, embroidery, jewelry, pottery, woodwork and leatherwork are all practised in rural environments, where the social structure remains essentially tribal, with the smallest social unit being the patrilinear extended family. On the other hand, the artistic tradition of the urban environment – developed in the imperial cities of Fez, Meknes, Marrakesh and Rabat, as well as in cities such as Essaouira and Tetouan – is determined by a strict set of aesthetic canons found throughout the

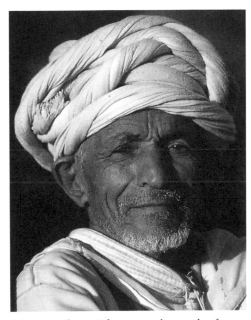

Musician from Talioune in the south of Morocco.

Moslem world: in general, it is more concerned with scripture, puritanism and devotion.

Life in rural Morocco is based essentially on farming and animal husbandry, with agriculturalists tending to live in permanent housing of adobe and stone. For the herders, subsistence consists of nomadic movements between the Sahara in winter and the verdant valleys of the Atlas Mountains in summer. They live in tents or in villages scattered over the plains and slopes of the mountains. Many aspects of rural life, not least artistic production, are intimately connected with nature and the agrarian cycle: planting, harvesting, reverence of the sun, moon, earth and the stars are all inherent in the symbolism of its cultural traditions.

The men and women who practise the rural artistic traditions are not professionals. They participate in daily activities other than solely artistic ones and use the materials available in their various immediate surroundings, such as wool from their sheep. Although the work produced is meant to be utilitarian, many possess exquisite beauty and are designed with exceptional inventiveness. The symmetrical and asymmetrical juxtapositions of designs present a remarkable balance of colours and textures. It is these powerful designs of the rural artistic traditions of Morocco that attracted the European artists and designers who were prominent influences in the 1920s and 1930s.

Much of the artistic vocabulary of the rural areas – that is, their symbols, designs, motifs and tattoos – originated from pre-Islamic beliefs influenced later by Islamic geometric patterning and ornamentation. However, as we shall see in the chapters that follow, the effect of Islam was slow to radiate to the countryside and had a weaker impact here than it had on the cities.

In the countryside, one can sometimes see a combination of rural and urban traditions, especially in the rugs, or one might find a kohl container or a wooden box with a star on the bottom, with the other sides totally covered in a typically Islamic pattern. One cannot deny the elegance and grace of this overall pattern when the Berbers apply their talent to it. While they might use the same pattern as the city artisans, Berber designs are less abstract – a pattern might be more recognizable as a leaf, for example. In the urban areas, however, everything is covered with the Islamic pattern: Islam is not only a religion, but a philosophy, so that in art, as in all daily activities, the Moslem refers to the Koran for guidance.

In contrast to rural areas, where artistic traditions are only a part of everyday life, artisans of the city make a full-time living from the work they produce. In the seventeenth and eighteenth centuries, the artisan class devoted itself to the Sultan's desires, creating the furniture, woodwork and other furnishings that decorated the mosques and palaces. Today, this same artisan class addresses itself to the demands of the wealthy social classes and, more recently, to the tourist market. In fact, different branches of the economy are organized in the city's quarters according to each group's speciality. The artisan class occupies certain

areas and is divided up into well-structured guilds (there are separate areas for other workers, such as potters, jewellers, leatherworkers and weavers). The guild requires artisans to move up through successive levels of an apprentice system, under the supervision of a manager, or master artist, called the *maallem*. When an apprentice has learned the trade and shown proof not only of skill but of the moral qualities required by his profession, he can, if he wishes, work for himself. But he can only do this if the maallem gives his consent and solemnly declares before witnesses that the student has become a master of his profession. The rigour with which the guilds are regulated and the professional standards they expect of their members have contributed greatly to the continuity and preservation of the techniques and designs of this tradition.

Each branch of activity has its own identity and well-defined standards, and the urban artisans treat the objects they create according to them. However, they will also present the same graphic expression in a product that distinguishes another geographical area – for example, the ceramics of Safi and Fez, which are not dissimilar – while maintaining their own region's distinctiveness, perhaps in the choice of painted ceramic slips and colours (this is also true of leatherwork, woodwork and weaving, etc.). Despite such regional variations, the characteristic unifying all these urban art traditions is the aesthetic of the Arabo-Moslem culture. During the Islamization of Morocco, new design styles and models were introduced into the country first by the Arabs, and later, and with greater impact, by the Andalousi (the mix of Arabic peoples living in Andalusia in Spain), who contributed greatly to the full development of the geometric patterning and styles so characteristic of this civilization.

The elaboration of the designs now common in Arabo-Moslem art was originally intended for architecture. Woodwork, jewelry, embroidery, ceramics and textiles were decorated with graphics inspired by the monumental designs of the mosques and palaces. But the miniaturization of such designs is such that the architectural model that gave birth to them is not always recognized. Nevertheless, if one looks closely at a well-designed chest with eternal sun symbols, its sides will resemble exactly the walls of a mosque.

The urban artistic vocabulary can be outlined as follows: epigraphic expression in the form of Koranic verses, names of Allah (of which there are ninety-nine), calligraphy and geometric designs composed of polygons and arabesques in floral and other vegetative motifs. Coming from the wide-open spaces of the desert, where water is revered, and conditioned by Islam – which itself came out of the Saudi Arabian desert – all Moroccans give great emphasis to gardens in their designs; their floral and leaf motifs symbolize a paradise of watered gardens.

Writing or script appears frequently in urban art. It is executed on architectural surfaces in the form of Koranic verses, religious maxims, praises to

rulers and the names of Allah or Mohammed. Two styles of writing are currently in use: the Kufic, formed of straight, angular, thick lines ending in a chamfered edge, and cursive script, which is devoid of angles and formed by lines in which downstrokes and upstrokes alternate. These two styles are engraved, sculpted and painted on to all materials used in many of the urban traditions, such as ceramics, woodwork and metalwork. Enriched with polychrome, the two scripts are combined and repeated infinitely, giving the objects and textiles they embellish an overall grace of pattern and a sanctity of visual order and space.

Much of the art is very meditative in effect, which is considered a virtue in Islam. The psychological conditioning of the Moslem towards meditation, through the frequent reiteration of prayers throughout the day, is expressed in the traditions of urban design by the infinite repetition of geometric lines, floral motifs and epigraphic verses from the Koran. Through this overall pattern, the artisan communicates an inner joy that is a primary expression of the urban art of Morocco.

The distinction between urban and rural art in Morocco, as we can see, is not as clear-cut as at first appeared. While the rigorously Moslem artisans of the city and the Berbers in rural areas maintain the identity of their respective origins and their belief systems, the two traditions have interacted significantly throughout the history of the country. The splendour and range of the objects illustrated in this book will, I hope, demonstrate, both to the initiated and to those who look upon them for the first time, the rich diversity of that culture.

BELIEFS, SYMBOLS AND TATTOOS

We shall show them our signs on the horizons and in themselves,
Till it is clear to them that it is the Truth.

Koran, Sura, 41: 53

In Morocco, among the Berbers in particular, many of the beliefs surrounding objects and textiles predate the introduction of Islam to the country. The belief in animism (that all animals and objects are animated by a spirit) has been crucial in the development of the artistic traditions of Morocco, not only in the sense that the objects produced, including the ceremonial arts, serve as a source of magic, power and protection from evil forces, but also because they are intrinsic to daily life.

In the urban tradition, textiles and other objects are created more emphatically as an act of worship and tribute to Allah, through the devotional work of the believer. As well as being a creative process, the act of decoration is considered a meditative practice, effecting the same quality in the end product. These objects can tell us a great deal about the social and religious background of the artisan and the craft specialization guild to which he belongs. It is clear that, in the past, Islam had a tremendous impact on urban artistic traditions, and on rural traditions, though to a lesser extent on the latter. That influence is today somewhat less dominant: the representation of humans and animals may still be frowned upon by the Koran, but it is not totally forbidden, a fact evidenced by their presence in much rural art. Although the Berbers do for the most part adhere to these restrictive canons, the depiction of such recognizable figures indicates an expression of rural existence and the relative freedom they experience, away from the laws of the cities. This free-spiritedness is also apparent in their social practices: most notably, Berber women are not veiled or segregated.

When one looks at the objects and textiles of the rural environment, one can trace a legacy of the popular, collective and sacred artistic traditions in Berber history; these are a testimony not only to the meditative and aesthetic power that decoration holds for them, but to a faith in supernatural power. Many pieces are valued not because of appearance alone – perhaps because of their form or the way in which they are decorated – but because they may contain a power known as *baraka*, a concept deeply embedded in Moroccan religious beliefs and crucial to the understanding of all artistic traditions in Morocco. Baraka has many

meanings in Morocco, but it is principally the positive power of the saints and the Sufi brotherhoods. It is a source of creative inspiration among most Moroccan artisans, both rural and urban: the religious faith of the maker and his belief in the supernatural are inextricably connected with the objects he or she produces. Baraka permeates all things to varying degrees; not only can it exist in jewelry, talismans and other manufactured objects, such as ceramics and textiles, it is also thought to suffuse plants, such as henna and oleander, and incenses, such as sandalwood and myrrh. Horses, camels and cattle are also believed to be endowed with baraka. This power is transferred to objects and textiles by the use of a particular artistic vocabulary of symbols, designs, motifs, colours and techniques that protect the object, creator and consumer. (Much of the art intended only for the tourist market is unlikely to have baraka, as it is now a separate industry from traditions embedded in these beliefs.)

In the case of jewelry, both the rings and the amulets (charms in the form of a ring, earring, precious stone, knotted string or sacred sign) found in necklaces, and talismans worn around the neck, are decorated with words or phrases from the Koran and any of the ninety-nine names of Allah, either engraved in the metal or written on paper and sewn into the leather. The efficacy of these charms lies in the baraka inherent in certain Arabic phrases or words – one of the simplest ways to receive baraka is through phrases such as *Bismi'Allah* (in the name of Allah), which is commonly repeated during everyday activities – whether eating, drinking or working, but especially when beginning a creative endeavour. Many of these words are used as protection against infertility or domestic difficulties, such as a husband's defection. In fact, since the whole Arabic script is believed to contain baraka, objects can acquire this power through the relatively simple means of being inscribed. The presence of baraka can also be achieved by transference through direct contact with the marabouts (holy men) – textiles or wool are often taken to them for blessings either by the woman who wove the piece or by the one who has received it. The textiles are sometimes draped over the tombs of saints or sprinkled with the surrounding earth.

Used in the creative sense, baraka is similar to Western perceptions of aesthetic ideals – the artist attempting to reach a higher self through artistic expression and thus instilling the work with a power that goes beyond the time and place of its creation. When the Moroccan artist is creating, weaving, sculpting or cutting *zillijs* (the small pieces of tile cut to make mosaics), he is often trying to attain baraka both for himself, through the experience of making the object, and for the object itself. In both cases, the pursuit of excellence involves knowing when to stop once a level beyond which no work can improve a piece has been achieved. One can sometimes tell almost from instinct alone, by looking at the intricacy of the geometric patterning and the colours used – is thought to contain and bestow baraka. There is also a term used by the Berbers and Arabs called *blanc coeur*

RIGHT *Early 20th-century gouache of a Moslem bride from Salé, by Jean Besancenot.*

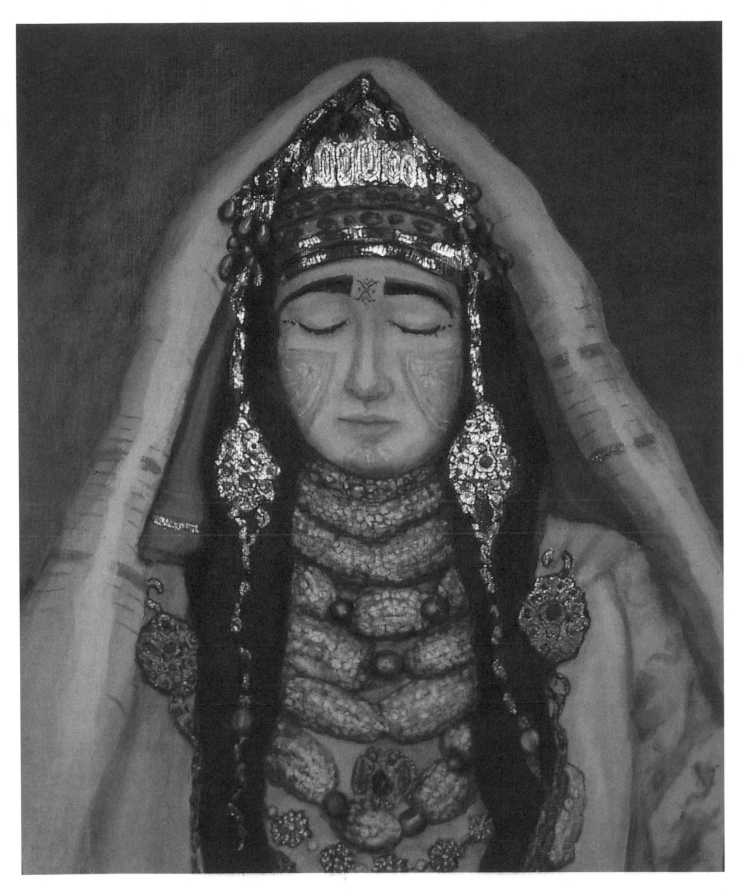

(the white heart), which signifies the amount of love and labour they put into their work of creation, to which all artists can relate.

Baraka is sought by many Moroccans as a means of dealing with darker forces – for curing illnesses and in turning back the *djoun* (evil forces) or the evil eye. Although many educated Moroccans no longer believe in the existence of these supernatural beings, they remain for the majority of people, especially Berbers and Moslems of the older generation, very much a part of the country's culture.

In Morocco, the practice of magic, by both men and women, can be defined as the attempt to control the supernatural world by use of spells, incantations, formulas, amulets and talismans (from the Arabic, *tilsamen*, meaning 'to make marks like a magician'). Throughout its history, the country has been famous for its magicians and medicine men (nearly all the magicians in *One Thousand and One Nights* were Moroccan). The apothecary stalls in the souks are evidence of the continuing use and practice of magic in Morocco. Tables upon tables are filled with a wide range of pharmacopoeia and the raw materials of magic – from incenses, perfumes, herbs and feathers, to bladders, entrails, snake heads, dried lizards, insects, teeth and bones. One can also find potions for curing and healing, for attracting love, pieces for making talismans and amulets, and ingredients for the practice of the art of *tseur*. This is a form of black magic controlled almost exclusively by women; it can be used for poisoning husbands and for casting spells against other women. The efficacy of this belief system lies simply in the creator and the wearer or recipient of the object believing in it.

Many Moroccans do not talk openly about the djoun, as the mere sound of the word said aloud might invoke them; they are referred to as 'Those Others'. The djoun are the mischievous spirits thought to inhabit desert places, cemeteries and ruins, as well as darker, danker places, such as caves, grottoes, streams and even lavatories. They are thought to surface from their subterranean dwellings at night, when they wreak disease and misfortune. When the djoun attack human beings, they usually take the form of a person or animal (not unlike the belief in 'shape-shifting' in Native American culture); for this reason, Moroccans believe that cats and dogs should never be killed in case they are an incarnation of a *djinn* (singular of djoun).

The evil eye, feared throughout the Mediterranean world, is a power held by certain people whose stares and glances are thought to bring bad luck to those upon whom they fall; there are numberless ways in which urban and rural artists in all traditions incorporate precautions into their work against susceptibility to these effects. Many pieces are meant specifically to divert or deflect the evil eye and the djoun, in which case the overall design can be considered talismanic. Almost all the decorative arts – whether urban or rural, representational or abstract – come out of and express the vocabulary of these beliefs.

Amulet – ihruz *– believed to have prophylactic powers and to contain baraka. Such designs are common in textiles, pottery and leather.*

Late 18th-century embroidery from Azemmour, showing the influence of the Italian Renaissance (filtered through Spain) in the depiction of ancient goddess figures.

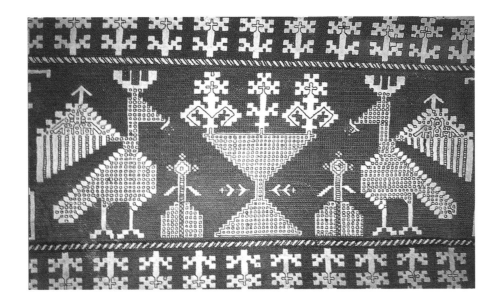

The belief in 'Those Others' is particularly evident in the weaving, embroidery, jewelry and leatherwork traditions. For example, weavers in many Berber and Arab tribes are always careful to look at the feet of the women washing the wool; if they are djoun, they will have goats' feet or hooves. There are numerous names for, and forms of, the type of djinn who takes this shape, of which the most famous is Aisha Kandicha, who in popular folklore was feared for her beauty and her power over men.

There is little doubt that the artistic vocabulary used by both the rural and urban artisan today in Morocco has changed over the course of the country's history. Many symbols, motifs and tattoos have disappeared altogether from use, or had their meanings transformed over time. There remains, however, a repertoire of designs that has been utilized by artisans for many centuries. This includes magic numbers, magic squares, verses of the Koran, the Arabic script, geometric figures (triangles, squares, crosses, eight-pointed starts, Stars of David, spirals, circles and diamonds), floral and other vegetative motifs, abstract and representational animal designs, human hands and eyes, and a vast array of tattoos.

There is a long tradition of interest in numerology in the Arab world, especially in the numbers three, five, seven, nine and their multiples, which are believed to have magical properties. The magic square – composed of a series of numbers so arranged that the sum is the same, whether the numbers in the rows are added up vertically, horizontally or diagonally – is often used to cure the sick and protect the wearer from the evil eye.

While the intercession of the local saints can be invoked for curing and healing, specific people are sought for different kinds of advice; for example, the job of a *taleb* (magician doctor), is to write the verses and words for talismans and amulets. A *fqih* (holy man), whose first and foremost duty is to examine the Koran and divine the verses needed for healing the sick or warding off the djoun, but especially for carrying out exorcisms, can also be consulted. A *shouafa*, a Jewish seer, is considered to be an expert in fortune-telling and clairvoyance, with additional healing powers and the ability to cast spells.

A talisman can be made of parchment, leather or cloth inscribed with symbols such as crescents, crosses, stars and hands. The simplest amulet or talisman in Morocco, and indeed in most of the Islamic world, is a piece of paper on which may be written a short prayer or a spell, words or verses from the Koran, the names of Allah, or numbers and squares with magical properties. All these talismanic designs and patterns come from the Koran, Medieval astrological

Khamsa design from Khenifra.

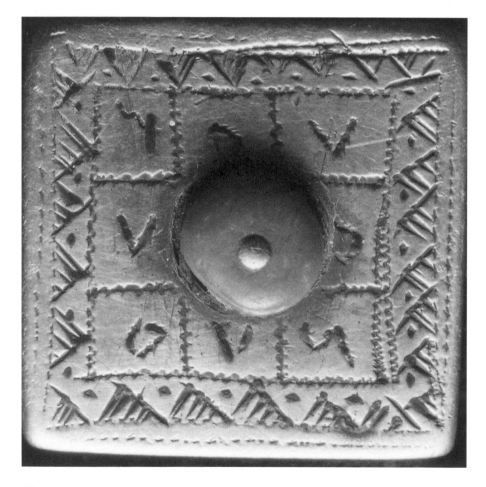

Close-up of an early 20th-century Berber talismanic ring, showing ancient and astral symbols, magic squares and the Libyan script, tifnagh.

Detail of a leather painting (see pl. 22) by Farid Belkhaia.

Berber eye symbol, believed to avert the evil eye, with the central cross deflecting such forces in four directions.

notebooks and from ancient divination manuals and are found engraved on jewelry, carved in wood and woven into textiles.

The symbols and motifs representing animals appear frequently in textiles, embroidery, pottery, ceramics, woodwork and jewelry. However, they tend not to receive the artistic recognition they deserve, mainly because of the restrictions in Islam against human and animal representation. These images can either be realistic or stylized and are often incorporated into floral and geometric designs.

Many of the animal images are executed with great simplicity and elegance; the representation of the most dangerous animal, a snake, scorpion or jackal, for example, is intended not to invoke fear in the viewer, but to act as a symbolic protector. Certain pieces of jewelry – for instance, a necklace or an anklet – are thought to protect the wearer, depending on the animal depicted. The fish symbol, common in many artistic traditions, represents water and rain, and, consequently, the fertility of the earth and general prosperity. The bird, frequently cited in the Koran as a messenger between heaven and earth, is associated with destiny, with the eagle more specifically symbolizing power. The lizard and the salamander are depicted as seekers of the sun – probably derivative of ancient sun cults – and represent the human soul searching for the light. The snake is associated with the phallus, itself a symbol of fertility and the libido, and is thought to have healing powers; it can either be depicted in detail, or represented simply, as a wavy or zigzag line in textiles and jewelry. Turtle and tortoise motifs are often seen in jewelry; they are believed to represent the saints, thus providing protection against evil forces.

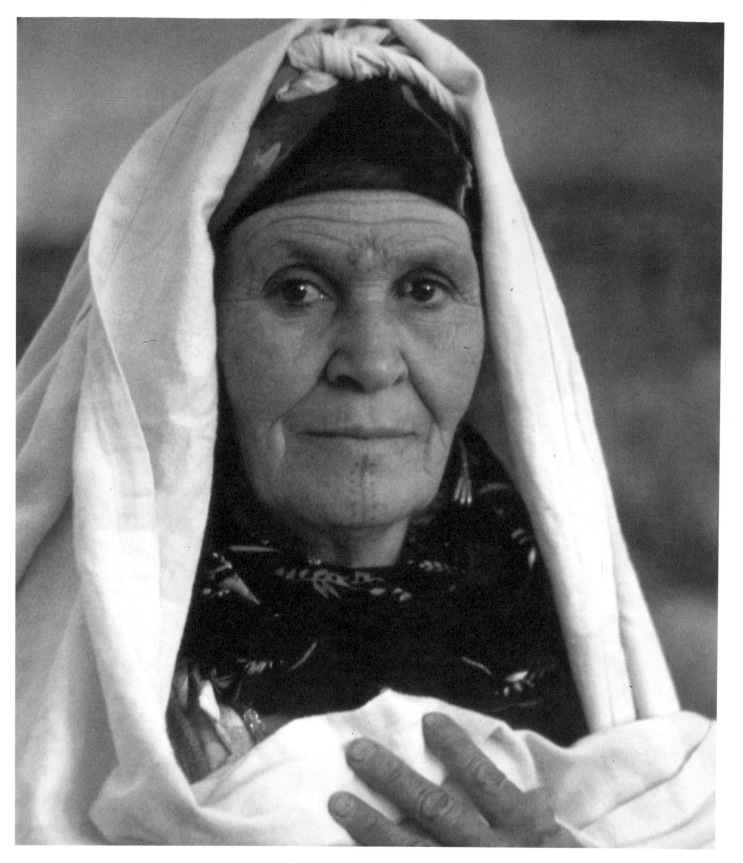

Tattoo design from the Middle Atlas, similar to a cabbalistic motif, intended to ward off the evil eye.

LEFT *Berber woman, from the Ait Mohammed region, with tattoos.*

Many of the fibulas have a turtle-shape design, as do many of the talismans in Berber necklaces.

Amulets – magical protectors against evil forces – might consist of an animal's real hair, teeth or claws. Not only are the charms themselves meant to possess magical power, but the motifs and symbols that characterize them are also believed to endow a piece with these properties.

After centuries of Islamic taboo about imagery and tattooing, some Berber designs show the compliant avoidance of human and animal representation. However, these characteristics may be clearly evident in other designs, though perhaps only suggested. The art of concealment, by using the magnification or reduction of certain characteristics, and the stylization of images, is very much a part of the Berbers' superior artistic skills. Despite the taboos, representation of humans along with camels and donkeys is found in some Berber textiles, and even on household utensils.

Two parts of the human body in particular – the eye and the hand – offer the greatest protection against the evil eye and the djoun; this is a significant impetus for much Moroccan art, both urban and rural. Whether engraved or carved, realistic or stylized, it is rare that some form of the eye or the hand is not displayed in a Moroccan dwelling, be it in the form of embroidery or jewelry. It would be even more unusual for a Moroccan – Berber or Arab – not to talk openly about these motifs. One even sees them openly depicted in the streets, painted on the backs of trucks or on exterior walls.

The hand, called *khamsa* – a symbol of human creative activity, power and dominance – symbolizes the number five, whose magical properties are believed to protect the individual from evil forces. The people generally considered most susceptible to the evil eye are brides, pregnant women and babies, who are likely to wear a variety of pendants cut in this shape. The khamsa takes the greatest variety of forms in jewelry: it, too, can be depicted in a realistic way or abstracted and stylized, with the fingers joined, spread or open.

In other pieces of jewelry, as well as in the textiles, one might find, rather than the hand motif itself, the number five represented by rows of triangles, diamonds, eight-pointed stars, Stars of David or crosses. In many of the rosette-shaped talismans found in Berber necklaces, one finds simply five dots and five lines. These are all representations of the protective hand of Fatima, the daughter of the Prophet Mohammed. Wearing or possessing any manifestation of the number five, or a depiction of the hand, is believed to have the same effect as poking the fingers into the evil eye and pronouncing the words *khamsa fi ainek* (five in your eye).

The eye motif, also represented realistically or abstractly, is particularly common in the textiles of the Berbers. It can appear as a triangle symbolizing one eye or as a row of triangles representing a pair; in fact, many weavers call the

triangle *el ain* (the eye). An inverted triangle, representing the eyebrow motif, is commonly seen in tattoo designs as one more depiction of the eye. Jewelry has many such motifs, especially anklets, as do household objects, such as oil lamps with a carved eye on the lip. Just as there is a wide variety of hand designs, the eye can appear in all kinds of ways, depending on the artisan involved. An entire cushion, for example, could be covered in an eye pattern, with the inverted triangles representing eyebrows, and lozenges representing the eyes. One of the most realistic and dramatic of all eye motifs in Moroccan art is the red oculus, seen most frequently in the embroidery on the backs of the snow capes of the Berbers of the western High Atlas region. In some of these cape designs, the energy emanating from the eye can be seen in undulating embroidered lines, which gives a glimpse of some of the possibilities available to the weaver in creating both realistic and stylized eyes, or rows of eyes and eyebrows. The way in which the movement of energy is depicted – in some ways analogous to the Mexican Huichol Indian yarn paintings, called *Ojos de Dios* (eyes of God) – makes it clear to the observer that these are not just decorative textiles: whatever the form of the eye, or the medium on which it is executed, these designs possess magical properties against evil, and are thought to protect people, animals and the object or textile itself. Such protection is the only action a human can take in the face of *mektoub* (destiny), the determining force behind every individual's life.

Tattooing, the indelible graphic marking of the body – mainly of women, but sometimes of men – is a widespread practice in traditional Moroccan society, among both Berbers and Arabs, and is integral to the country's artistic vocabulary. It resulted from the belief that the body orifices were vulnerable and in need of protection from the evil which might enter easily through them. Cave paintings in many parts of North Africa, for example in Tassili in Algeria, show evidence of tattooing; Herodotus, the Greek fifth-century BC historian, also noted the traditions of tattooing, as represented by Nit, the goddess of Egypt's Nile delta, depicted as tattooed. Tattooing was practised with greater secrecy, however, when Morocco was invaded by the Arabs, which accounts for the many mutations of the designs in different media that have kept the tradition alive. There was a revival of tattooing in 1912, when the French occupied Morocco, in an effort to preserve tribal identity and the art itself.

Tattooing is usually done during a ceremony, because it is considered a social activity. The tattooer, who can be male or female, traces the motif on the skin with the aid of bluing or pot black (obtained from cooking pots); indigo can be added to this, after which the design can be covered in henna or saffron for healing purposes and for making the mark more visible. The skin is then lightly pricked along the lines already marked by the dye, after which dried pulverized leaves of various special plants are added. Once the inflammation has subsided,

a permanent blue–green emerges. Tattoos are a form of non-verbal communication and as such exemplify the role of women in Moroccan society. The significance of the tattoo does not necessarily lie in the particular motif, but simply in the fact that a woman is tattooed, as it is considered an indicator of her social group, its system and values. In various parts of Morocco, most girls between the ages of ten and sixteen are tattooed, marking their entry into adulthood; it can signify either an approaching marriage or the fact that a woman is married already. The tattoo also permits a woman to communicate outside her immediate social group. I once met a woman who had been married several times and consequently tattooed as many; she had acquired an amazing array of designs and patterns, including a necklace, complete with talismans and hands, tattooed around her neck and chest. She told me her tattoos were hidden under her clothing, to hide them from the Arabs.

Tattoos are never figurative, but rather stick-like, simple geometric formations, which create both closed or open spaces. Their simple designs are probably due to the limited range of techniques available in their execution. There is no shading or elaborate all-over body decoration of the kind found in other parts of the world, such as in some Pacific cultures.

The repertoire of tattoo designs for men is minimal and their placement is restricted to certain parts of the male body: a tattoo may be located on the nose, the hand, or the right arm, in which case it is meant to protect the man from danger, or failing that, give him strength in a dangerous situation. The range of designs for women, and the parts of the body on which they are placed, however, is very extensive; they can be located on the forehead, chin, cheeks and neck, as well as on the chest, arms, feet, and sometimes the thighs and umbilicus. Tattoos are also considered an enhancement of female beauty. The actual placing of the tattoo can often be a cosmetic change, almost restructuring or emphasizing certain features. Tattoos on the arms, fingers and wrists can lend gestures a kinetic lightness and delicacy, and when placed near the breast and pubic areas are intended to increase the sensuality of the female body. Tattoos also provide protection against evil forces and are usually placed on the ankle (tattoos on the hands of both men and women, however, are believed to avert the evil eye). Some special tattoos applied to a woman's back are believed to both prevent infertility and treat it. The healing properties of tattooing are often a reason for its practice; I once met two women who had broken their wrists in an accident; as the bones had not set quite properly, a tattoo was placed on each spot in order to cure the malformation of the bones.

The abundance of graphic combinations of tattoos has not escaped the attention of the practitioners of rural artistic traditions in Morocco. Many objects, including pottery, textiles, embroidery and woodwork, undeniably incorporate tattoos as part of their design. The ones used by female artists can

either be a revival of an older vocabulary, kept secret from Arab invaders, or they can be more stylized forms of the marks on their bodies. In some cases, just as in the execution of the eye motif, the tattoo design may be reproduced in great detail or cover the entire textile as an overall pattern.

Another aspect to consider in regarding these tattoo motifs is the combination of the kind of medium onto which the tattoo is transferred from its original source (that is, the human body) and the limitations of the particular technique. If a tattoo is woven, painted on pottery, or engraved on jewelry, its appearance will necessarily be different to its manifestation on human skin. At a first glance it may look nothing like the original body tattoo, unless magnified.

It is hard to identify a range of tattoo designs or their origins with a particular geographical area, for which there are several possible explanations: one may be that the tattooer, who is not necessarily a professional, though very capable, becomes sought after by another, distant clan. Often, because the parents pay for the tattoos, and because the mother usually has a specific design in mind for her child, she may commission a tattooer from another region. The movement of nomadic people across the country, not to mention the extent of tribal warfare over the years, has also meant that it is almost impossible to pinpoint geographically and historically the origins of many motifs.

There is no doubt that the practice of tattooing is in a transitional state in Morocco, and that many of the original meanings, as well as the availability of the repertoire of designs, are also changing. But the use of tattoos in the different artistic traditions has always had a special significance: through them, women are able to find a means of expression without words, beyond the constraints of Islamic society and beyond a mere enhancement of physical beauty.

The legacy of these ancient beliefs has today a wide-ranging influence. After talking to many Berber artisans in the countryside, and to a new generation working in the cities, I received the impression that there has been a shift in their perception of their role as artists: they see themselves not as mediums of Allah, but as part of a universal, creative source. However, it is both Islam and magic that have long been and remain the impetus behind Morocco's artistic traditions.

1 *19th-century clay storage vessel from the Rif area in the north of Morocco; pottery in this region closely resembles ancient Carthaginian pieces, showing the considerable and continuing influence of that civilization on techniques and designs.*

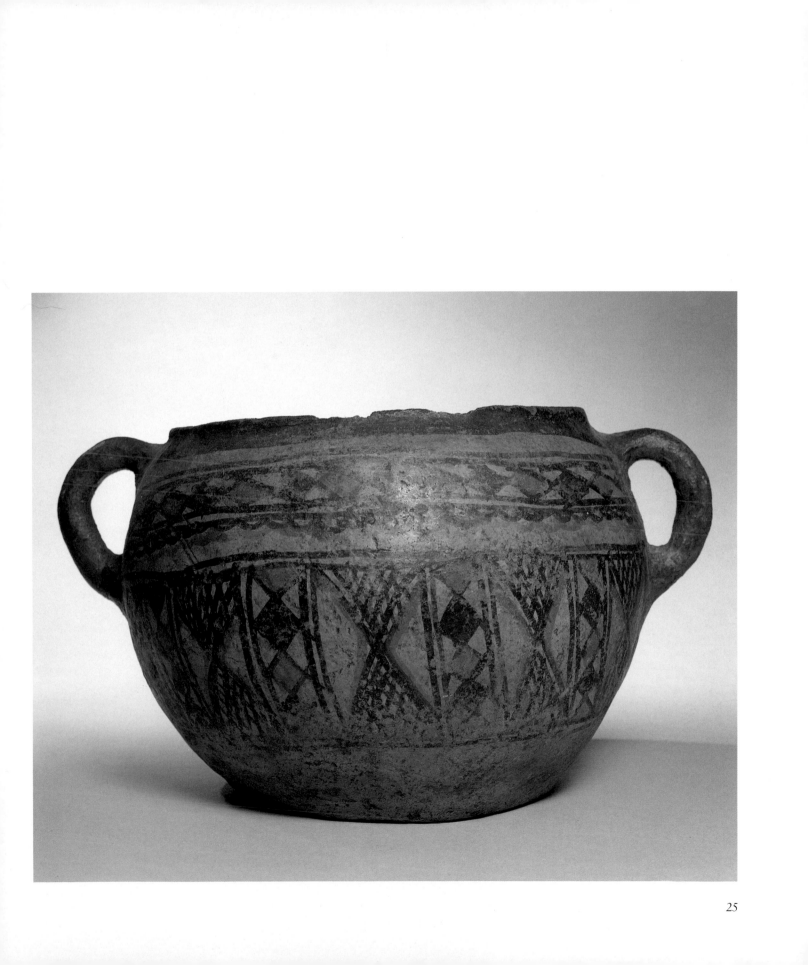

2 RIGHT *Carthaginian terra cotta oil lamp from the 2nd century. The eyes of the lamp are believed to repel evil forces and the wick of the oil lamp is sometimes burnt in order to predict the fate of a marriage: if the wick is extinguished, the relationship is over, but if it continues to burn, the marriage will thrive.*

3 CENTRE *Roman oil lamp from the 4th century. Romans used mainly terra sigillata (a reddish-brown earth), which they decorated with stamped designs coated with a clear glaze.*

4 FAR RIGHT *Phoenician limestone head of a deity, c. 800 BC; the Phoenicians were the greatest traders of the ancient world and the founders of Carthage.*

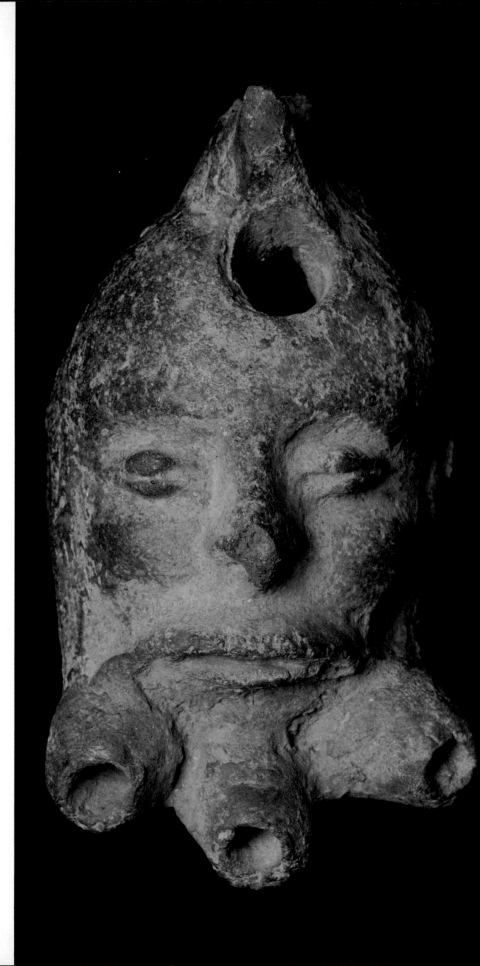

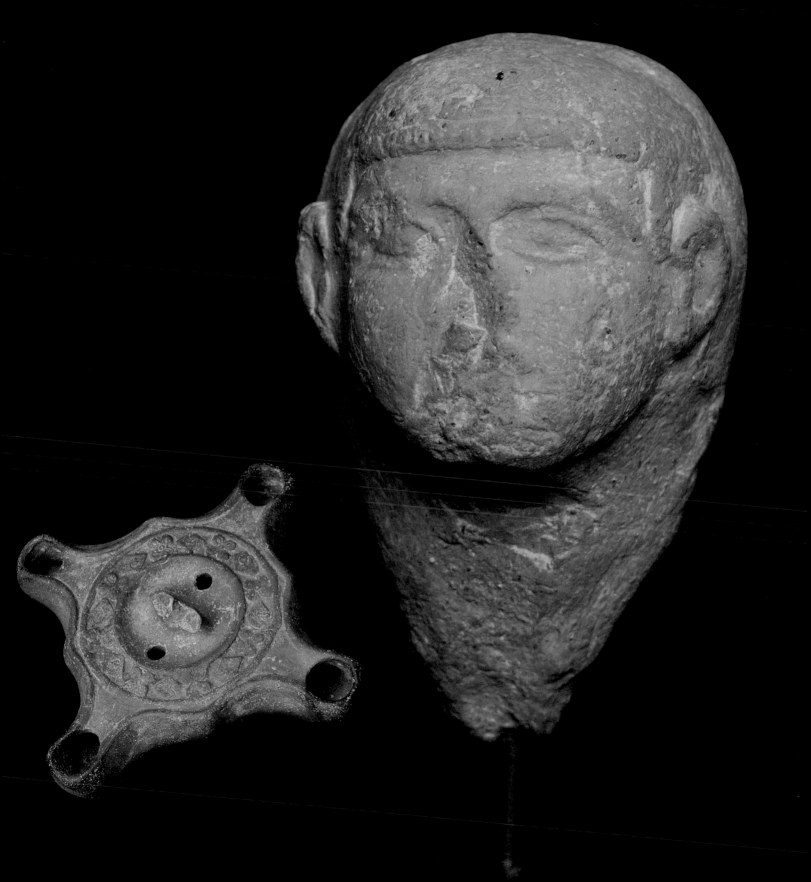

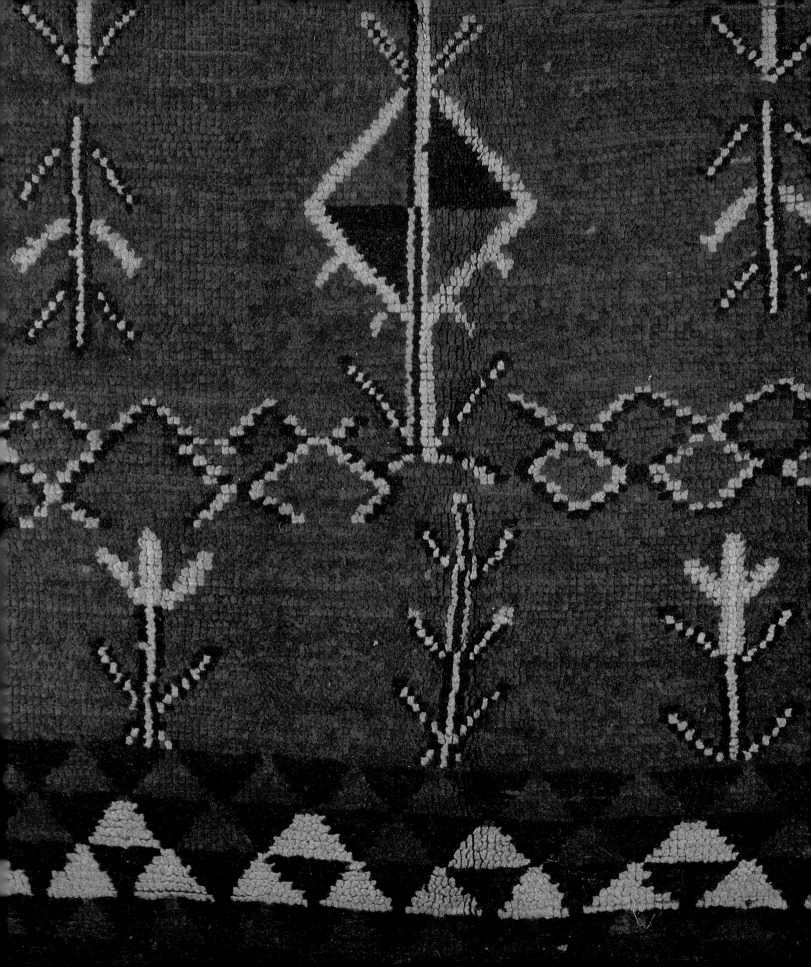

5 LEFT *Close-up of an early 20th-century* Chichaoua, *a rug named after the town on the Haouz plain in the north, famed for its textile production. This shows tattoos and scorpion designs.*

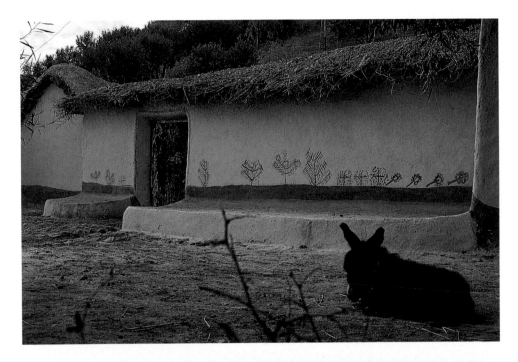

6 LEFT *Folk painting on a wall in Tissa, north Morocco.*

7 ABOVE *93-year-old Berber woman from Khemisset (west of Meknes) with tattoos; these indelible marks – usually of geometric designs rather than figurative forms – can identify a woman as part of a social group, as well as celebrate a marriage or any major ceremony in her life.*

8 LEFT *Women watching the* boujeloud, *a festival performed only in Jajouka, a village in the foothills of the Rif mountains. It celebrates the 'goat god' (the ancient figure of Pan), with a figure dressed in goatskins, lit up by a bonfire and snatching up switches to whip the women, who run screaming before him. It is believed that if a woman is caught, she will become pregnant before the end of the year.*

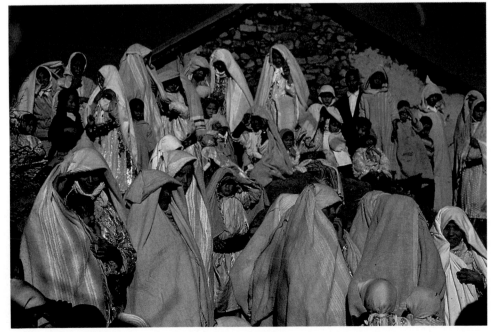

9　*Early 20th-century* ikanaf *(burnoose), an outer garment worn only by men, with wefted brocading in wool. Made by the Ait Sektana, a subclan of the Ait Ouaouzguite, who are the major tribal weaving confederation in the High Atlas region. The eye, eyebrow and geometric tattoo designs are part of the Berber animistic vocabulary thought to have prophylactic powers.*

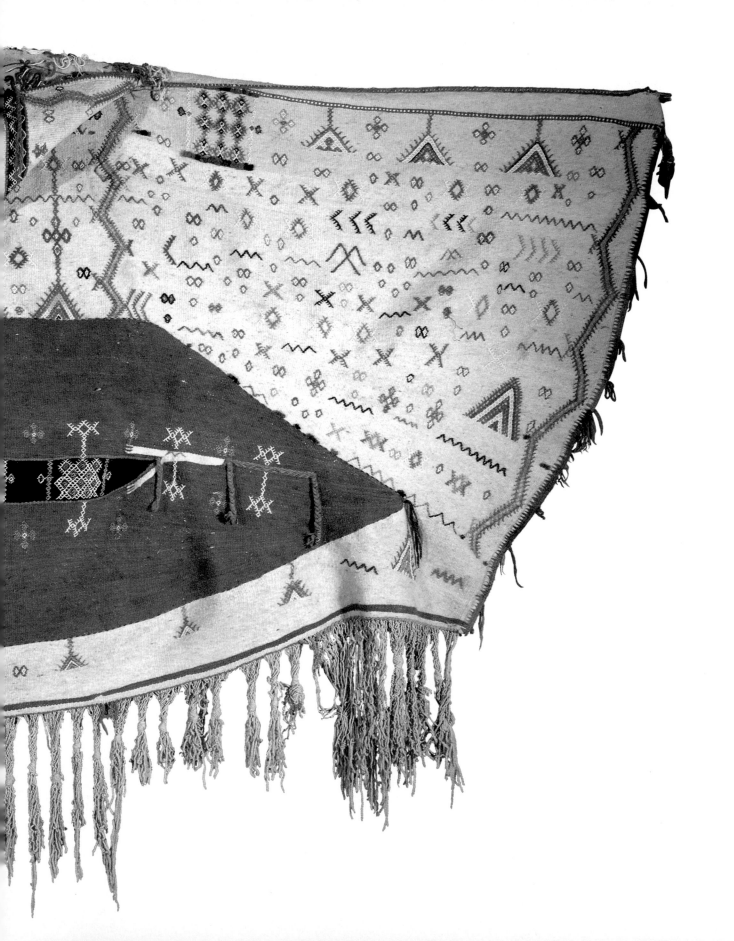

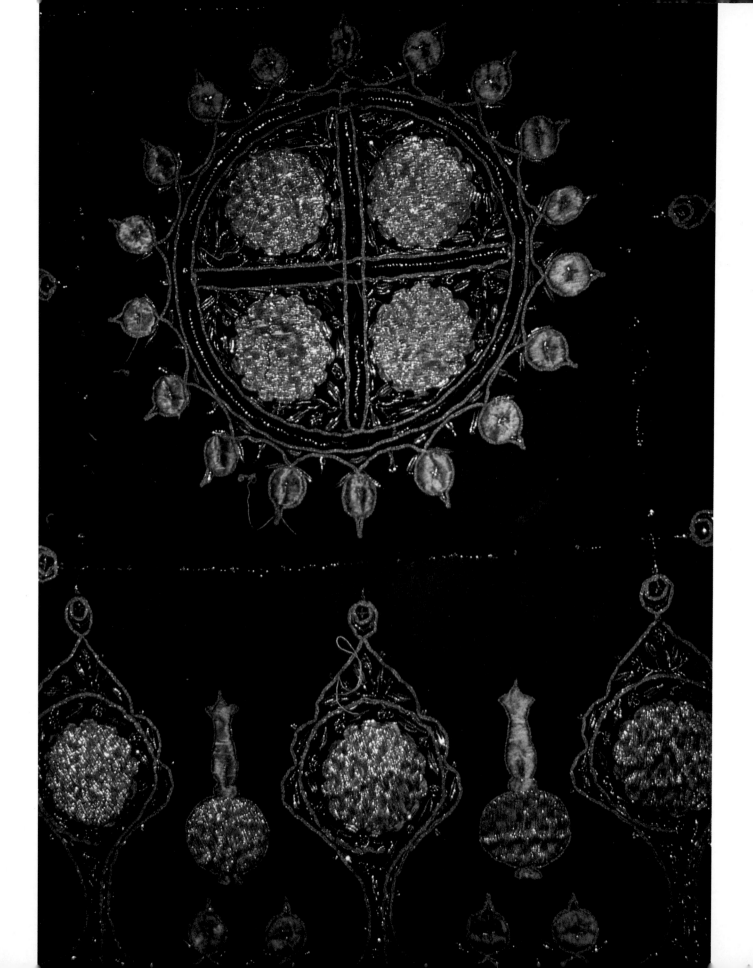

10 LEFT *Close-up of 19th-century wall hanging, embroidered with metallic thread, from the Rif region; hangings such as these were very common in many urban Moroccan homes and in the tents of the rural rich.*

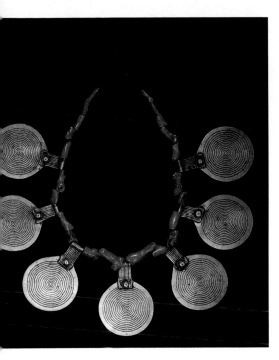

11 ABOVE *Early 20th-century immortality necklace from the Tiznit area in south-west Morocco, with coral and silver niello spirals (silver inlaid with black resin).*

12 RIGHT *Early 17th-century pendant necklace from Fez; the bird, in enamelled gold filigree, is encrusted with pearls, emeralds and garnets. Most urban jewelry is made in gold, while the rural tradition produces pieces almost always in silver.*

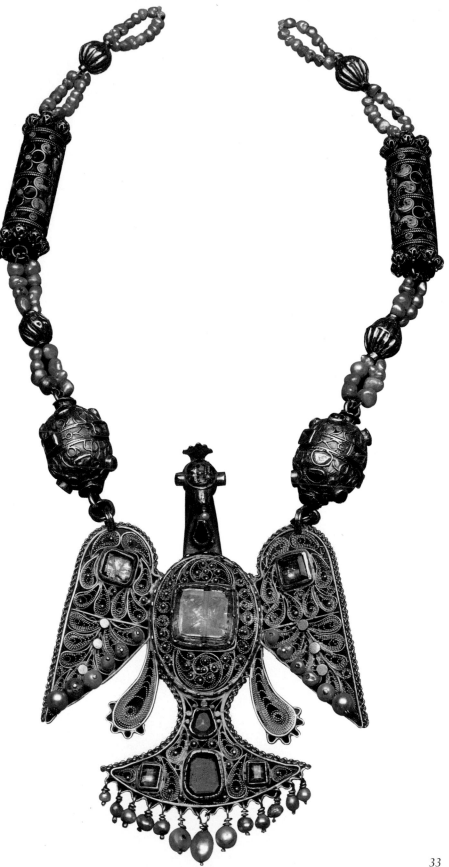

33

13 *Painted ceiling in Jajouka with geometric designs and astral symbols; the latter are part of the animistic vocabulary that distinguishes rural art from urban art.*

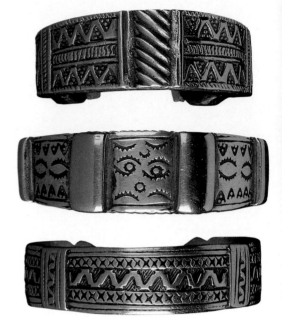

15 ABOVE *Three silver anklets, with rows of eyes, eyebrow motifs, and star and snake designs, from the valley of the Dra. Women usually wear more than one anklepiece, not least as an indication of wealth.*

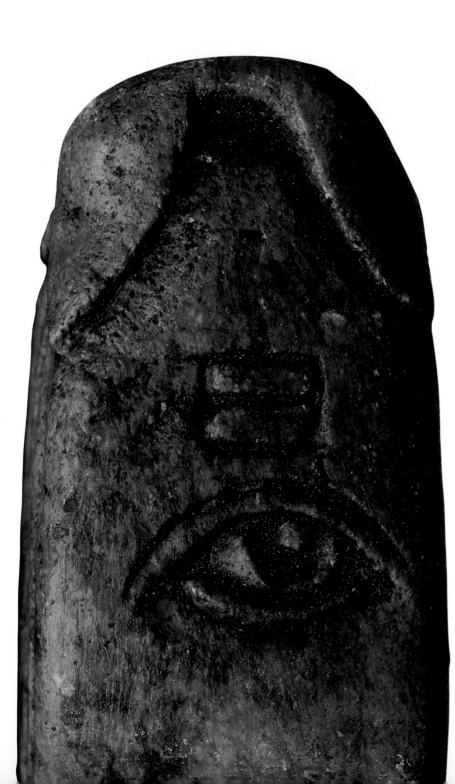

14 LEFT *Detail of a 19th-century oil lamp in the shape of a phallus, made in clay, probably from a Marrakesh brothel; the eye carved near the tip is intended to ward off the evil eye.*

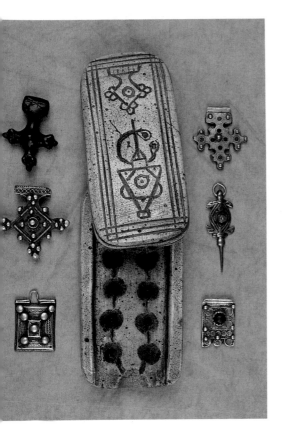

16 ABOVE *20th-century amulets or charms worn either singly or as part of a necklace, on a chain or a piece of leather.* LEFT, TOP *Carved wooden cross from Tafroute.* LEFT, CENTRE *19th-century Ait Atta fibula with turtle motif and coral beads.* LEFT, BOTTOM *Cloisonné (enamel inlay) cross from Tiznit.* CENTRE *Stone container for making gun powder, with carved fibula and cross du sud, believed to have prophylactic properties and associated with the Berber Queen Kahina, a great warrior revered by men during warfare.* RIGHT, TOP *20th-century ceramic cross du sud from Ouarzazate.* RIGHT, CENTRE *19th-century fibula of a turtle with a coral bead.* RIGHT, BOTTOM *Koranic box.*

17 RIGHT *Talisman in the shape of an ostrich egg, with Arabic calligraphy, greatly revered for divining and magic. Beneath it are five Berber talisman rings decorated with astral symbols, magic squares and tifnagh, one of the ancient Berber scripts. The bead in the centre of the ring second from the left represents the eye of the universe.*

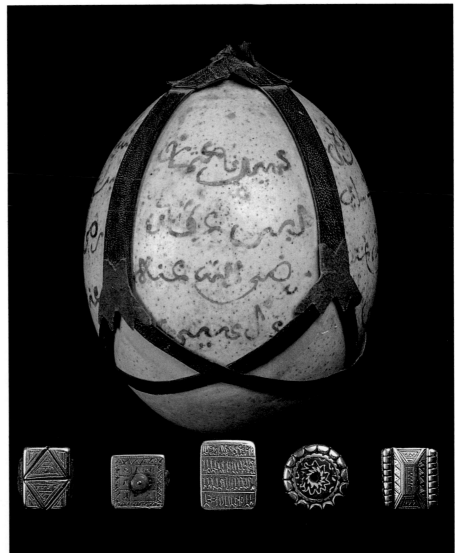

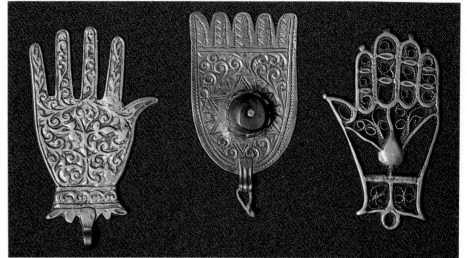

20 BELOW *Early 20th-century urban silver khamsas. Any form in the shape of a hand, and even objects signifying the number five, perhaps with mere dots or lines, represent the protective hand of Fatima, daughter of the prophet Mohammed.* LEFT *Filigree hand with heart motif from Fez.* CENTRE *The malachite inlay is an example of the heritage of Jewish jewelry-making.* RIGHT *From Essaouira, a southern city with a long history of Jewish metalworking traditions.*

18 TOP *Berber woman with tattoos from Azrou, south-east of Meknes.*

19 ABOVE *Hennaed hands in designs characteristic of the Anti Atlas region.*

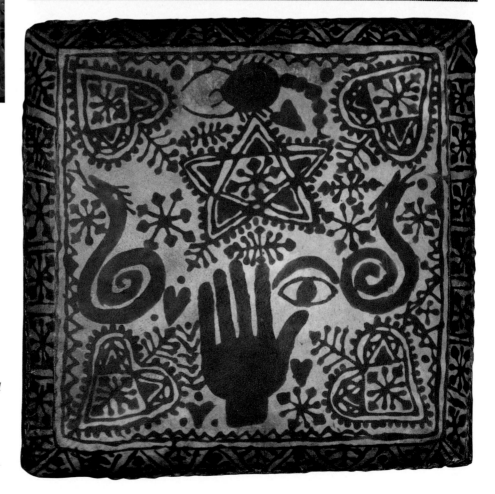

21 Handira *(a blanket-type shawl draped over the shoulders) made by the Beni Ourain, and a* deff *(square-shaped drum), painted with a variety of motifs – henna and tattoo designs, as well as eye and hand symbols – laid on top.*

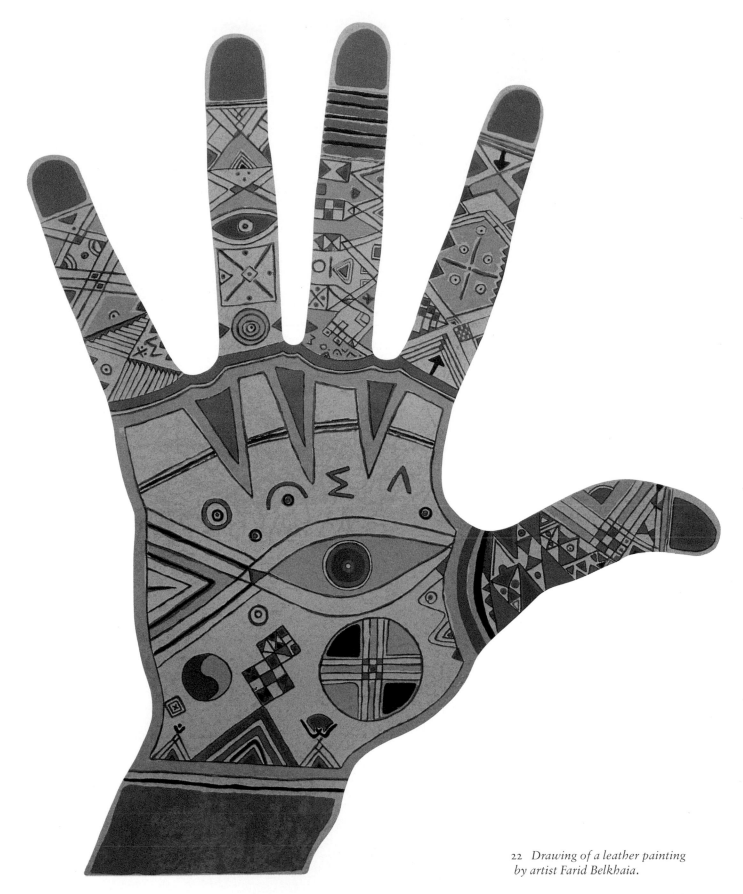

22 *Drawing of a leather painting by artist Farid Belkhaia.*

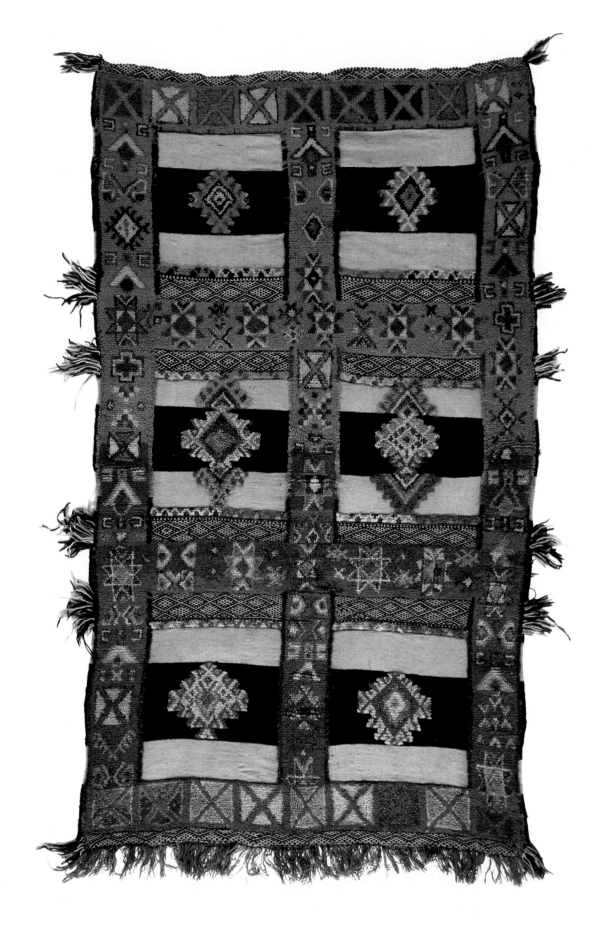

40

TEXTILES: CLOTHING, WEAVING AND EMBROIDERY

He who enters Fez with a rug, leaves with a money bag.

Moroccan saying

Textile production, which in Morocco can be divided into clothing, weaving and embroidery, is the greatest artistic tradition, due mainly to the large number of people involved and the extent of the materials used. It is also one of the most ancient: when the Berbers came to North Africa in 1500 BC, they brought with them some form of primitive weaving techniques, employed for both utilitarian and magical or religious purposes. The movement of nomadic peoples, and the trade between the Berbers, Black Africans and Arabs, with the transport of goods from north to south, and west to east across the Sahara, as well as contact with Europeans, nurtured external influences on Moroccan culture and its artistic traditions. Moroccan weavings are a legacy of that trade.

Women of both nomadic and semi-nomadic Berber tribes prepared the fibres used in the weaving of shawls, blankets, rugs, tent bands, sacks, pillows and grass mats – items which they still produce today. However, through contact with the Phoenicians, the Berbers learned more specialized techniques in weaving and in the art of dyeing, and added a wider range of artistic symbols and designs which they incorporated into their well-established animistic vocabulary.

The spread of Islam in the seventh century enabled merchants in North Africa to control trade between the North African and Islamic capitals as far as the frontiers of Egypt. Also at this time, another trading centre in southern Morocco, at Sijilmassa, became a link to trans-Saharan trade; as a result, textiles became an integral part of the Moroccan economy. The increase in production in the ninth century, due to the economic, architectural and artistic changes advanced by the Arab invasion, had a great influence on the weaving traditions – the symbols, designs and motifs, as well as new materials – of other parts of Africa, in sub-Saharan countries and West Africa, particularly Mali, Nigeria and Senegal.

Ibn Khordabeh, a ninth-century Arab scholar and traveller, wrote of Berber, Arab and African Jewish merchants journeying partly by sea and partly by land to the vast borders of the Islamic world, trading woollen cloths, brocade, silks and *tiraz* (fine embroidered woollens) from the Maghreb to the East and down south beyond the Sahara.

23 *Early 20th-century* zanafi (rug), *made by the Ait Tamassine, a subclan of the Ait Ouaouzguite, using a technique combining pile and flatweave with twining.*

Traditionally, although Berber tribes produced textiles for their own use alone, there is evidence supporting the fact that they traded their wares, from medieval Arab and Portuguese sources referring to 'linen cloths' and 'woollen prestige cloths', to archaeological proof in the form of eleventh-century West African textile fragments of Moroccan *hanbels*, flatweaves used as blankets, coverings for the floor or for general domestic use, decorated with lozenge designs and saw-toothed edges.

The techniques created by these Moroccan artisans have been preserved over the centuries, mainly because weaving and embroidery are an essential part of the daily life of the people, but also because they are believed to act as a source of magic and power.

CLOTHING

Morocco is a land of contrasts, and this is reflected not least in the styles of clothing, which vary both between rural and urban areas, and from one tribal region to another. Outward appearance differs not only in the materials used, but also in the way the garment is worn, which in traditional Moroccan costume means being either draped or sewn. The *jellaba* and the *selham* constitute the primary costume for men in both rural and urban areas. The former is a short-sleeved outer garment, sometimes striped, sometimes in earthen colours, with a hood of wool flannel. The latter, also an outer garment, is a very full sleeveless cloak that has a hood decorated with silk pompoms. The burnoose and the *ghandoura* – also worn by men – are sometimes even more elaborate in certain areas than the *jellaba* and the *selham*. The burnoose is an outer garment with embroidery around the hood and often in the middle, as worn in the Atlas mountains. Although the burnoose has been somewhat replaced by the *jellaba*, it is still worn in the countryside and by wealthy men in the cities, usually in white and black. The *ghandoura* is a silken robe for men, also usually worn by the wealthy.

The rural costume is mostly made of woven cotton and wool fabrics, consisting of a plain length of cloth draped on the body (except in the mountainous areas, where the fabric is sometimes cut and sewn). The art of draping fabric for men can be as creative and involved as sewing. When walking in the souks of the cities, or along the paths of the oases in the south, the men in their draped garments can evoke the appearance of Roman senators, or African princes and Nubian kings.

In both the rural areas and the cities, decoration is afforded by elaborate woven belts, which form a part of the dowry of marriage gifts. These belts are ritually knotted or untied at weddings, the birth of children, circumcisions and

Early 20th-century rug made by the Guernane in the Middle Atlas. The two bands showing the eight-pointed star are reminiscent of the ancient Egyptian symbol of fertility and immortality.

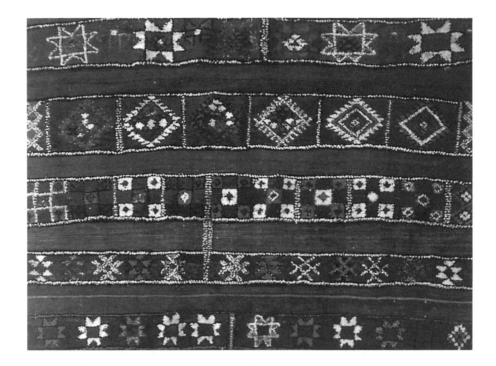

funerals. Some of the finest weaving and embroidery is produced to be worn during the celebrations revolving around these landmark events in life.

Most women in the urban areas dress very simply and usually in a *haik*, a huge piece of fine woollen cloth that conceals the body, acting as a veil, cloak and hood all in one. The colour is often white, but one can find robin's egg blue and black *haiks* in the southern oasis regions. It was traditionally considered that no decent woman in Morocco would go into town unless veiled in such a way; most women are only allowed to go about unveiled and exposed to the public in the evenings and on rooftop terraces.

Rural women have a much freer existence, and, except for the Arab tribes on the coastal plains, do not veil themselves. Berber clothes are always draped and never sewn; the size, material and colour may vary, but the *izar*, a long piece of clothing with which every Berber woman covers her body, is reminiscent of the flowing garments we associate with Greece and the Mediterranean in ancient times. In both the mountainous area of the Atlas and on the plains, the cloak most often seen is the *handira*, a blanket-type shawl woven by the women and draped over the shoulder.

WEAVINGS

Moroccan tribal textiles are some of the most dazzling and impressive in Africa. The rhythmic variations of design patterns, the vibrant colours, the variety of textures and the power they embody, make them quite distinct from other Islamic and African textiles.

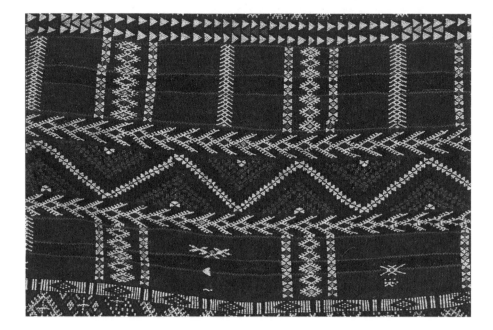

Detail of an early 20th-century cushion made by the Zemmour in the Middle Atlas, reproducing chin and ankle tattoos.

The traditional weavings of Morocco are fundamentally utilitarian, made for use by the family as furnishings for the house or tent, and as personal clothing. Textiles can also act as an indicator of wealth, social status and the religious background of the weaver, as well as of the daily life of her tribe, in a medium that allows her relative freedom of expression, even within the confines of strictly conservative design traditions.

For the non-nomadic people of the cities and rural areas, textiles can function as interior furniture as well as decoration – as bed, chair, blanket, cloak, pillow, trunk and saddle. For nomadic and semi-nomadic people, the rug can become the roof, doors, wall and partition as well. The 'table' of most Moroccan households, whether a house or a tent, is in the form of a large rectangular rug covering a divan. The vibrant colours and motifs of the rug offset the often dimly lit houses in villages and cities. The rooms are usually innately dark because of the small windows and doors designed to protect the interior from the wind and cold – and to seclude the women indoors – and are a characteristic feature of Arabo-Moslem architecture.

Many decorative weavings have a ceremonial as well as a practical function, and as such have a sacred status. A *handira*, for example, is used to wrap a bride en route to her new home, while some blankets are used as funerary gifts to spread over a woman's shroud. The finest rugs, blankets and cushions are used to decorate guest tents during the *moussem* and, when worn or carried to a marabout, are used to honour the saints (marabout can mean either holy man

or holy shrine). All such weavings contain baraka and are entwined with the age-old customs, rituals and beliefs of Berber culture. The protective, magical and mystical properties the Berbers believe their textiles possess are arguably even more important than their complex social and decorative aspects. The animistic culture of the Berbers, one of the few remaining in Africa, is inspired by the natural world: references to the sun, moon, stars, plants and animals form a large part of their artistic vocabulary. Riding on a mule one day in the Atlas Mountains, I looked up at the sky, where the clouds, which formed a series of white puffs, seemed to me just like the uncut float ends on rugs I had seen, and on the underside of some *handiras*.

Weaving motifs, patterns and designs act on different levels. They can identify a family or tribe, through tattoos or *wasms* (Arabic for tribal identity marks), ward off evil and bring good luck as a talisman, depending on the significance of each symbol used.

Weaving is a tradition associated with numerous saints from region to region, but the one most revered as being the inventor of weaving, embroidery and tailoring by all rural weaving tribes, as well as city weavers, is Sidi Moulay Idriss. According to popular belief, he was a Koranic sage who was said to have great magical powers, particularly in sand divination and the use of mathematics in working with the supernatural.

The loom itself remains the ultimate symbol of magical protection: it is looked upon as a living thing and treated as such, and it is thought to possess baraka. During the process of yarn production, there is a constant awareness of the spirit world on the part of the artisan. Wool is considered lucky, although the weaver must always be on her guard that evil does not enter between the threads during the weaving. *Mushats*, the weaver's hammer combs, have handles carved with designs meant to avert evil; these talismanic symbols are also woven into many Moroccan tribal textiles. If the weaver takes all the necessary precautions in remembering the number and combination of threads to produce a design, the finished textile will not only give aesthetic pleasure, but be imbued with talismanic power and contain baraka, acting as a 'power shield' against the evil eye and the djoun. The overall design of these textiles can be looked upon as a woven 'net' affording protection against evil forces. Alone among African and Islamic weavers, the Berbers believe that their finished weavings evoke a power capable of protecting not only the weaver and her family, but the textile itself.

Among the motifs most frequently encountered is the hand of Fatima, used to ward off the evil eye and the djoun. This symbol can be represented in weavings by a variety of stylizations, including crosses – either at right angles or diagonally – triangles, lozenges or eyes, tattoos or *wasms*. Representational designs of motifs such as scissors, weaving combs and knives, are believed to

Woman from the High Atlas using mushats, *the weaving hammers decorated with symbols to prevent evil forces entering the textiles during weaving.*

People selecting dyes and materials at a market at Azrou.

counter the effect of the evil eye. Others, such as snakes, lizards, scorpions and turtles, are associated with fertility and have prophylactic functions against adultery. Danger from any of these creatures is also believed to be averted by the use of these configurations.

Used as textile motifs, tattoos and crosses are believed to have the power first to draw and then disperse or dissipate evil in the six directions of the Berber universe – north, south, east, west, above and below. This explains the use on textiles throughout Morocco of the cross, either by itself or in a linear sequence, and of the eight-pointed Berber star.

One of the dominant designs used in textiles to avert the evil eye is the central red oculus also found on the snow capes of the western High Atlas Berbers, discussed in Chapter One. Within this huge eye is depicted a lizard, a symbol passed down from ancient sun cults; all the designs around the lizard, both inside and out, are looked upon as eyes. The flow of energy is represented by curved, wavy lines. Variants of this design made near Talioune by the Ait Sektana have white backgrounds and contain a multitude of symbols displaying the vast range of the Berber artistic vocabulary. Other examples of the use of the oculus as talismanic design are the *akhnif* (men's capes) made by the Chleuh-speaking Berbers of the Western Atlas and the Ait Ouaouzguite of the Jebel Siroua.

The weaver's sophisticated artistic iconography can sometimes be difficult to decipher. For one thing, the meanings of geometric symbols may vary from region to region. Thus, a 'house' may be denoted by a square in one area, and by a triangle in another, depending on the shape of a tribe's domicile. Or, as I have previously noted, a weaver may, after marriage, incorporate outside influences into her designs.

In Berber circles, it is said that no two rugs are ever alike. Perhaps the key element to this is the freedom of the weaver to express herself – a freedom entrenched in the most ancient traditions. While the weaver has an ample vocabulary of natural symbols, naturalistic representations of animals and geometric shapes, it is the tattoo that makes a design unique and complete. If a woman has a tattoo, she may use only a part of it in the rug she weaves, or she may magnify it over the entire field of the rug. Often the placement of the tattoo design may correspond with its position on her own body – at the side of a rug, for instance, if it is on her hand, or she may wish to change its position. The practice of tattooing is now less common in some areas, and the origins of the designs unknown, but its graphic visualization is preserved in the textile arts. And even though the weaver might not have one herself, the tattoo is still considered a source of magical protection and power.

Today, one can see that the changes in textile production resulting from centuries of acculturation have not diminished the coexistence of the Berbers'

own vocabulary, aesthetics, symbolism and magic. The tribal weavings featured here live on through the twentieth century as a legacy of all these traditions and as a testimony both to the art of decoration and to supernatural belief and power.

In the urban areas, weaving is more of a specialized activity centred around groups of itinerant professional weavers, who travel from town to town plying their trade on demand, unrestrained by the social and residential limitations imposed on the women who live in the rural areas. (Silk weaving is practised by the men, particularly when the items made, whether clothing or weavings, are intended for sale.)

In the rural areas, weaving involves the social gathering of women, who sing and chant about times of plenty and romance, and tell tales of superstition and magic as they work. They are the main weavers of the tent cloths and furnishings and of all the decorative textiles, assisted by their daughters or young girls learning the craft. For these women, weaving is an age-old tradition, passed down from generation to generation – a Berber girl traditionally learned the art of weaving from female relatives. It is a skill that commands great respect and prestige, and the likelihood of a greater bride price. Likewise, the inability to make textiles for beds and clothing can be considered shameful and reduce a woman's dowry value. Among some Berbers – the Beni M'Guild, for example – all the women are afforded respect from men and other women as weavers. In others, a *ma'allema* (head weaver) has a higher reputation than most, and her future husband must pay a correspondingly higher dowry price because of her skill and creativity.

The men guard the flocks and shear the sheep. However, like weaving itself, all the phases of yarn production – washing, spinning and dyeing – are done by women in nearly all the various Berber tribes of Morocco. The exception are the Ait Segougou, Ait Belam and Ait Youssi, where there is evidence that the men supervise some of the designing and weaving of pile rugs. Men also sew and stitch saddle bags woven by the women and add tassels or plaited strips on cloaks and women's shawls. In the High Atlas, the men also crochet and knit trousers and caps.

Moroccan tribal weavers have since ancient times prepared dyes from local vegetable and mineral sources which they gathered themselves. Indigo was used for blues and greens, madder root for red, pomegranate skins for black, saffron and almond leaves for yellow, and tea, henna and a variety of indigenous plants for red-brown earth tones.

The development of more sophisticated techniques came when Morocco, or Mauretania as it was known under the reign of the Roman Emperor, Juba II, developed a purple dyeing works near what we now know as Essaouira on the Atlantic coast. The dye came from the murex shell and was greatly valued, as in

Roman society purple clothing was a symbol of rank. The use of chemical dyes dates back to the second half of the nineteenth century. Tribal weavers now purchase their dyes at local markets.

Moroccan tribal weavings are produced by two distinct groups – the Arabs and the Berbers – who today inhabit the High, Middle and Anti Atlas Mountains and oasis regions of the south. However, the origins of this tradition can be traced back to the Berbers. Their patriarchal, polygamous society consists of tribes and tribal configurations. Many of the latter were initially founded for the purposes of warfare or to gain control of trade routes. Although the term 'confederation' (meaning a large tribal group with numerous subclans) is applied to tribes who produce textiles, it was originally a French colonial concept, and does not reflect the way in which the Berbers perceived themselves. Today, these groups are comprised of several hundred different tribes that range in lifestyle from nomadic and semi-nomadic to non-nomadic, agriculturalist people.

Historically, many originally nomadic Berber and Arab tribes migrated northwards into the Atlantic coastal plains and Atlas Mountain regions and

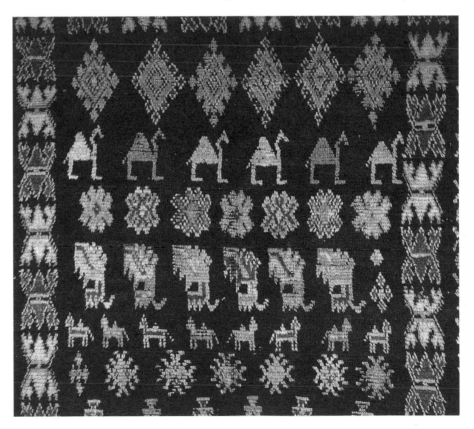

Close-up of an early 20th-century pile carpet with animal motifs, made by the Ait Ameur or the Zenata, showing a Turkish influence.

evolved a semi-nomadic culture. In overall design, their weavings reflect the three types of subsistence – nomadic, semi-nomadic and sedentary agriculturalist. Weavings produced in the Middle Atlas by nomadic and semi-nomadic groups, for example, are quite different to those of settled farmers in the High Atlas. Many nomadic rugs are characterized by zigzags and diamonds, with no central focus or border to enclose the design. The primary weaving confederations of the Middle Atlas region, including the Zaer and the Zemmour, inhabit the coastal mountains and lower plateaux. The Zaine, Beni Mguild and Beni Ourain live in both central Morocco and north of the Atlas range; in the summer, the shepherds and their flocks climb to higher pastures, returning in winter to the valleys and plateaux. Most yarn is produced in spring and summer, and most weaving done during the autumn and harsh winters. Most of the other Berber tribes make flatwoven rugs, blankets and pile rugs featuring an overall design of lozenge and zigzag diamond patterns. Several different types of knot are used to create pile; symmetric, Spanish, clove-hitch and Berber knots are quite common, although the asymmetric knot is unique to the tribes of the Beni M'Guild confederation.

Weavings characteristic of this area include flatwoven *hanbels*, such as rugs and tent linings, *handiras*, saddle bags and covers, cushions, bolster covers and tent bands. This tradition utilizes a variety of techniques, among them skip plainweave (a compound weave in which complementary wefts produce a double-sided effect), tapestry and other compound weaves, and a mixed technique with brocading in cotton and, more recently, rayon, to enhance and embellish the basic cloth.

One of the largest confederations are the Zemmour, who produce textiles in which deep red horizontal stripes of plainweave alternate with a variety of intricately patterned bands.

In the Anti Atlas, along the edge of the Sahara, the most notable weaving tribe is the nomadic Zenaga. They combine geometric and representational symbolism in their flatwoven and pile weavings, and use a variety of anthropomorphic and animal motifs combined with High Atlas border designs. Their textiles reflect the cultural links between the Berbers and sub-Saharan Africa, many of them alluding to trade routes, depicting camels, palms, tea pots and other motifs borrowed from the western Sudan.

The weaving tribes of the High Atlas region farm the area around the Jebel Siroua and south to the towns of Tazenakht and Ouarzazate. Their textiles are typically comprised of neatly composed lattice designs within substantial borders. The main tribal confederation of this area is the Ait Ouaouzguite, with various subclans such as the Ait Sektana and Ait Ouaherda, from around Jebel Siroua. The Ait Haddidou, with their subclans of the Ait Brahim and Ait Yazza, live on the eastern slopes of the area. High Atlas weavings are among the most

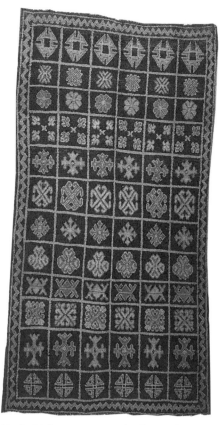

Early 20th-century wool pile rug from Kamounia near Meknes, with floral and tattoo designs.

highly regarded Moroccan textiles. Characterized by flatwoven stripes and piled black and white designs, many of them, particularly those from the Jebel Siroua area, are referred to as *Glaoua*, a name derived from Pasha El Glaoui, who controlled the region until the early 1930s. Little research exists on the historical movement of tribes around the area, and there is consequently much confusion about attributing a particular textile to a particular region. However, there are certain characteristics common to many. The various weavings produced by people of an agricultural background include flatwoven polychrome carpets embellished with symmetric knots. These may have either a central medallion, vertically arranged lozenges, or diamonds organized in bands within a clearly defined border. *Shedwis* are flatwoven rugs with black and white bands separated by tapestry weave and twining; when made from goat hair and harsher wool, they are used as feedbags. A rug with a combination of pile and flatweave embellished with pile knots and slit tapestry is called a *zanafi*. Rugs of a simple pile technique are woven in a black and white checkerboard pattern. Other typical High Atlas textiles in mixed plainweave, tapestry weave, twining and pile-knotting techniques include *handiras*, *akhnifs*, gun bags, saddle bags, cushions and belts.

The area encompassing what was once known as the Haouz plain, and including the Rehamna and Ahmar regions, as well as other rural Arab and Berber tribes of the Tensift River area and the western plains of Marrakesh, has a diverse weaving tradition. Many of its textiles are referred to as *Chichaoua*, named after the town which now has a large weaving cooperative. It is a term that includes a variety of Arab and Berber tribal weavings, among them those of the Oulad Bou Sbaa, Boujad and Beni Mellal. Tribal groups inhabiting the Tensift area are, by tradition, Bedouin from the East; as a result of centuries of intermarriage, they produce textiles which refer to both their original and adopted cultures.

Textiles showing freedom of expression in the use of design and texture coexist with others having a very formal Rabat or urban design, with a clearly defined field and border composition, and a central medallion. The weavings of some tribes, such as the Oulad Bou Sbaa, whose territory bordered several trade routes, show influences from the Berber, Bedouin and courtly Arab traditions. Berber and Bedouin influence is seen most clearly in the flatwoven pieces, while court elements, themselves Turkish-influenced, appear more strongly in pile weavings. Weavers of the Tensift region work in a distinctive style, somewhat reminiscent of Paul Klee's paintings in the quality and interplay of colour and texture. Another important characteristic of many Tensift textiles is the use of representational motifs, placed either randomly or in a structured composition. Such motifs are characteristic of the western Sudan, and are similar to those found on Zenaga (Anti Atlas tribe) weavings, which is unsurprising,

considering that this part of the Tensift River region was in direct contact with the trans-Saharan trade routes. Weavings from here range from slit-tapestry rugs and those with a combination of a flatweave and pile technique, to flatwoven rugs, blankets, hangings and cushions. Usually on a red ground, there is either an interplay of recurring patterns, consisting of representational designs and motifs, or else a more formalized pattern of geometric shapes with a central medallion on a field surrounded by borders. The symmetrical knot is used for the piled areas combined with other areas in a slit-tapestry weave.

Sheep's wool is the predominant material used in Moroccan weaving, to which small amounts of goat hair, cotton, silk and rayon are often added, depending on the textile. Tent cloths are usually wool, although goat hair is sometimes added by the nomadic and semi-nomadic tribes of the Middle Atlas for the bands and strips of the tent. Wool and cotton are used for both pile and flatwoven rugs, men's and women's blankets, women's shawls, capes or cloaks, saddle covers and bags, and cushions. Silk or rayon is added for brocading and defining designs. Sequins, shells and glass beads are sometimes used to embellish saddlebags.

There are several techniques and knots characteristic of weft-faced Moroccan textiles, which have been researched and defined by notable sources, such as Peter Collingwood's *The Maker's Hand*. Tent cloths, such as bands, strips and flaps, are woven on a broad horizontal, single heddle, ground loom. However, the tent furnishings and all the decorative textiles are woven on a single heddle, fixed vertical loom. The skip plainweave, or 'two-faced' technique, is used throughout Morocco. The Berbers consider the fully knotted side to be one face and the reverse to be the other. In the High Atlas, twining separates the rows of design on pile and flatwoven rugs, and on *hanbels* (many Moroccan flatwoven textiles, however, employ several techniques together).

There is evidence to suggest that the earliest Moroccan weavers used the hoop cut and uncut loop in their weavings. Both these knotting techniques were probably introduced by the Arabs during the seventh or eighth centuries. The *akrus*, or clove hitch – a method widely used in the Middle East – is similar to the technique used in the urban rugs of Rabat. It resembles the symmetric knot, looping around two warp threads, and is used in both Middle and High Atlas weaving. The Berber knot, virtually unknown elsewhere in the Islamic world, wraps around four warp threads, appearing on the reverse as two horizontal bands. It thus resembles a symmetrical form of the *jufti* knot, which is mainly used in Khorasan in Iran. The only Berber group to use asymmetrical knotting is the Beni M'Guild in the Middle Atlas.

There are not as many varieties of city pieces as there are in the rural artistic traditions, but they are fairly distinguishable from one another. In the urban areas of Rabat, Salé and Medouina, the style and design of weavings is inspired

by those of the Orient, in particular by those of Asia Minor, from which the composition, motifs and colours are borrowed. The symmetrical placement of their geometric and floral designs, their borders and their many colours (red, orange, green, blue, purple and black) in pronounced tones make them fairly recognizable. These carpets are very similar to those made in Algeria and Tunisia.

The weaving of city pieces predates the sixteenth century. This can be explained by the possibility of an influx of weavings and craftsmen after the fall of Granada in 1492, or of pieces plundered by the pirates of Rabat and Salé, whose designs slowly infiltrated the weavers' vocabulary. By the nineteenth century, the trading link with Turkey became mutually influential, particularly in textiles, but also in the embroidery tradition, whose development followed a similar route.

EMBROIDERY

There was, there was not,
Shall we tell stories
Or sleep in our cots?

Embroiderers' opening saying

Embroidery, one of the primary forms of textile production, is very much a part of both the urban- and town-dwelling traditions in Morocco. The artistic vocabulary varies from city to city, but includes many of the same symbols and motifs found in other media.

Embroidery was probably brought over from Andalusia by Jewish, Arab and Berber refugees who settled in and around different Moroccan cities. Each area has its own distinct embroidery styles, techniques and materials, with some districts specializing in silk, cotton, or cotton embroidery on linen, and others in gold embroidery (although some of these have now been replaced by rayon or nylon thread). Embroidery, like weaving, is practised predominantly by women. This can mean embroidering their own clothes and household linens, which they will do in their homes, or it can mean that they belong to a cooperative with a ma'allema (head embroiderer) as a professional teacher. Many girls start embroidering by making items for their trousseaux; this can involve everything from clothing to home furnishings. It is a social activity and a skill that is passed down from generation to generation through the female line. Many pieces are finely executed and entail hours of work; the selection of motifs, as much as in any of the other artistic traditions,

is an integral part of the prophylactic and protective devices directed against the evil eye and the djoun.

The artistic vocabulary of embroidery, together with the patterns, styles and colours used, has over time undergone the same kind of changes that have occurred in weaving. However, there are certain areas where particular traditions have survived unchanged; for example, one motif frequently seen in embroidery is derived from the henna designs painted onto women's hands after marriage (and sometimes before). The designs themselves are usually derivative of tattooing; in the past, they were a secret way of keeping the ancient art of tattooing preserved, while hiding it from the Arabs. As is the case with all crafts in Morocco, there are regional variations of styles, a few of which are outlined here. For instance, the embroidery of Azemmour, a small town off the Atlantic coast, is distinguished by European-looking, stylized scrolls and animals. The women here use cotton and silk thread to decorate mattress covers, cushions and the bottoms of curtains. They use a variety of stitches, including the chevron and cross-stitch. The older Azemmour women create very interesting designs in Renaissance Italian (an influence filtered through Spain) and Spanish patterns and many of their pieces bear motifs of vases surrounded by doves, peacocks, stylized flowers or cypress trees of life, so formal that some suggest the Jewish menorah. Another typical design is of stylized female figures reminiscent of ancient Mediterranean goddess motifs.

Chechaouen, a small hillside town in northern Morocco, also has a history of the settlement of refugees from al-Andalus. The embroideries typical of this region and history are very rare and date from around the eighteenth and nineteenth centuries. These include cushions, covers for chests and special hangings draped on feast days from the carved and painted wall shelves that are so typical of Moroccan interiors. Embroidered on white linen or cotton, the thread is silver and looks very much like tapestry. In fact, they look similar to the Hispano-Moresque embroideries of al-Andalus. Other pieces from this area are distinguished by a star design on a simple background, consisting of one large star flanked by two smaller ones from which radiate a burst of creativity. Although the detailed work in this design makes it look almost like filigree, no gold or silver is used.

Fez is probably the most prolific centre of embroidery production and styles, continuing a long history of royal court traditions. It has for centuries been a centre for trade, as well as for all the arts. Even in the twelfth century, Fez already had in production over three thousand looms, and a sixteenth-century account, written shortly after the Andalusian exodus, states that there were twenty thousand textile workers in Fez. The city not only welcomed craftspeople from al-Andalus, but those who came from the East. There was a flourishing Jewish community next to the Sultan's palace called the *mellah*.

Embroidery thread spools at a souk at Meknes.

Jewish artisans were involved both in the dyeing of textiles and in metalwork – hence the making of the gold and silver thread utilized in some embroidered items, such as prayer cloths that incorporate calligraphy, belts, and the *haetis*, wall hangings, cushions, bags and other hangings found in many Moroccan houses and tents of the wealthy. In addition to the gold and silver thread, the Jewish men in the mellahs of the imperial cities such as Fez, Meknes and Rabat made beads and sequins (originally in metal).

Gold embroidery is practised in urban centres all over Morocco, but Fez is the most renowned for it, and the abundance of such work at the souks shows the great demand for it. Gold and silver embroidery is done on velvet and leather; as a rule, the women do the embroidery on cloth and the men on leather goods, such as slippers and bags.

Many motifs found in Fez embroidery are rooted in the ancient cultures of the Mediterranean and the Middle East. These include the *fleur-de-lis*, the eight-pointed star, the hand, a wide variety of geometric floral patterning and many other designs one sees in mosaic tiles and stylized vases. The Fez stitch is the one most commonly used – a reversible back stitch worked in steps. Persian and Turkish stitches are also used, but are believed to be a fairly recent development. The ground is usually cotton and the thread of fine silk. The pattern is drawn on the cloth, by counting (tacking) threads, and the design is reversible; examples of this can be found on cushions. Mattress covers of cotton are worked with monochrome, red, black and purple silk.

The patterns themselves are largely geometric, but borders tend to consist of stylized plants, particularly trees, on which birds, usually storks, are perched. The stork is thought to bring good luck and possess baraka. Many perch on top of mosques and other holy places, such as tombs. These designs are found on bags, curtains, hangings, belts, several types of wrapping-cloths, square cloths for the *hammams* (public baths), handkerchiefs and napkins.

Meknes, also an imperial city, is known for its embroidered scarves and cloths in fine etamine (cotton or light worsted in a loose mesh), edged with floral patterning and worked in a stepped running stitch with many coloured silk threads.

Tetouan, settled after the Reconquista, is famous for its mirrored hangings and cushions for display at marriages. Fine-quality cotton is worked with pastel-coloured silks usually decorated with floral motifs, to produce embroidery that is quite distinct from other areas in Morocco. It has been suggested that their origin is Turkish, because of the design, colour and the kind of stitches used (the thread is fine silk and the stitches are variants of the Turkish brick stitch).

Rabat and Salé, both once centres for piracy and trade and only a few miles apart, are also famous for their embroidery styles. Refugees from al-Andalus

settled in these cities and produced large quantities of embroidery both in clothing and furnishings. Stylized floral motifs on white curtains are the best-known embroidered textile from both these cities. Hung as decorations on ceremonial occasions, they were the most important items officially listed in a woman's dowry. Many of the colours in these curtains resemble those found in stained glass windows, with carmine usually predominating. In Salé, the geometric patterning, characteristically of stylized plant motifs, utilizes the same stitch as that of Fez, but more loosely worked and not reversible.

Inevitably, the growth of technology has had an effect on embroidery, as on every tradition where increased production results in increased demand. However, despite the popularity of the sewing machine, handmade embroidery has been revived in some areas, a testament to the skill of the individual artist and the uniqueness of each piece.

24 BACKGROUND *19th-century cushion from Fez, for centuries perhaps the most prolific and influential centre of embroidery, attracting craftspeople from both al-Andalus and the East.*

25 INSET *diaphanous blue* haik *made in Tafroute; this is a large piece of fine woollen cloth serving as a cloak, hood and veil all in one, and worn by most women in the cities.*

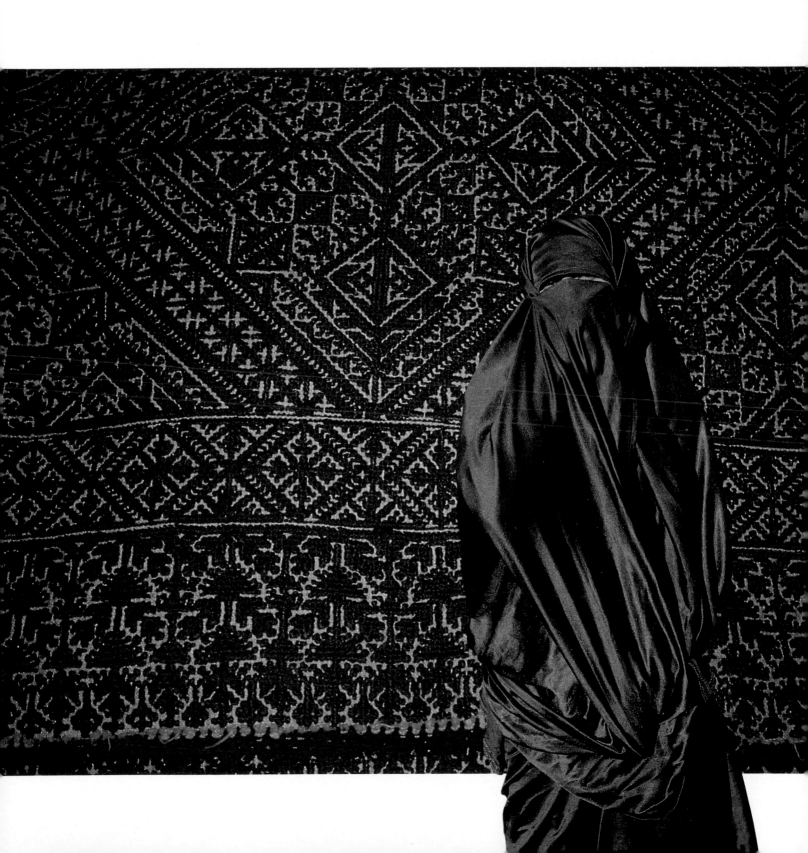

Most textiles are very brightly coloured, due partly to the need to brighten the dimly lit rooms that characterize Moroccan homes.

26 LEFT *Embroidered mattresses and cushions for display at marriage ceremonies.*

27 BELOW LEFT *Tailor in the valley of the Dades working with metallic thread for embroidery.*

28 BELOW *Late 18th-century* tensifa, *a harem or mirror curtain in linen and silk.*

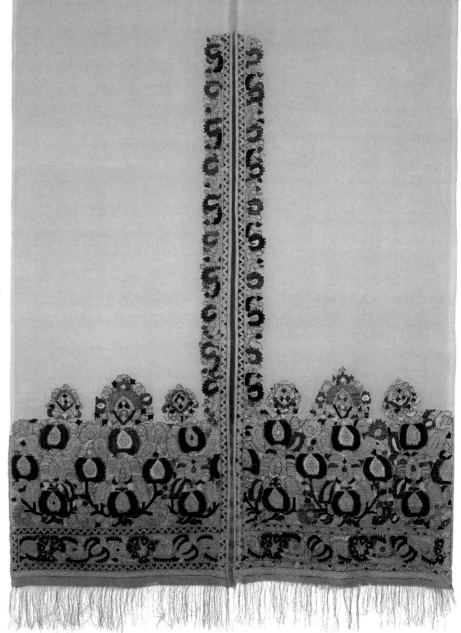

29 BELOW *Late 18th-century embroidered cushion in silk and linen. The designs are of Moorish Spanish origin.*

30 RIGHT *Mid-19th-century embroidered curtain in silk and cotton from Rabat.*

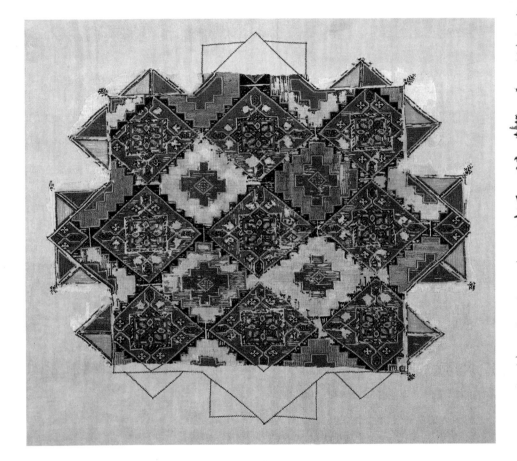

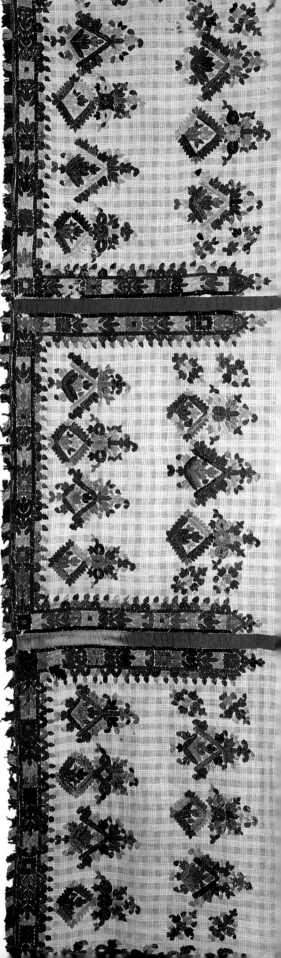

All pieces were made by the Ait Ouaouzguite and their subclans.

31 RIGHT *Late 19th-century wool cape with cotton embroidery. The imagery – the red oculus, the sun symbol and the lizard – are all believed by the Berbers to avert the evil eye.*

32 BELOW LEFT *Early 20th-century silk and wool pile rug with elaborate diamond pattern made by the Ait Warhada; the star patterns on the border derive from an Egyptian symbol of fertility.*

33 BELOW RIGHT *Early 20th-century rug with lattice design.*

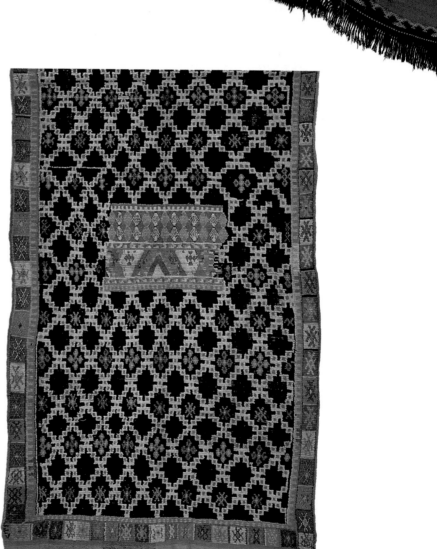

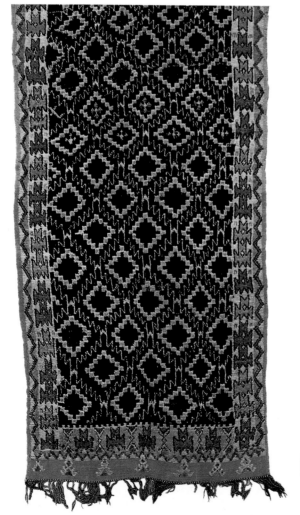

34 BELOW LEFT *Early 20th-century carpet, probably by the Ait Warhada, unusual in the heavy lattice-work surrounding the central design.*

35 BELOW CENTRE *Early 20th-century silk and wool mixture pile rug..*

36 BELOW *Early 20th-century rug, probably by the Ait Semgan, with a stepped diamond pattern.*

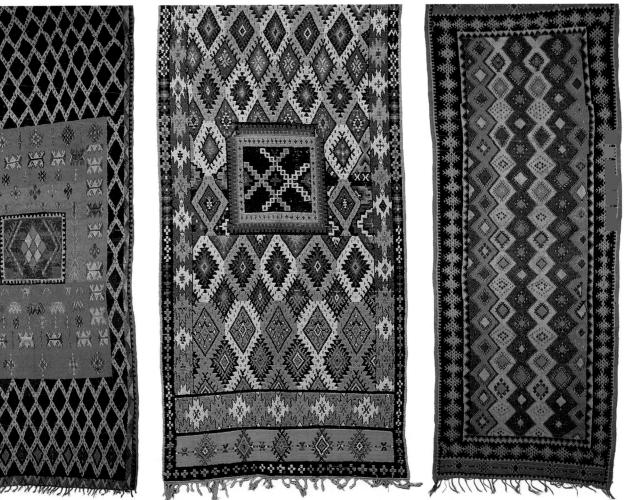

37 BELOW *Late 19th-century Ait Ouaouzguite pile carpet.*

38 BELOW RIGHT *Mid-20th-century polychrome wool pile rug typical of the Rehamna region, with abstract and asymmetrical patterns.*

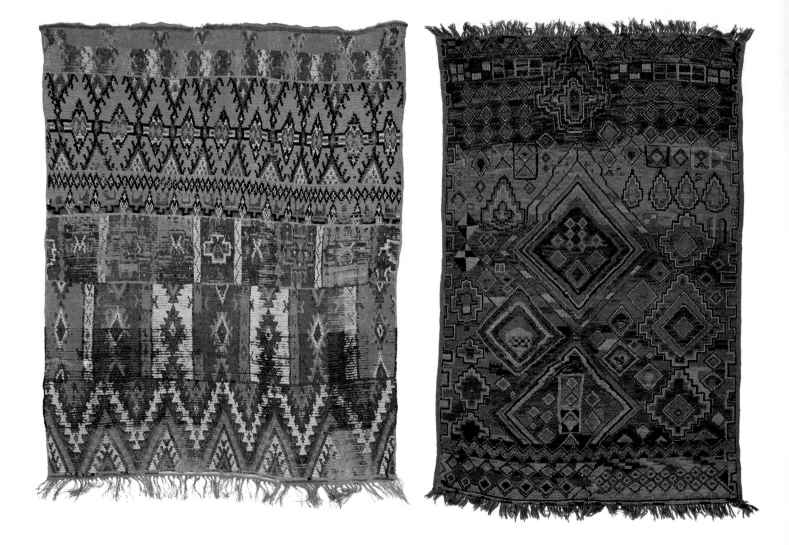

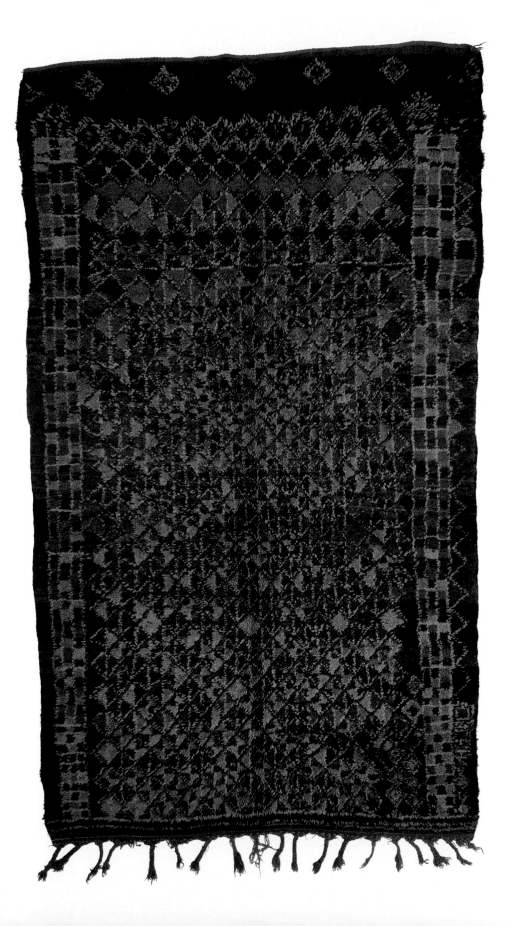

39 *Early 20th-century thick-pile reversible rug from Rehamna; the diamond checkerboard pattern, the magic squares and the abstract designs and tattoos are believed to have meditative and prophylactic properties.*

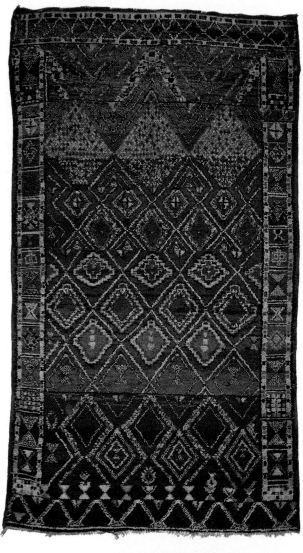

40 LEFT *Early 20th-century wool pile polychrome rug made by the Beni Saddene in the Middle Atlas, with geometric shapes, stylized mountains and a lattice pattern of diamonds.*

41 LEFT, BELOW *Mid-20th-century knotted pile wool rug, from Boujad in the Middle Atlas, whose panels evoke energy and movement.*

42 BELOW *Early 20th-century wool pile rug made by the Chiadma, a tribe near Essaouira, with a diamond lattice design and tattoo motifs.*

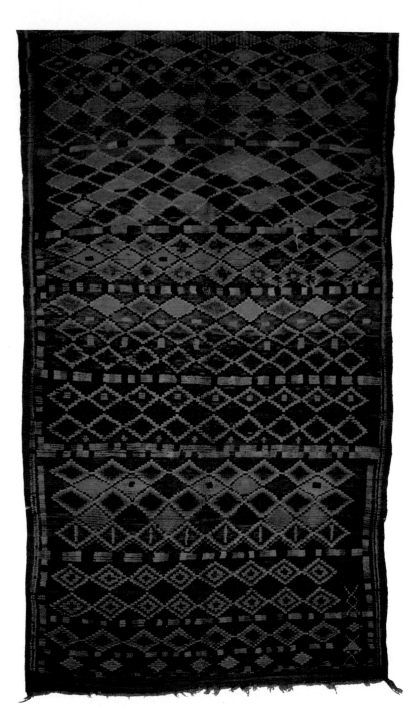

43 BELOW LEFT *Detail of an early 20th-century saddle bag for men, with metal sequins, made by the Beni M'Guild in the Middle Atlas. These bags are very common among Berber tribes.*

44 BELOW *Late 19th-century polychrome wool carpet from Rabat with a central medallion and floral motifs.*

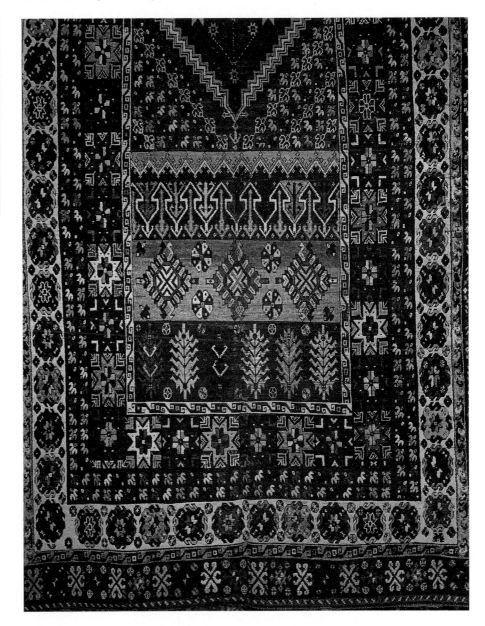

45 BELOW *Man's wool blanket mixed with silk rayon, made by the Zemmour, one of the main tribal weaving confederations of the Middle Atlas.*

46 BELOW RIGHT *Mid-20th-century Zemmour woman's blanket, with simple but unusual red cross and diamond motifs.*

47 RIGHT *Close-up of an early 20th-century flatweave Zemmour saddle cover with metal sequins.*

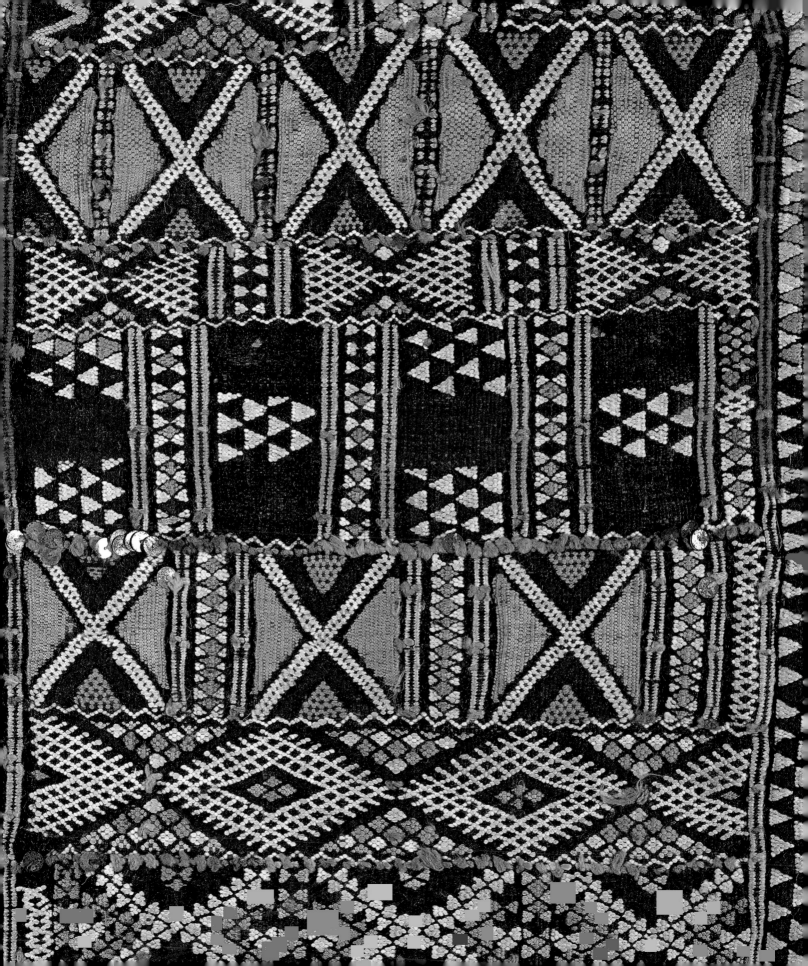

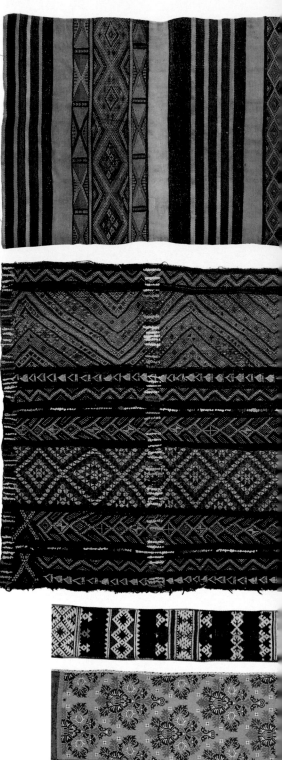

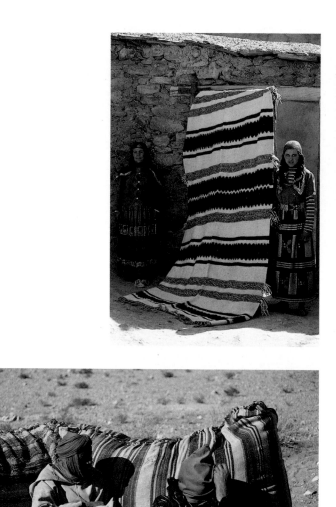

48 TOP *Weavers – almost always women – in the High Atlas region displaying a* shedwi, *a flatwoven rug with black and white bands separated by a tapestry weave and twining. For women, producing textiles can reflect not only their lineage and status, but also allow them a rare opportunity to express individuality and creativity.*

49 ABOVE *Berber men waiting for trucks with grain in the Anti Atlas.*

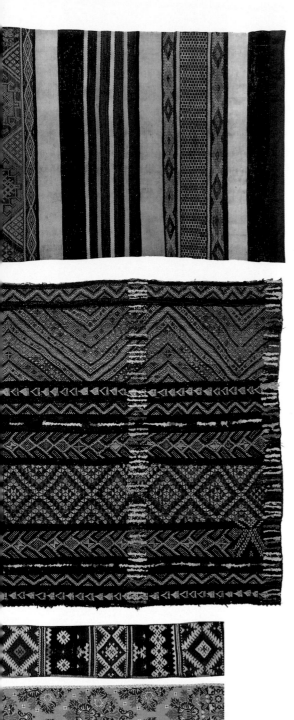

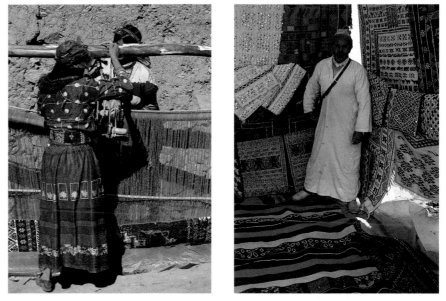

50 LEFT *Early 20th-century wool flatweave blanket cover with pile panels from Salé, a city which, like Rabat, is inspired by techniques and designs from the East.*

51 LEFT, BELOW *Early 20th-century Beni M'Guild* hanbel, *a blanket with knotted tufts that separate panels consisting of various flatweave designs.*

52 LEFT, BOTTOM *Elaborate woven belts can form part of the dowry, and during certain ceremonies, such as weddings, circumcisions and funerals, they may be ritually knotted or untied. The belts, from top to bottom, are from the Ait Ouaouzguite, Fez and Tetouan.*

53 ABOVE LEFT *Berber women in Tachokte working on a loom on a flatwoven belt of slit tapestry for a pile carpet. Looms are a symbol of magical protection in Morocco and, as the wool itself is thought to be lucky, the loom will have combs with talismanic motifs to prevent evil forces becoming entangled in the weave of the piece as it is being made. The end product can be seen as a shield against the djoun (evil spirits), protecting not just the textile, but the weaver and her family as well.*

54 ABOVE RIGHT *Merchant at Azrou market selling rugs with elaborate tattoos.*

55 BELOW Mid-20th-century tahlast, *a carpet used for sleeping on as well as for shelter; this example, by the Beni Ourain in the Middle Atlas, is made of white fleece with black, asymmetrical zigzag designs, and is typical in its lack of a border.*

56 BELOW RIGHT Wool plainweave blanket or tent band with weft substitution *made by the Zaine in the Middle Atlas, embellished with bands of knotted cotton shag and metal sequins attached to tassels.*

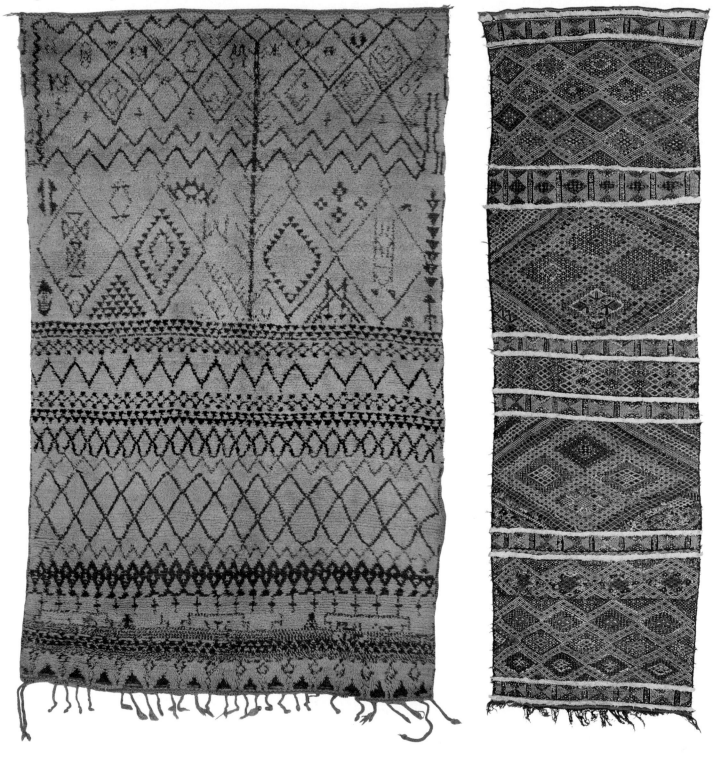

57 BELOW *Mid-20th-century wool carpet with Berber-knot pile made by the Zaine; the freer, lattice configuration identifies the piece as a product of the rural tradition.*

58 BELOW RIGHT *Early to mid-20th-century saddle bag made by the Zaine; the two 'faces' of the bag have patterned panels with plainweave backs.*

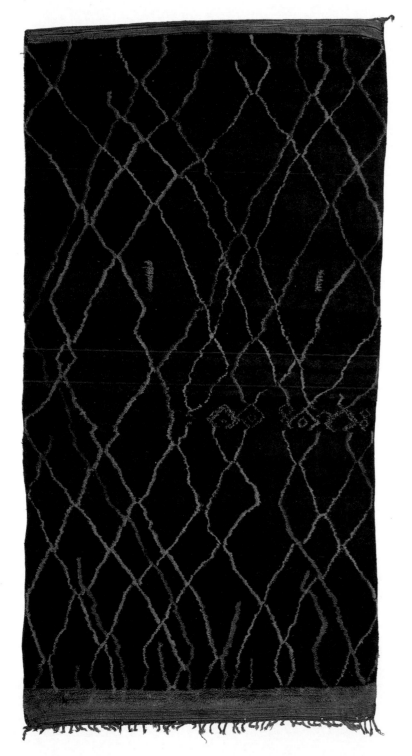

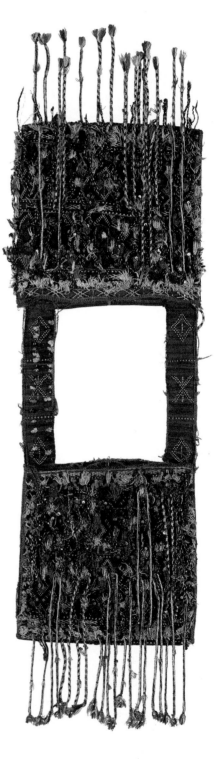

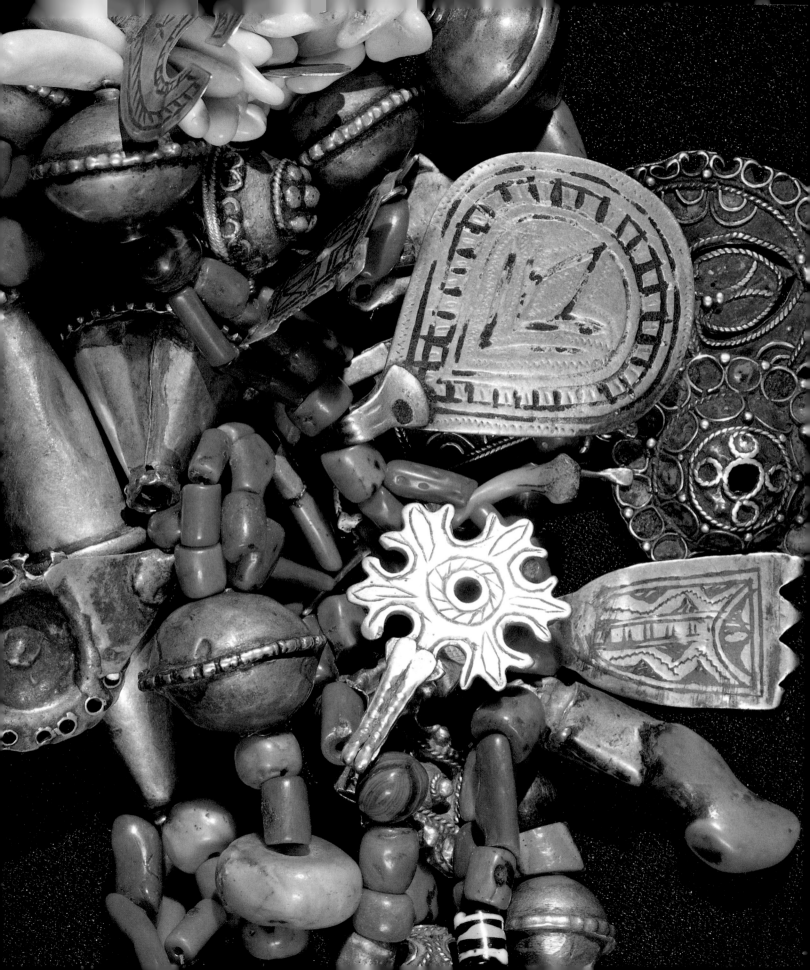

JEWELRY AND ADORNMENT

Grandmother, grandmother, since he departed I have been
Thinking of him only and seeing him everywhere ... he gave me a
Fine silver fibula. And whenever I set my *haik* upon my shoulders,
When I fasten its flap upon my bosom, when I take it off at night
To sleep, it's not the fibula I see, but him!

A song from Tassaout

The myriad forms and exquisite configurations of designs in Moroccan jewelry are some of the most dramatic and powerful in Africa. There are certain forms that are common throughout Morocco, including fibulas or pins, to fasten garments, with chains, as well as brooches, headdresses, breastplates, rings, bracelets, anklets and pendants. Other pieces one might see are Koran boxes, Agades crosses, amulets, belt buckles, hands of Fatima in numerous sizes and designs, and a variety of other charms and talismans with geometric and zoomorphic designs.

The wearing of jewelry in Morocco is not only a way to set off beauty, but also a significant means of communicating wealth, social status, love, tribal identity, fecundity and religious beliefs. It also projects a powerful statement about the unique creativity of the women who make the assemblage necklaces, which, to the Western eye, might evoke a sense of 'primitive' elegance. Moroccan jewelry differs from forms of adornment in the West, where it is worn mainly for decoration only, because it is worn as a fastening for the draped clothing. The individual piece – whether an earring, bracelet or ring – is not considered complete in itself, but more as a part of an artistic and sacred whole. The jewelry forms part of an elaborate and highly developed ensemble, other elements of which are the clothing and hair coiffures, into which the jewelry is braided and wrapped as an embellishment.

The history of jewelry-making in Morocco – its techniques, forms and symbols – follows a similar development to that of weaving, pottery and other traditions, as a result of each succession of Phoenician, Carthaginian and Roman invaders, as well as the movements of the great trading caravans across the Sahara. Islam subsequently introduced new techniques and materials from Arabia, and the Islamic empire brought still more to Moorish Spain, influences that give Moroccan jewelry forms that are unique in Africa.

In ancient times, most of the work in silver and gold was done chiefly by Jewish silversmiths, evident in the pieces from the Anti Atlas region and in the south around the Dra and Dades areas. The greatest influx of Jewish artisans,

59 *Detail of an early 20th-century assemblage necklace (some beads and talismans date to the 18th and 19th centuries), made by the Ait Atta, with cowrie, copal, conus whorl (the cut piece of a conus shell), several talismans and wool counterweights tied around the neck. Apart from displaying wealth for dowry purposes, these flamboyant necklaces often express the greater freedom of rural areas and contain healing powers, depending on which components in the necklace are talismanic.*

however, came after the Reconquista of Spain, from where many artisans fled to take refuge in Morocco. There is little doubt that they brought with them their traditions, customs and techniques of enamelling, niello (a black oxycedar resin inlay) and filigree. They were confined to a specific quarter called the mellah, adjoining the *medina*, which was the old, central part of Moroccan cities, such as in Tangier, Tetouan, Rabat and Fez, where the jewellers' guilds flourished. The mellahs of the north eventually became so overpopulated that these artisans moved farther south and inland to the oasis regions, towards Mogador Essaouira, the Anti Atlas, Dra and Tiznit.

Jewelry-making is as distinguishable by the two traditions of rural and urban work as the other traditions in Morocco. Urban jewelry is primarily Arab, or at least strongly Arabicized, as well as being influenced by Jewish traditions, and pieces are made chiefly of gold or gilded silver. Rural jewelry is always in silver. Although travellers' accounts have attested to Berber chieftains who wore gold earrings and who gave gilded jewelry to their wives, these cases must have been exceptional: the popular belief among the Berbers was that gold was evil. Although rural forms, techniques and symbols are predominantly characterized by Berber culture, its development has clearly been affected by the influences from Moorish Spain.

The metalwork – in either precious metals or iron – in the village was created by the 'master of fire'. The village silversmith was held in awe and regarded as an important member of Berber society, because fire was associated with the djoun and the devil, and because it was thought that no one could make such a beautiful piece of jewelry without having made a pact with them. This wariness of the involvement of the djoun in the metalworking process may account for many Berbers commissioning pieces of jewelry from urban Jewish silversmiths, or acquiring them by trade.

The art of jewelry-making was and is practised almost exclusively by men: it was always passed down from father to son in both urban and rural areas, but there were also organized guilds with a maallem, or master smith, in the cities. The rich variety of forms in Moroccan jewelry stems from the many long-established techniques employed by urban and rural artisans: casting in metal and sand, relief or *repoussé*, engraving and filigree, chasing, enamelling, champlevé, niello and gilding, as well as the attachment of stones, beads or glass.

There are two methods of preparing the metal for these techniques. The first is in the forger's hearth, where the metal is heated with a pinch of arsenic, and poured into a sand mould. After cooling, the mould is removed and the resulting piece heated again. From that point, the artisan works by chasing, engraving and polishing the desired form. Fibulas – elaborate pins and brooches – worn in the Atlas regions are cast by this process. In the second technique,

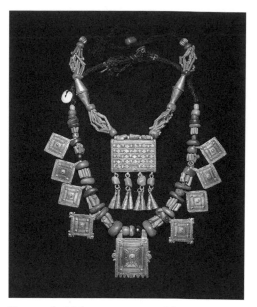

Two early 20th-century assemblage necklaces, the top consisting of a silver Koranic box and coral from the Ziz region; the other is comprised of silver Koranic boxes, coral, amazonite, amber and silver niello medallions with geometric and astral symbols.

after the initial procedure, the melted metal is pounded into sheets, which the artisan flattens with a hammer until the required thickness is obtained. The piece is then cut, bent or soldered, according to whatever form it is going to take (amuletic Koran cases and Agades crosses are hollow and made in this manner). Once it has been secured onto a slab of wood, it can be inlaid with niello, enamelled, filigreed or repoussé, or semi-precious stones and glass can be fastened to it.

The practice of certain techniques can characterize different areas. For example, niello is commonly seen in jewelry worn by the Ida ou Nadif (Anti Atlas) and by the Ait Serhrouchen and Ait Youssi (Middle Atlas). Filigree requires wrapping twisted silver wire, singled or grouped, into intricate curvilinear shapes, which are then soldered to form a lace-like design. The Tiznit and Anti Atlas regions are known for this technique, in particular the geometric figures and the well-known enamelled eggs. Many filigree pieces can be further enhanced by adding polychrome enamels of red, blue, green and yellow. One technique of enamelling, called cloisonné, practised in the northern regions around Tetouan, Fez and the Middle Atlas, consists of tracing the decorative motif by digging out the metal, and pouring enamels into the hollow areas. In the southern regions near Tiznit and around Meknes, glass beads are pulverized and the dust distributed on the metal in a variety of designs, including arabesques, circles and egg shapes. Enamel champlevé, which does not obscure the filigree, but fills only the hollows, is particularly common in the Sous, Anti Atlas and Tiznit regions.

The significance of an item of jewelry goes beyond mere decoration. A necklace, in its most minute form, will be received at birth and worn not only by Berber girls, but by boys as well. It may consist of one bead of true amber or copal, a silver amulet, a pendant or a khamsa on a leather or cloth string. After this initial necklace, the boy will never wear jewelry again, except for a silver ring given to him by his father. The female child, on the other hand, will receive amulets and beads for necklaces from her mother until her marriage, after which they might well be disassembled for new ones. Necklaces are one of the most important items of a woman's jewelry. They are worn in both small and massive sizes, sometimes several at once and in varying lengths, with some fitting tightly around the neck like chokers, while others hang past the breasts to form a breastplate of often striking beauty. Smaller necklaces are usually worn every day, as the women work in the open fields or around a loom. But the finest display of dowry and folkloric pieces worn with the entire ensemble occurs during pilgrimages to the marabout, for funerals, for visiting neighbours, and for journeying to the numerous moussems held throughout the year to celebrate life and the harvest.

Some necklaces, especially in the northern Rif and Middle Atlas areas,

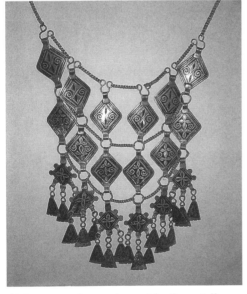

19th-century breastplate with silver niello plaques made by the Ait Serhrouchen in the Middle Atlas.

consist of only one or two materials, such as coral or amber beads with silver coins. Others, in the Anti Atlas and southern oasis regions, are massive and quite flamboyant, and are a composite of numerous beads, khamsas, enamelled eggs, amber, filigree balls, glass beads, Czechoslovakian glass (which came to Africa through trade with Europe), Agades crosses and talismans. They usually have numerous strands of coral intertwined with silver amulets and talismans on the right and left sides of the necklace. The centre can consist of massive pieces of amber beads combined with cowrie or conus shell whorls. The size and width of some Berber necklaces can be astounding, especially those of the south. There can be little doubt that such displays are a statement of wealth and status, but it is not inconceivable that they also represent a reaction against slavery and a celebration of their freedom. There is a legend about the Haratin, the descendants of the Black African slaves, whose necks had once been covered with chains. In the Koran there is a saying, 'save the necks', or 'untie the necks', which refers to the freeing of these slaves. As the slaves were liberated and intermarried with the Berbers, the Haratin ornamented their necks in joyous celebration; the massive necklaces seen at folklore festivals and moussems represent that freedom and joy.

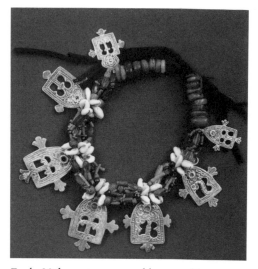

Early 20th-century assemblage necklace consisting of silver, amber, coral, Czech glass and amazonite with turtle and salamander talismans from the Middle Atlas.

The fibula, made by any of the techniques outlined earlier in this chapter, is also a very important part of a woman's jewelry. The fibula with chain is indispensable in fastening the draped garments she wears. It is also the ultimate symbol, rooted in ancient times, of fertility and fecundity and was used in much the same way by Greek and Carthaginian cultures (it is said that Berber women resemble Greek women of antiquity). Moroccan fibulas take a range of shapes and sizes: they can be triangular, circular and oblong, and can be anything from one or two inches in diameter to seven or eight. Some are zoomorphic in shape – for example, the turtle, which symbolizes fertility and protection against the evil eye and the djoun. Other fibula forms have their origins in the ancient cults of the ram, and mountain and astral worship.

Bracelets, probably the most common form of jewelry among women, also come in a wide variety of types and sizes. They can be hinged, hooked or open. Bracelets and anklepieces (more common in the south) range in size from one thin strip to several inches in width, and are usually worn in pairs or more, depending on the wealth of the woman's husband.

The diadem, or headdress, is often worn with other pieces of jewelry. It can be a band of silver or leather with elaborate enamelled and niello designs on metal, with stones (usually coral) and coins attached. Berber women also wear simple earrings, which are passed through the earlobe. Others, ornaments for the temple, can be large configurations of amber, amulets, coral, glass beads and shells; they are placed across the head, braided through the hair, or attached to a diadem with chains.

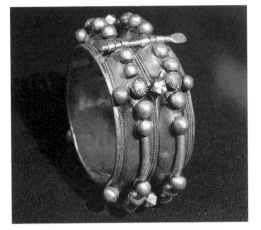

Early 20th-century silver bracelet from Goulimime, with four evenly spaced lonzenge plaques, with applied filigree, and a symmetrical arrangement of seven granules, alternating with four spiralled wires.

Among the most characteristic forms of urban jewelry, usually in gold and rarely in silver, are diadems, bracelets, necklaces of fretted gold, brooches, pendants and belt buckles. The garnets, emeralds, rubies and pearls used were often brought back from Mecca and were set in gold with polychrome enamels. One seventeenth-century account describes the opulence of women wearing gold necklaces, with coral and lapis, and necklaces of precious stones and pearls the size of eggs. Many of these accounts are evidence of the fortunes of the bourgeois families in the cities, who evaluated their wealth by the weight of the gold, and by the necklaces worn during ceremonies. For example, during the Arab wedding, which takes place over one week, the bride's attire was expected to be made up of such a great quantity of jewelry that only the richest families could afford to provide this for her. There were, as a result, certain families who rented jewelry and sumptuous clothes in order that the bride might appear honourable and worthy to her husband. Fez was particularly well known for these extravagant spectacles and the Pasha often had to issue edicts to limit such displays of apparent wealth, because families would get into serious debt as a result.

Symmetry is the rule for design in most urban pieces of jewelry. Overall floral geometric patterning is commonly executed in most Islamic pieces, with some designs mixed with garlands, tracery and curvilinear shapes; the delicacy and elegance of this jewelry is worked by filigree, relief and engraving.

In the rural tradition, the jewelry was created in numerous centres dispersed between the regions of the Rif, Middle and Anti Atlas, Sous, Dra and Dades in the south, using the same techniques as the city artisans. However, each region has its own artisans, who perpetuate the tribal style to a point where, according to the form and ornamentation, the tribe of the women wearing the jewelry and hair ornaments can be identified. In theory, the ensemble of jewelry pieces and coiffure are exactly the same for each woman of the tribe. The jewelry acts as a clan mark, in the same way that tattoos, whose designs have survived through their transference to textiles, distinguished between tribes and subclans.

For the Berber woman, jewelry is an expression of herself and her creativity. Despite being produced under a controlled artistic vocabulary of symbols and materials, the piece enhances the woman's individuality, while acting as a means of identification within her tribe. Women are the only ones who make the assemblage necklaces of coral and amber. They can decide the design and structure of the overall piece, while the men produce the worked metal and act as the source for other materials – there is an old saying that 'a man is ashamed if he makes necklaces, but praised if he makes silver'.

When a Berber man marries, he will commission necklaces, bracelets and other pieces to be made by his mother or sister, as it customary that the wife-to-be should prefer jewelry that has been specially made for her. If new materials

are not available or affordable, older pieces will be taken apart and coins melted down so that brides can receive a new item. Traditionally, the jewelry, as dowry, is kept by the wife and added to until her death. However, in Moroccan law, the husband in fact only loans it to his wife. Divorce is controlled by men, so that if a woman asks for a divorce, she must return all her jewelry and dowry. But if a woman can prove she has been ill-treated physically, or that her husband has been absent for more than three months, or that he is sexually impotent, she may be able to acquire a divorce and keep the jewelry and dowry.

Most of the materials for assembling new necklaces would traditionally be acquired from the *attar*. He was a magician – some say a holy man, as well as a commercial messenger – a travelling salesman who sold, among other things, spices and apothecary items, along with the news of the cities. He was a principal link among the women for acquiring precious beads, charms, khamsas and talismans. There are two other unique instances where a man helps a woman obtain material for a necklace. The *fqih*, skilled in the teachings of the Koran, can act as a consultant in selecting the khamsas and charms that are suitable for that particular woman and her needs (among the Berbers, the women believe that they are more vulnerable to the evil eye and the djoun than the men). A *taleb* (magician), who has curative powers, can also be consulted for these charms. The completed piece may be intended for a whole variety of

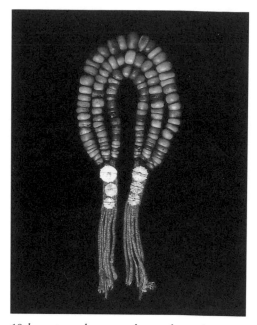

19th-century dowry amber and copal necklace made by the Ait Haddidou, who live on the eastern slopes of the High Atlas mountains.

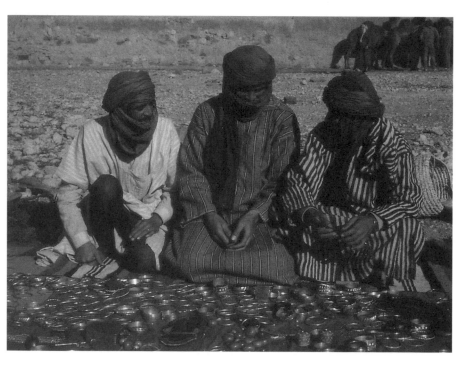

Dealers of silver and coin jewelry in Goulimime.

protective uses: from the evil eye, the djoun, disease, accidents, snake bites and the loss of one's lovers, to helping ease childbirth, bear male children and dispel jealousy.

Jewelry is also a financial investment, and when times are hard, it is sold to provide for the family, while a good year provides the means for a woman to add to her collection. In the Berber tradition, the value of jewelry is not determined by age, as it is in the West: three quarters of its value is determined by its weight, and the quality of the work of a piece is responsible for the remaining quarter. But even more important than the beauty, social and financial value of the Berber necklaces, are the protective, medicinal and magical properties the wearers ascribe to the materials. The Berbers love silver; believed to cure rheumatism, it is favoured by Allah and comprises many of the charms, amulets and fibulas included in the assemblage necklaces (silver coins are also used in many of the pieces).

Coral is also praised by Allah and cited in the Koran as a precious and beautiful stone. Berbers used it for its curative powers long before the Arabs arrived: it offers protection against the evil eye, symbolizes fertility and is thought to contain much baraka. Amber is also highly valued; it is a symbol of wealth, believed to be a cure for colds, a perfume and aphrodisiac, and is worn for protection against the evil eye, witchcraft and sorcery. Much of Moroccan amber is copal, a fossilized resin from West Africa, acquired by trade. Amazonite and carnelian are stones found in the desert region of Goulimime and Tafilet, and are used in divining fortunes. Amazonite also symbolizes the tattoo in many Berber tribal groups. Shells such as cowrie, conus whorl and limpets may be found in many necklaces and hair ornaments. They were traditionally traded from East Africa by caravan, and symbolize fertility as well as deflecting the evil eye. Small clusters can be found in some necklaces of the southern regions and are also used as magical potions.

The animism of the Berbers' culture, as opposed to Islam, which disapproves of the use of human and animal motifs, inevitably informs their artistic vocabulary, with images of the sun and moon, the stars and numerous fauna and flora. While the forms may be stylized, one finds amulets, pendants and charms resembling features of the natural world, such as the turtle, salamander and scorpion, and the beehive and snake.

Among the Ait Atta, these charms are called *tachrouchts*, and are considered protective and prophylactic. The snake and scorpion motif will protect the wearer from the bite by its design, and ensure fertility and strength in childbirth. The most common motif to ward off or deflect the evil eye and the host of djoun, which are such a strong presence in Berber life, are the hand and its five fingers, or some symbolic manifestation of them, on silver charms, pendants and talismans. These might include the number five as a design in

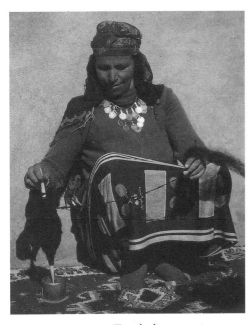

Woman weaving in Taochokte, wearing a necklace of silver coins.

configurations of five charms together, or five beads in a row. There are many representations of the hand, ranging from realistic images to impressionistic ones, such as five dots, the shape of a curve, a zigzag, chevron, triangle and the cross. The eye, or a pair of eyes, is also a recurring image in Berber traditions. The triangular fibulas not only symbolize fertility and fecundity, but also protect one from the evil eye because of their sharp-edged shape.

Among the Berbers, the symbols and motifs I have mentioned not only protect the wearer, but also the piece of jewelry they adorn. A necklace, or the fibulas with chains, might be better understood as an all-encompassing talisman emanating power for protection against evil forces. Moroccan jewelry thus lives on through the twentieth century as a legacy of popular, collective and sacred traditions, as a means of adornment and a symbol of wealth, and as a source of supernatural and religious power for women. It reveals something of the social, religious and geographic background of the wearer, as well as of Morocco's artistic heritage, past and present.

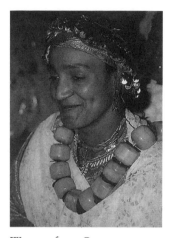

Woman from Ouarzazate wearing a necklace of tazras, *large copal beads.*

60 OPPOSITE *19th-century gold* tizara *(pendant necklace) from Fez. It is composed of numerous strands of seed pearls, flanking two elongated, gold embossed beads. All three pendants have a rosette motif studded with sapphires, emeralds and rubies in an alternating pattern. Such an elaborate piece of jewelry would be worn by the bride at her wedding, to indicate to the groom the wealth of her family. Many families in the past got into debt by renting extravagant jewelry and wedding clothes.*

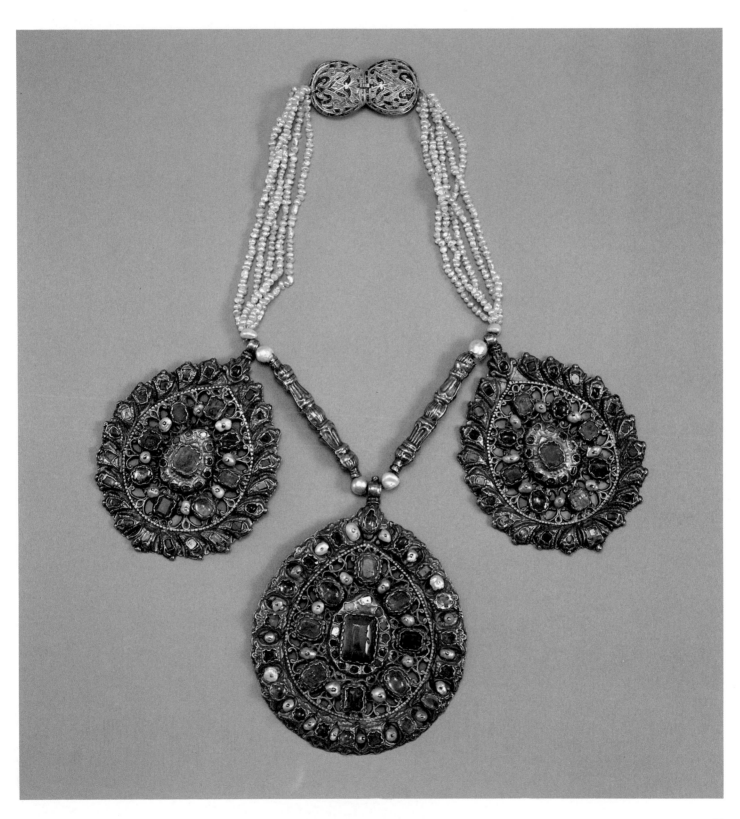

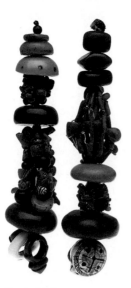

61 ABOVE *Early 20th-century earrings made by the Ait Atta, worn at the temple and fastened by being braided through the hair. They consist of pieces of copal, amber, coral, glass and wooden beads, silver, conus and limpet shell, and* talhakimts, *the rings at the base of each.*

62 ABOVE RIGHT *Full view of the necklace detailed in Plate 59.*

63 RIGHT *Early 20th-century Ait Atta necklace for festive events such as wedding ceremonies, with several strands of coral and silver coins on the collar; silver in any form is believed by Berbers to cure rheumatism.*

64 FACING PAGE *19th-century dowry necklace made by the Ait Atta, consisting of coral (praised by Allah and thought to have curative powers), amber, Czech glass, conus whorl, silver coins, enamelled beads, amber, copal and cowrie shell on braided wool, as well as enamelled filigree eggs* (taguemouts), *for which the Tiznit and Anti Atlas regions are famed.*

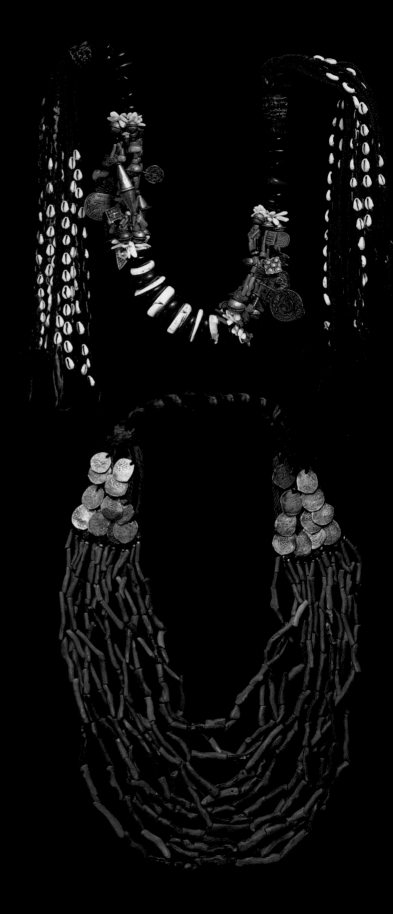

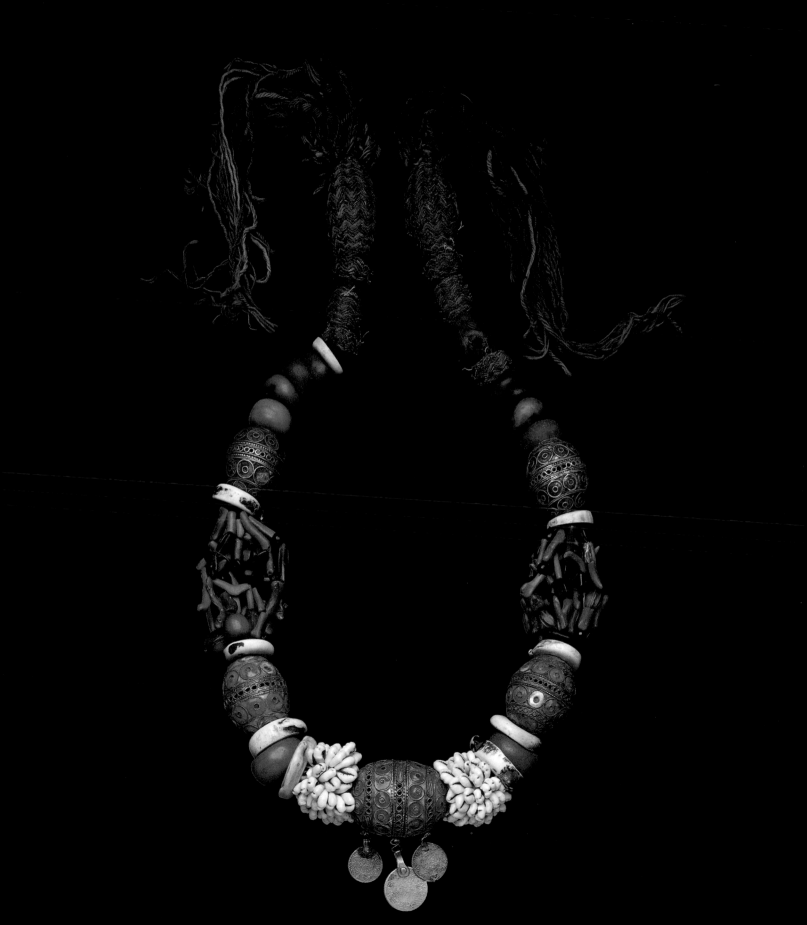

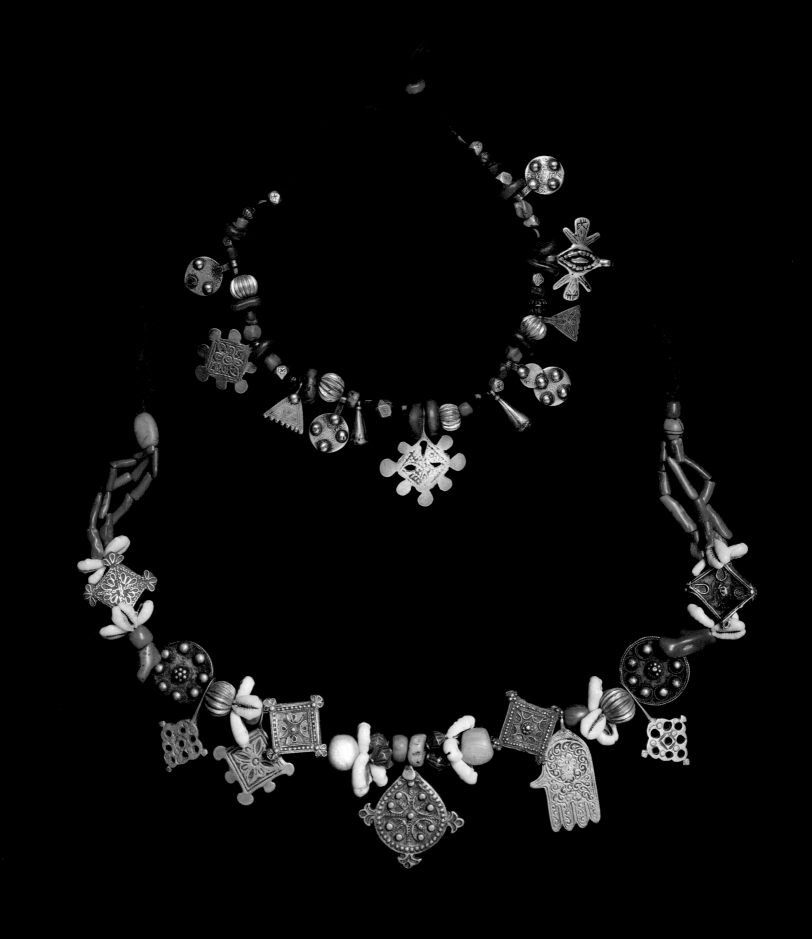

65 LEFT, ABOVE *Late 19th-century* tachroucht *(assemblage necklace) with amber, amazonite, coral and various* tachbats *(talismans) of silver, such as the beehive, pigeon's foot and turtle. One source of the components for a necklace was from an* attar, *a holy travelling salesman, who would bring beads and charms to the rural areas from the cities, as well as apothecary herbs and spices.*

66 LEFT, BELOW *Early 20th-century necklace from the Dra region of the south, with pieces of coral, amber, mother of pearl, cowrie shell, hands of Fatima to ward off the evil eye, beehive talismans and enamelled Koranic boxes.*

67 BELOW *Late 19th-century necklace from the Dra region, with coral, amber, glass, conus whorl and* taguemouts *(see Plate 64).*

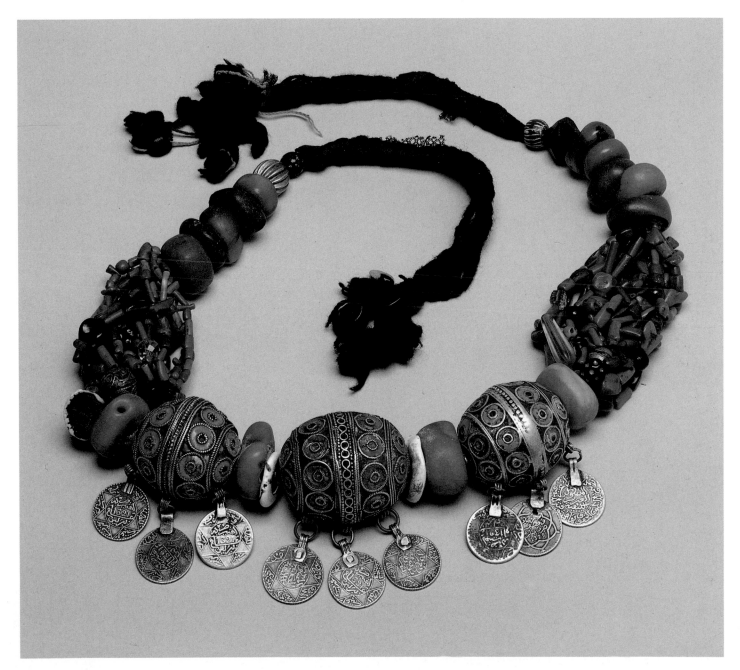

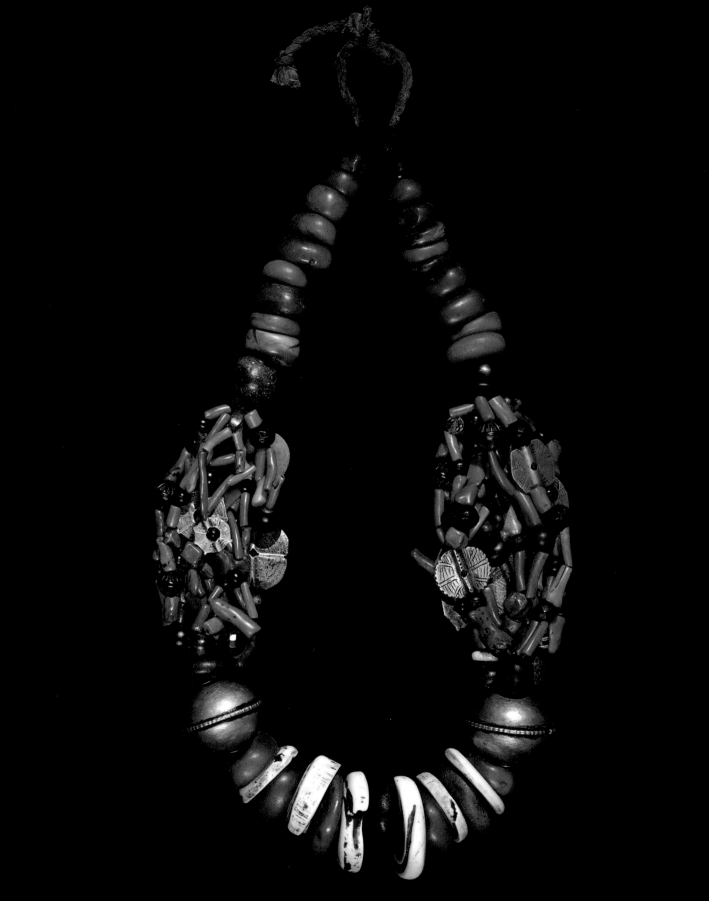

68 LEFT *Late 19th-century assemblage necklace from the Dra region, consisting of amber, copal, silver balls, conus whorls, Czech glass and bronze West African and ebony beads.*

69 *Late 19th-century necklace from the area around Tiznit and Dra, with coral, silver beads and an enamelled centre plaque, from either Mauritania or Mali, on wool.*

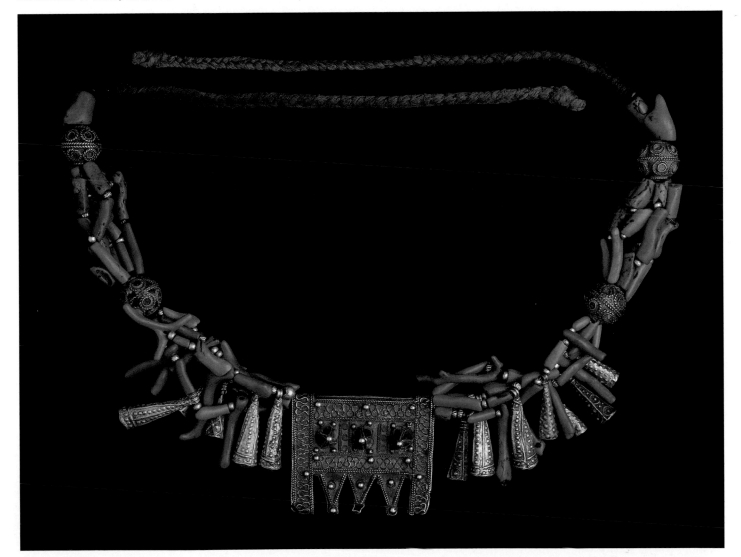

70 BELOW *19th-century Ida Oundif diadem, with coral and repoussé silver on a leather backing. The repoussé effect is achieved by hammering through a pattern from the underside of a thin piece of metal.*

71 BOTTOM *The amazonite in this necklace is used because the stone is believed to have healing powers, while the iron beads at the neck are thought to instill power in the wearer.*

72 RIGHT *Early 20th-century necklace from the Figuig region bordering Morocco and Algeria, made by the Beni M'Guild. Uncut coral is believed to contain far more power than cut beads; the silver coins space out the other components of the necklace, such as the ebony and iron beads, adding to the prophylactic power of the assemblage.*

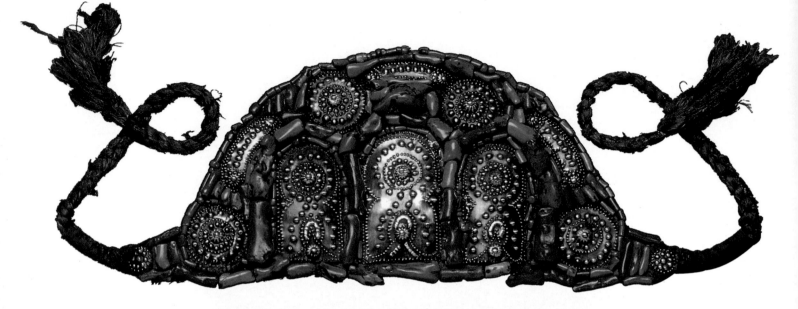

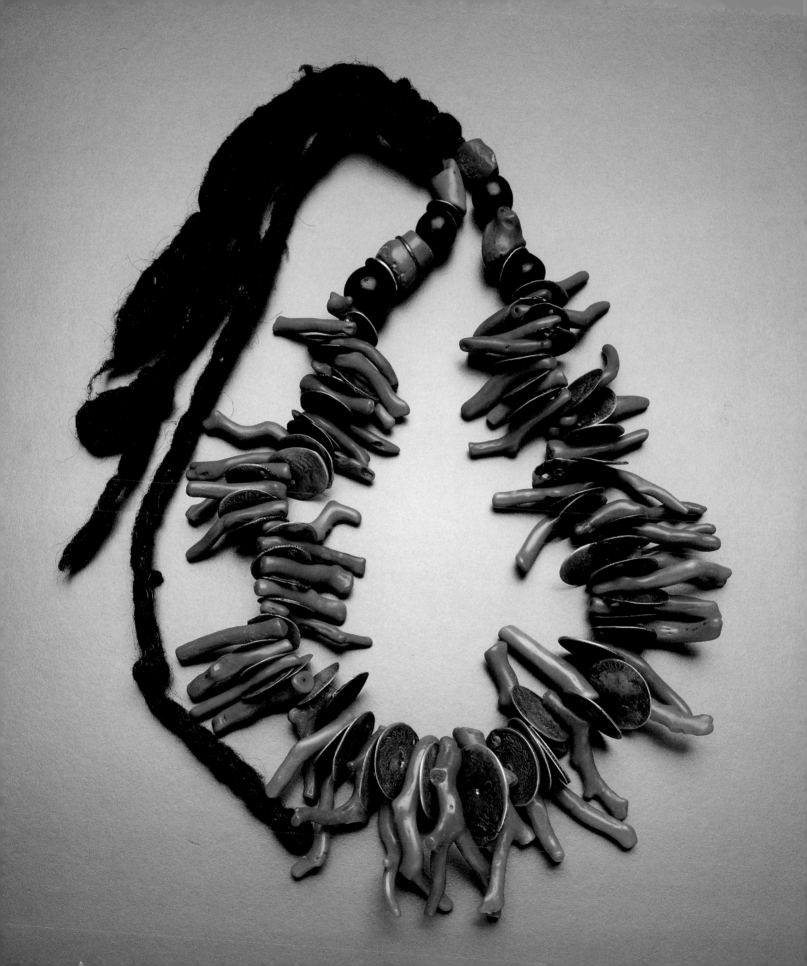

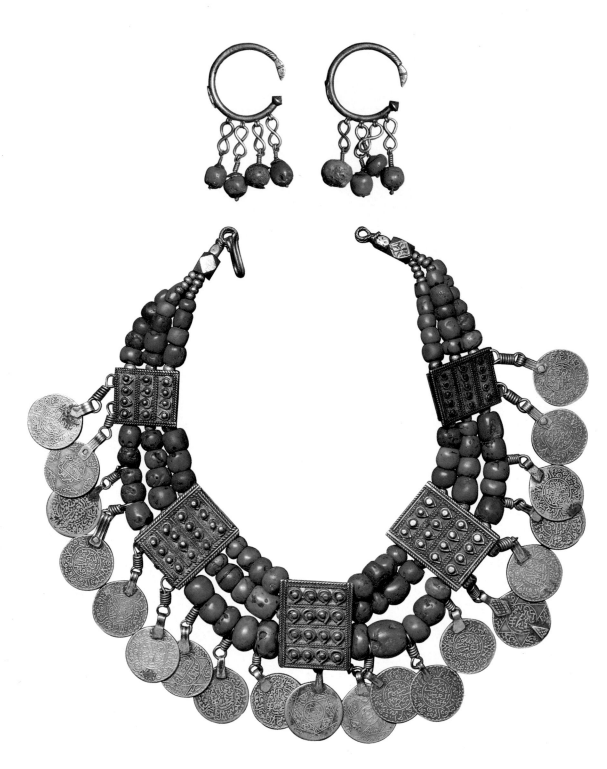

73 LEFT *Early 20th-century pair of earrings from Ouarzazate in the Tiznit region. They are worn simply through the earlobe, although some earrings can form part of an elaborate assemblage braided through the hair or attached to a diadem.*

74 LEFT *Early 20th-century Berber choker, intended as a ceremonial dowry piece, made by the Zaer-Zaine in the Rif region. It has coral and silver coins on silver wire and five silver Koranic boxes (the number five is a magic number and symbolizes the khamsa, believed to ward off evil forces). Koranic boxes are made by the following process: the metal is heated, flattened with a hammer and cut; it is then secured onto a slab of wood, after which it can be inlaid with enamel or decorated with stones.*

75 RIGHT *Early 20th-century necklace from Zaine in the Middle Atlas, intended for festive occasions, with coral and silver threaded on leather.*

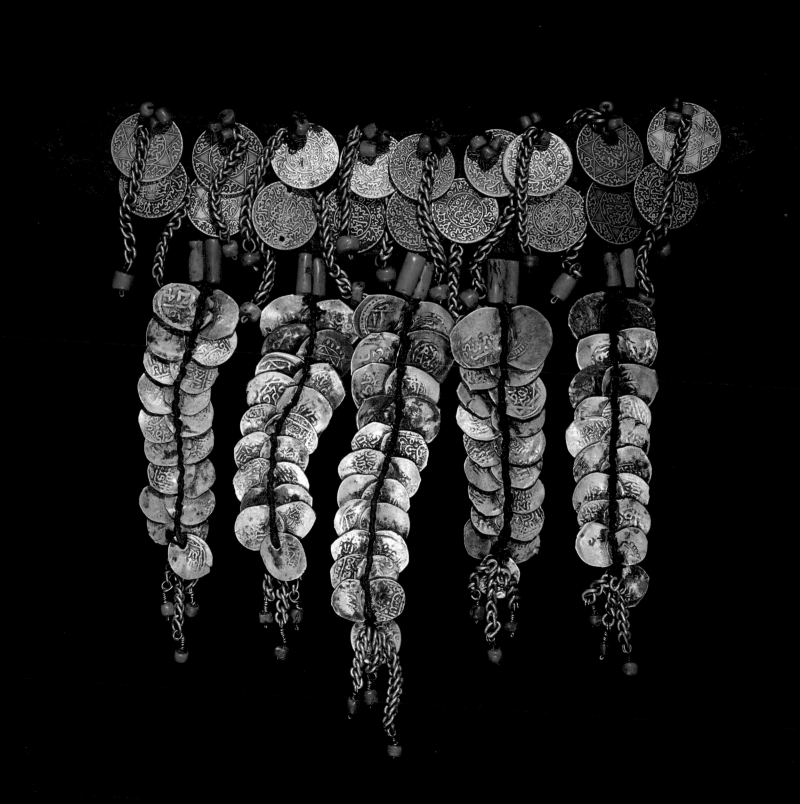

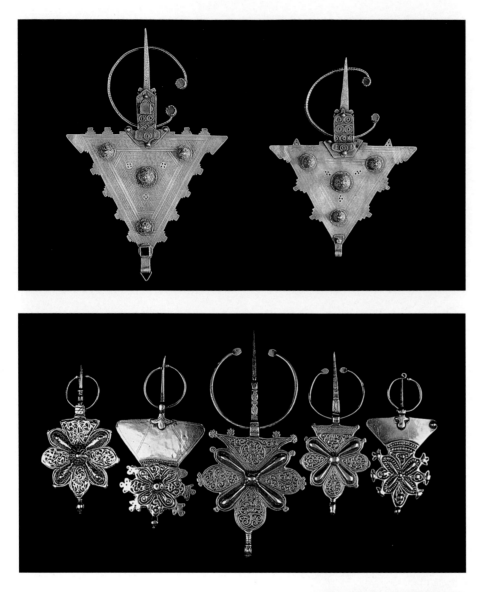

76 LEFT *Two 19th-century filigree* tizerais *(fibulas) made by the Ait Ouaouzguite and from Tiznit (left and right respectively), with enamel applied by the cloisonné technique – digging out the decorative motif and pouring the enamel into the hollows – as well as enamelled bosses beside pierced floral patterns. The rings are studded with coloured glass. The fibula, a symbol of female fertility and a guard against evil forces, also has a practical function as a fastener for the draped garments worn by Moroccan women.*

77 LEFT, BELOW *Five engraved silver fibulas. From left to right: with jackal paw pattern, by the Ait Hadiddou in the central High Atlas region; from the valley of the Dades; from the central High Atlas region; from the Ait Morrhad; from the valley of the Dades.*

79 BELOW *Early 20th-century necklace from the valley of the Ziz, south of the High Atlas, comprised of amber, silver and niello medallions, with geometric and astral symbols threaded on leather.*

78 RIGHT *Silver pendant khamsa, hammered and incised. The khamsa can be any form of the hand – whether symbolic or representational – of Fatima, the daughter of the prophet Mohammed. It may appear as five fingers, or as five dots, a zigzag, chevron, triangle or the cross; whatever its manifestation, the khamsa protects the wearer from the evil eye. As the female sex is thought to be more susceptible to such forces, each woman may have a different, personalized khamsa, advised by a* fqih *(a Koran scholar), or a* taleb *(a magician with curative powers).*

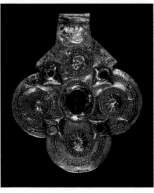

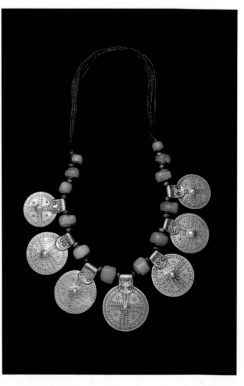

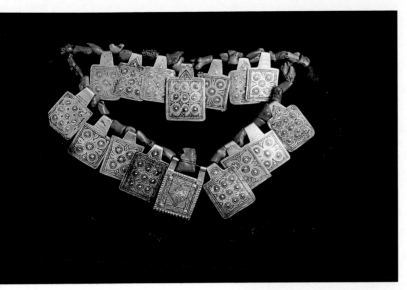

80 LEFT *Early 20th-century assemblage with uncut coral and double-tiered plaques acting as a breastplate.*

81 BELOW LEFT *19th-century amber necklace with a silver collar and silver beads.*

82 BELOW *Late 19th-century necklace from Oasis Bani in the Foum Zguid region, with silver niello plaques and amber beads on leather.*

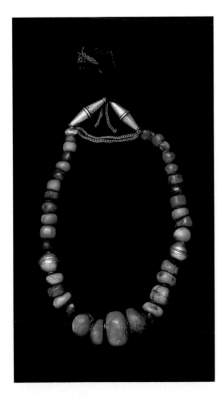

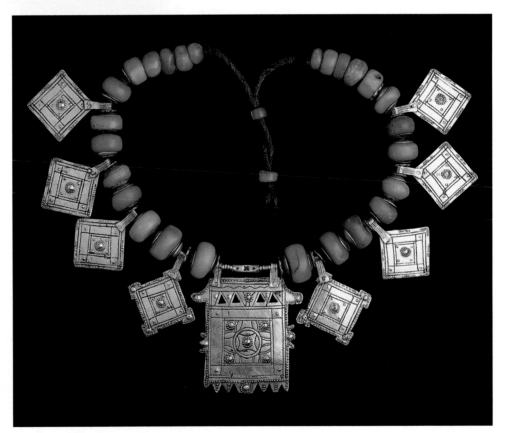

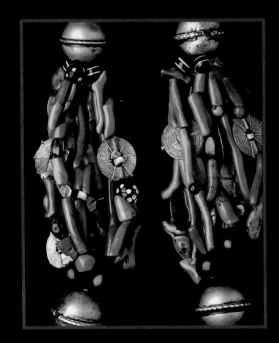

83 LEFT *Detail of a Dra necklace with coral, bronze, silver wire ornaments from West Africa, Czechoslovakian glass and silver balls.*

84 LEFT, BELOW *The top and bottom bands are early 20th-century ornaments, from the Anti Atlas region, for the head and hair, consisting of tufted cotton and wool with silver coins and beaded coral. The three pieces from the Tiznit region in between are silver filigree and enamelled ring-shaped hair ornaments which can be used to hold aromatic herbs or scented wool.*

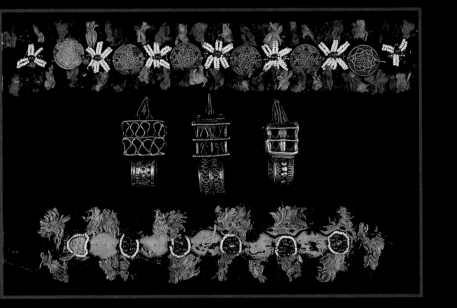

85 RIGHT *Late 19th-century diadem by the Ait Ousmalal (from Tafroute in the Anti Atlas) with silver, coral, leather ornaments and monkey fur, intended for festivals and weddings.*

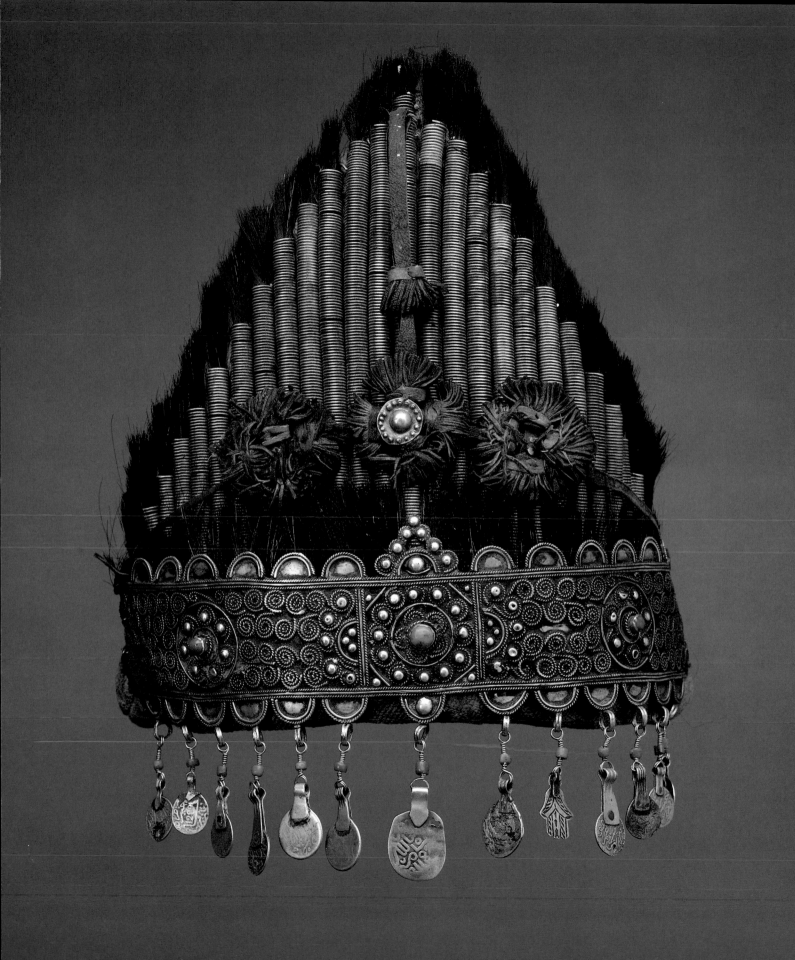

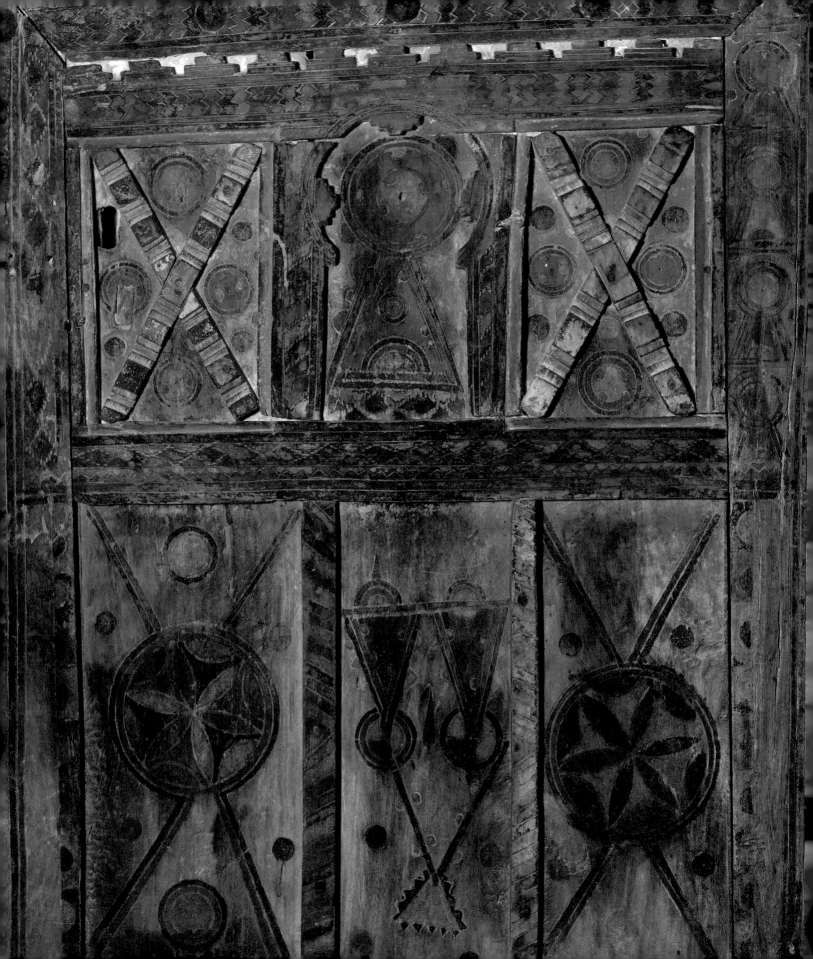

CHAPTER FOUR

LEATHERWORK, WOODWORK AND METALWORK

A maallem is a poet who does not write on demand. He uses but the humblest materials, for what is required is imagination, and imagination knows no enemy but time.

Maallem saying

The leatherwork, woodwork and metalwork traditions in Morocco share a similar history of development, religious inspirations and vocabulary, with the same distinctions between urban and rural practices. They are, however, in fact different from other traditions such as jewelry-making and weaving, in one important respect: leatherwork, woodwork and metalwork are executed almost exclusively by men (the only exception being that in the southern regions of Morocco women might embroider and appliqué leather goods, such as bags, tent dividers and Koran cases). The articles they make are intended for traditionally male activities, whether warfare or farming. Due to this identification with men, there is both a symbiotic relationship between the leather, wood and metalworkers themselves, and a traditionally strong artisan–client relationship common to all three. They also require a certain amount of geographic mobility – unlike traditions practised by women – because many commissions will be outside the normal tribal boundaries, and even beyond those of the cities. For example, a Berber man may use the village smith for basic things such as tools and blades, but if he wants a leather saddle with sixteenth-century-style bronze stirrups, he may go to a city to commission it. It is customary for men to take great pride in selecting their equestrian equipment, war weapons, camel- and donkey-trappings – not everyone has to have the same red saddle or the same guns. The greater freedom of expression found in these artistic traditions corresponds inevitably with the greater social freedom men experience in Morocco.

Leatherwork, woodwork and metalwork have always been among the most productive traditions of Morocco. They were formed into corporations under the control of an *amin*, who supervised several maallems of one guild. The role of the *amin* involved acting as an administrator, an arbiter in disputes, an advisor in the quality of work being produced and as a holyman. The various maallems taught the apprentices, who would traditionally have been their sons, passing the skills and techniques from one generation to the next. These guilds were a very closely knit group socially, religiously and politically; there were

86 *19th-century door of a granary, with astral symbols, part of the wide range of the Berbers' artistic vocabulary. The granary (*agadir *or* tighremt*) was a fortress-like building situated on the top of a mountain with limited access by a single steep path; its position and the strength of the wood protected a family's food supplies in case of war, with the extra, talismanic deterrents of the symbols on the door.*

strict laws and modes of performance, to which each member had to conform, and, likewise, punishment for those who did not. Each guild even had its own songs and stories, kept alive by each succeeding generation.

The cities of Fez, Marrakesh, Rabat, Essaouira, Tetouan and Meknes have all produced works of great beauty in leather, wood and metal, especially for architectural furnishings and in utilitarian and ceremonial objects for urban life. Today they also produce objects for the tourist market, such as doors and chests. Islam has dictated the iconography and conventional style for production in urban areas. As I mentioned in my discussion of jewelry in Chapter Three, large numbers of artisans, many of them Jewish, fled Moorish Spain in the fifteenth century and took refuge in Morocco. In sheer numbers, there were probably more of these people working in leather, wood and metal than in any other tradition. The Jewish artisans settled in the city quarter known as the mellah; it is an Arabic word originally meaning salt, whose meaning was changed in Fez, where it referred to the Fassi Jews, who were employed by the Arabs to salt the heads of the Sultan's executed prisoners and to display them on spikes at the main gate.

LEATHERWORK

Leatherwork, today and throughout its history, involves the largest number of people, and consists of several specialist techniques and products. In Fez, for instance, different types of hide – sheep, horse or goat – had their own tannery in addition to there being a different institution for the particular object, such as a saddlemaker's or a shoemaker's guild. All the shops on one particular street were occupied by members of a single guild. The guilds also bought up *fonduks* (caravanserais, or inns) and turned them into warehouses for their products. Over time, however, their function has changed and, although a few store only the work of one guild, they are now more commonly used as warehouses for stalls that act at wholesalers for a wide range of goods.

Moroccan leather has long been sought after by people all over the Moslem world, as well as by those in the Western Sudan and around the Sahara. Goatskin is the primary material used – and it as fine as the proverbial kid glove – which is dyed in brilliant colours. The skins are today still tanned by an archaic method of immersion in animal urine (visitors to the works are given a sprig of mint to counteract the powerful odour). The hides are subsequently dyed in huge vats sunk into the ground. The three most common colours were yellow, green and red, from, respectively, Marrakesh, Tafilet and Fez. Many of these fine-coloured skins were traded in the south and beyond, and the colours characteristic of the leatherwork from the Saharan regions of Tuareg and Maur were

highly sought after. The Tuareg are fond of using green leather, because the colour has a magical meaning for them: it relates to the earth, healing and spirits of fertility.

In the urban centres, exquisite workmanship is displayed in the form of bags, purses, embroidered saddles and other horse-trappings, belts, wallets, and sword- and dagger-sheaths. One of the most common leather items produced is the slipper, the *babouche*, which nearly every Moslem man or woman possesses, whether plain or decorated. *Babouches* are traditional footwear that are easy to slip off when entering a Moslem home or mosque. They are made of a flat, soft leather in various colours, including red, purple, black and green. Yellow is favoured for outdoor slippers for the men, while white is preferred for indoors; red is usually the colour worn indoors by women. *Babouches* are embroidered in gold and silver silk thread for more special occasions, such as weddings.

The most impressive leatherwork found in Morocco involves the binding of books, manuscripts and the Koran, as well as their gilding and gold-stamping. The leather most commonly used was a very fine, almost paper-thin vellum made of goatskin, although gazelle skin was occasionally used; the goat would have to be slaughtered according to sacred Islamic law. The ornamentation can be very intricate; interlacing polygons, eight-pointed stars (originally an Egyptian sign of immortality and fertility), and Solomon's seals interconnect with magnificent designs. The skills of the Moroccan bookbinder and calligrapher refer always to spiritual inspiration in the form of their relationship with Allah. The binding of the Koran, especially when it has been inscribed with calligraphy and illuminated, is thought to be the most sacred of traditions, because of the unique compatibility of the medium and the philosophy behind the process.

The techniques and products of the south have been influenced by the Tuareg and Maur artisans of the Sahara. For centuries, they had trade relations with each other, mutually influencing their artistic vocabularies and techniques. Many of the western Sudan and Tuareg leather pieces, especially the older ones, are made of Moroccan leather; this is distinguishable by the mustard-yellow colour, with designs embroidered in other colours. The sub-Saharan pieces are generally of a much darker brown, although the same techniques and some of the same designs are used.

The geographical nature of nomadic and semi-nomadic life – the lack of physical boundaries – brings about a greater and continual exchange of materials and design vocabularies. Embroidered and appliquéd leather, and the various techniques, such as weaving into the leather sections peeled from the outer layer, incising it with a knife, stamping prophylactic symbols and designs with dyes, are used all over southern Morocco.

The technique of embroidery on leather is done with a very narrow strip of leather acting as a thread, woven like raffia for a relief effect, and often combined with painted, polychrome pieces of leather. Black, red, green and yellow against some of the subtle and subdued colours can be most striking. Long fringes on the bags, cushions and camel sticks are also commonly seen (the latter, common in the far south, consist of four sticks on each end of a camel saddle, which support a tent-like covering over the rider).

Among the Berbers in the northern regions, such as the Rif and the Middle, High and Anti Atlas Mountains, leather objects commonly seen are the belts (*m'dammahs*) worn by many Berber men with silk or rayon tassels, boots, bags (*choukaras*), which can be plain or embroidered, wallets in different sizes and shapes, sword and dagger scabbards embossed or perforated with brass trimmings, as well as cushions and amulet cases. A heavier leather is used to make more substantial bags, cartridge holders, chests studded with nails, and gilded, embossed or etched saddles for horses and camels.

Leatherworkers, like artisans working in other traditions, relied on the saints for protection and inspiration; they all revere Moulay Idriss, but each region also has its own patron saint. In Fez, for example, Sidi Mohammed Ibn Attab is revered by the numerous guilds. In the southern regions, Moulay Ibrahim is prayed to for counsel, and each year a camel, which is believed to bear the bad luck and evil of the city, is sacrificed to him. All who want to prosper at their trade load this camel with items relevant to their craft – whether bits of thread from embroiderers or pieces of wool from weavers – which symbolize their wishes; these are attached to the hair of the camel, which is then paraded about the tanners' quarters, before going to the marabout, where the sacrifice takes place. After the sacrifice, the camel's skin is brought to the tanners and sold by auction, to fund the purchase of new skins for tanning until they can afford to buy another expensive camel and sacrifice it for the pilgrimage at the time of the Mouloud (the birthday of the Prophet Mohammed) the following year.

The association between the leatherworking tradition and the camel has always been a strong one; the saddles and trappings produced fostered the domestication and utilization of this animal, the most revered in all Morocco, and one that has played a vital role in its history. In fact, some historians have said that no animal ever played such a decisive role in humankind's history: for a thousand years, until the ship of the Portuguese Prince Henry the Navigator ventured southwards past the Moroccan coast in the fifteenth century, it was the camel alone that made possible any contact with inner Africa beyond the Sahara, and thus to the sources of gold that lay further in. This accessibility to the rest of the continent increased the wealth and power of Morocco and the rest of the Maghreb until the Middle Ages, spreading also to the Black African kingdoms of Ghana, Mali and Songhay (an African kingdom from the eighth to

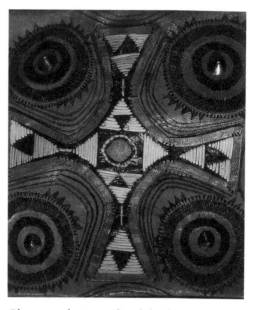

Close-up of a painted and dyed leather provision bag from Layoune in southern Morocco.

the sixteenth century, consisting of modern-day Mali, Ghana and Niger). The camel also allowed for the development of the oasis regions in southern Morocco along the trade routes, and was the main means of transportation for religious pilgrimages to Mecca across the vast and formidable desert.

WOODWORK

Woodwork is used mostly for architecture, whether in an urban or rural environment. Urban work utilizes a vocabulary that includes calligraphy, as well as polygonal, arabesque, floral and other botanical motifs characteristic of Islamic art.

The mosques, *medersas* (seminaries where holy men learn the Koran), *hammams* and many of the private homes in Morocco attest to the exquisite workmanship involved in this craft. The elaborate woodwork against white stucco walls creates a wonderful interplay of light and dark, making this form unique among the Islamic countries of Africa.

Timber is more abundant in Morocco than in most areas of the Maghreb, and there is correspondingly more work produced in wood, at least in urban areas. Cedar, found in the Middle Atlas region, is the most common material for woodworking; it is ideal for carving and bas relief and does not have to be treated or varnished, although it must be dried properly to make it resilient. Other woods, such as argana (a hard wood, like mahogany), lemon, ebony from Madagascar and mahogany from West Africa are used in marquetry (inlay work).

Woodworking requires forethought, strict preparations and long elaboration. The basic design is chosen by the maallem from a vast geometric vocabulary; he closes his eyes and envisages the design, after which it is drawn out and made into a paper stencil. The design then has to be matched to different woods, for which various techniques can be employed, such as painting, incising, inlay, pyroengraving and stamping.

In Moroccan cities, such as Marrakesh, Fez and Meknes, it is commonly said that a piece of wood is not finished until it is painted. Painting is probably the most sought-after embellishment applied to woodwork. The painter is called a *zawwaga* and works with fine donkey-hair brushes. The compilation of painted floral, plant and geometric star patterns of eight, twelve and sixteen points, is called *tastir*, and when repeated in an overall design, is known as *zaaq*; they are the most common configurations seen decorated in wood.

There is a wide range of architectural features made in wood, from exterior balustrades to interior embellishments and furnishings, such as screens, doors, lintels and tables. Work on a smaller scale includes ceremonial Koran holders, wooden inlay for sword hilts, dagger handles and powderhorns. Some of the

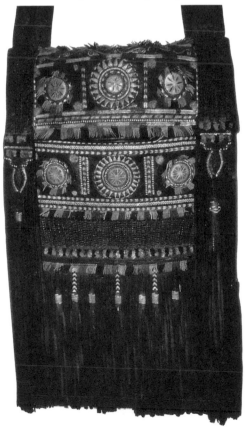

19th-century men's leather bag (choukara) with silk embroidery, from the Rif region. It is used to carry tobacco, kif and powder.

more elaborate work practised in the urban tradition includes painted and carved ceilings, multi-layered roofs, cupolas, dome-like *koubbas*, similar to cupolas, and truly remarkable vaulted structures called *muquarnas*, in which pieces of wood seem like millions of stalactites descending from the ceilings.

Some of the designs found in the architectural pieces are derived from the Andalousi tradition of Moorish Spain. There are myriad kinds of painted and carved structures, including doors, lintels, beams, balustrades facing patios, windows and shutters. There is one architectural feature in particular that is highly characteristic of Moslem countries: the *moushrabiya*. This is a screen formed by a series of knob-like turned wood pieces glued or nailed in a mesh or grid of thin strips, or it can be densely designed, with star-shaped or octagonal openings carved out of a large flat piece. Its design and use reflect the position of many women in Moslem society; in accordance with Islamic law, they do not mingle with men in places of worship or in reception rooms. The *moushrabiya* is installed in the upper gallery of the patio of private homes and allows the women of the household to remain unseen while they observe the men's activity through the small openings in the wood. It can seem very mysterious to a Westerner seeing these windows or partitions for the first time.

Other examples of Moroccan woodwork that act as the main forms of interior furnishings, are chests mounted on feet or fastened to the wall, shelves, exquisitely painted and carved tables for tea, and marriage chairs; in the urban tradition, the latter are elaborate and high off the ground, while in the rural tradition, they are more like a huge tub into which the woman is placed before being carried around on a donkey. Another valued item in the Moslem household is the *koursis*, an elaborately carved and embellished Koran holder with inlays of mother of pearl, ivory or contrasting woods.

In the courtly tradition, the Sultan, as well as the bourgeois families of the cities, required weapons that served for both decoration and warfare. These included rifles with stocks that were carved, incised and inlaid with ivory, with powder horns to match, as well as bejewelled sword hilts and dagger handles. Soldiers of lesser rank would have had plain weapons.

Wood is also widely used in the architecture, furnishings and weapons of the Berbers. They painted, incised and stamped their ceilings, door posts, house posts, lintels, beams and windows with the vocabulary of geometric and animistic symbols common to all their traditions. Hand symbols, fibulas and entire stylized necklaces and chokers were frequently carved and painted on doors, for example, to protect both the door and the contents behind it. Doors are clearly the most likely feature of a household to be decorated with such symbols; this can sometimes be done quite elaborately, with circles, diamonds and spirals. While each symbol has its own meaning, when designed as an ensemble, the pattern can create an intricate interplay of colour and texture.

Early 20th-century wooden mortar containers for herbal remedies.

102

Also highly decorated are the doors of the *agadir*; this is the granary, a citadel-like fortress on top of a mountain, accessible only by one steep path. Tunnel-like passages link storage rooms arranged like a beehive. These carved and painted doors, in front of the cubicles, protect individual families' surplus supplies in case of war and siege; when the Berbers had to defend themselves from fierce marauding tribes, such as the centuries-long war with the nomadic Regubiat people, these *agadirs* protected their lives and possessions. With a fibula, necklace or hand carved upon it, the door acted as a large talisman protecting the contents against other tribes.

Whether carved, painted or pyroengraved (done with hot irons), doors and ceilings, such as those found in the Ait Bou Goumez region, are just one kind of visual and historical documentation of the vast repertoire of the Berbers' artistic vocabulary. Other items commonly made in wood, and displaying the same motifs, symbols and techniques used, include chests, in which anything, from arms to jewelry and textiles, can be stored; cosmetic bowls for henna; *merrouds* (containers) for kohl, or mascara for the eyes; sugar hammers for making tea, and cups and bowls.

Wood is a revered substance in both the urban and rural traditions. All woodcarvers are under the protection of Sidi Noh, as well as one other saint associated with the region in which they work. Popular belief affirms that the first master craftsman in wood was Noah and that he endowed Morocco with one thousand and one compositions and as many dazzling design motifs.

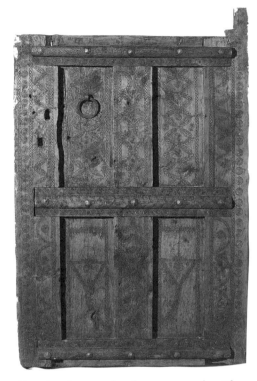

Exterior door made of argana wood, with carved fibulas for protection against the evil eye and the djoun.

METALWORK

The metalwork tradition, whose most common materials are iron, copper, brass and bronze, is also part of Morocco's rich heritage. In the urban tradition, doors and beams were studded with iron and nails made of brass; strap hinges of both brass and iron can be found on various different pieces and door knockers were generally made of iron, bronze or brass. Those in iron were more commonly found on the doors of the poorer rural people, while those in brass and bronze, often in the shape of Fatima's hand, or a pentagram – or a combination of both – graced the doors of the wealthy in many Moroccan cities.

Wrought iron is produced in Fez, Salé and Marrakesh, where artisans can specialize in grilles, lamps, straight or curved daggers and flintlocks or pistols. Iron grilles are a very common architectural feature used in balustrades or in windows and partitions. Sometimes the grilles are polychrome, and there are numerous designs in the ironwork imitating spirals, foliated scrolls and cloud rings. They are found in both urban and rural houses, and are probably an influence from Andalousi Spain.

Smiths who specialize in copper, brass and silverwork are found in many cities, but Taroudant, Fez and Marrakesh are the most renowned for the expertise of their artisans. The more decorative objects most commonly made in brass and copper include trays, vases, perfume and incense burners and rosewater bottles, as well as oil lamps, chandeliers for mosques and candelabras; they are often decorated with designs of pentagrams, rosettes and arabesques that can be hammered or engraved into the metal. Other items made in brass and copper of a more utilitarian and domestic nature include tea pots, braziers, samovars, kettles and cooking pots. Traditionally, weapons such as rifles, pistols and powder horns were all decorated with inlay, usually ivory. Bronze sword hilts, sheaths of embossed silver or brass, and silver damascened blades were common items commissioned from metalworkers all over Morocco.

The Berbers have also had a long tradition of metalwork, creating numerous tools and instruments of purely utilitarian fashion, such as ploughs, pistol locks, hoes, knives, axes and nails, as well as some of the more decorative spurs, stirrups, straight sword blades, curved daggers in the Sous and Atlas regions. Traditionally, the sword blades were made locally or traded from the East, but by the sixteenth century, manufactured blades were imported from Europe, from Spain in particular, and incorporated into Berber and Arab weaponry.

Some significant changes have taken place in these traditions over the course of the twentieth century; while in the countryside the trades are still passed on from father to son, the closely knit guilds of the cities, which were so integral a part of Morocco's urban past, have in some areas been disappearing, with many artisans setting up on their own. However, despite such changes in the infrastructure of these traditional organizations, the disciplines of leatherwork, woodwork and metalwork continue to thrive in quantity and quality.

87 BACKGROUND *Late 17th- to early 18th-century shutter from Meknes. Islam provides the iconography for all urban pieces.*

88 INSET *Camel made from thuya, a smooth burled wood, by Mustapha Boumazzough, a contemporary artist from Essaouira. The camel is the most revered of animals in Morocco: it was crucial in making trade routes accessible from the north of Africa across the Sahara to inner Africa.*

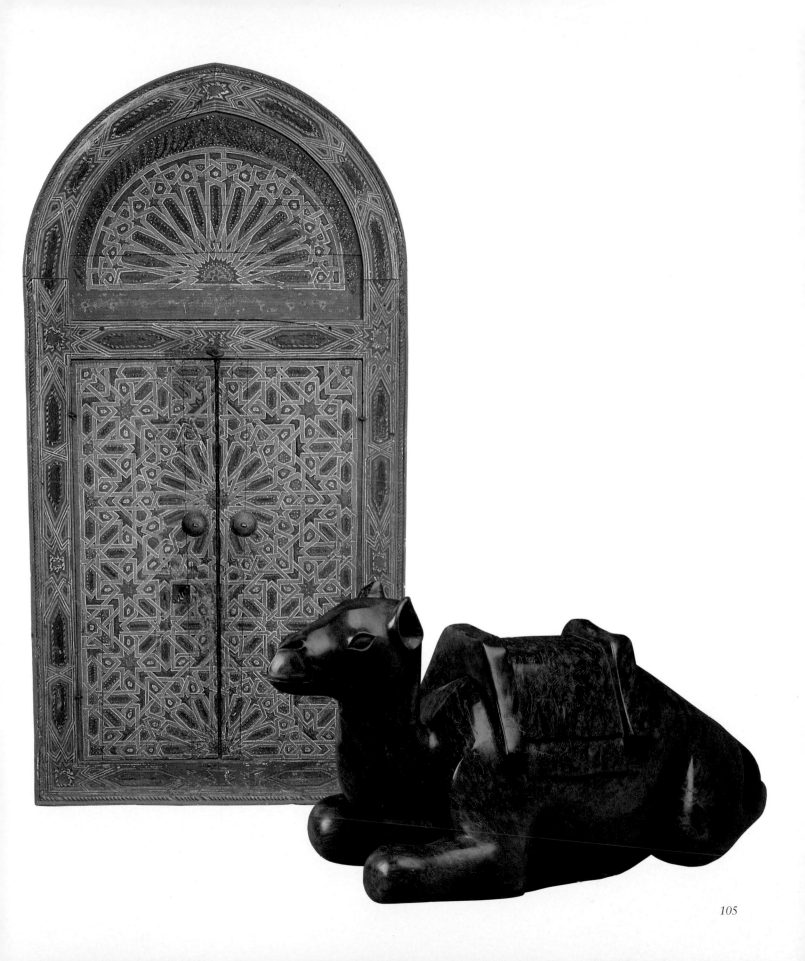

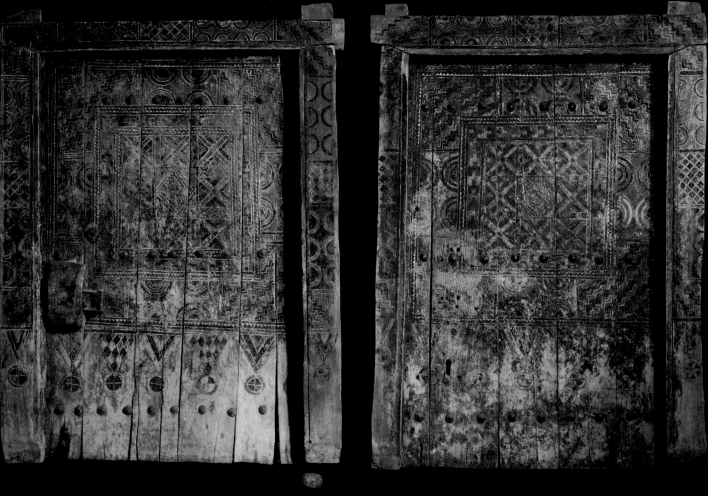

89 LEFT *19th-century painted interior doors from Tagmout, east of Goulimime in the Anti Atlas. Doors are considered as much a part of the interior decoration as other furnishings, such as tables or screens.*

91 BELOW *Late 19th-century cedar jewelry box from the High Atlas. Cedar is the most common material for woodworking, ideal for carving and bas relief, as it needs only to be dried thoroughly to become resilient.*

92 BOTTOM *Early 20th-century wooden tea table with a compartment for glasses and sugar.*

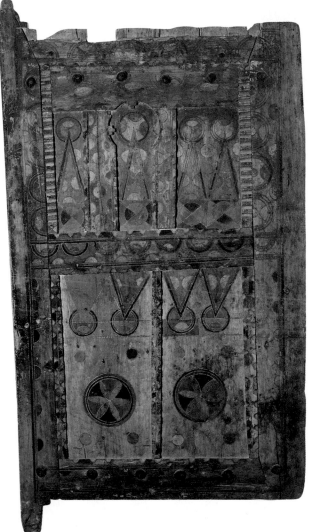

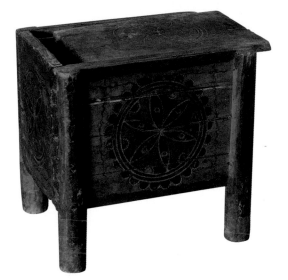

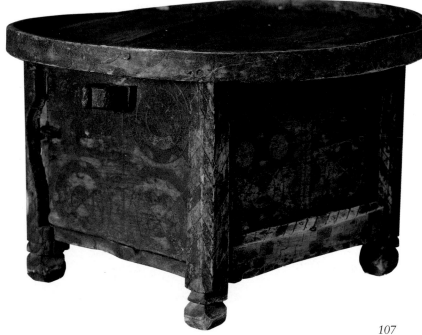

90 ABOVE *The Berbers decorate their wood to the same extent as artisans working in the cities, except, as with all rural traditions, the artistic vocabulary is strikingly different; they display their animistic beliefs through designs such as the astral and geometric symbols on this 19th-century door from Taliouine in the Anti Atlas.*

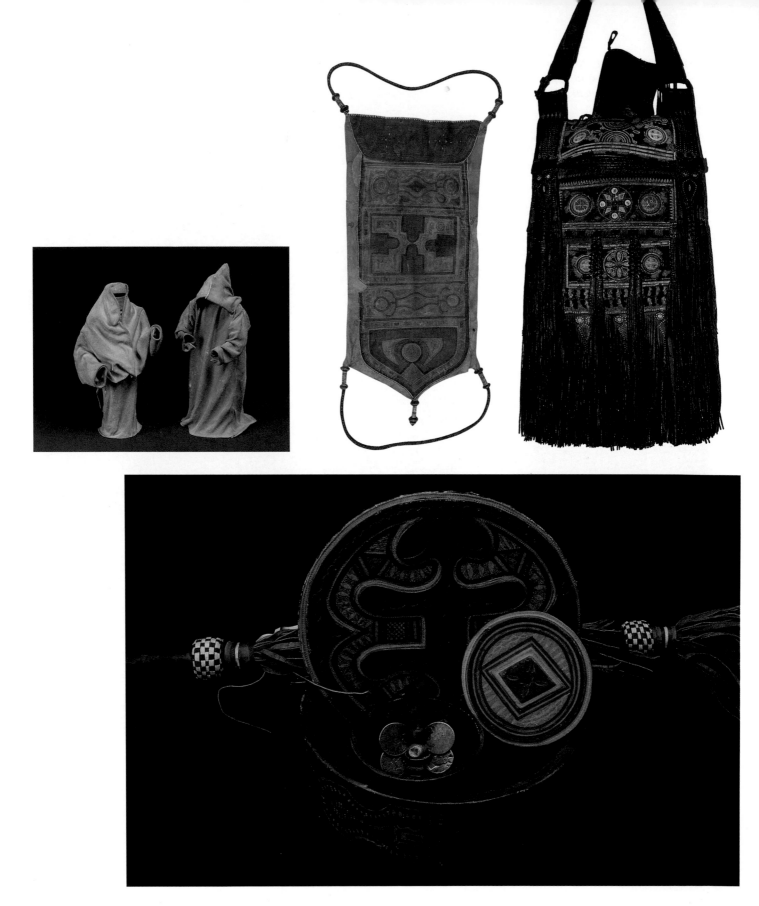

99 OPPOSITE, TOP LEFT *Two leather figures by a contemporary folk artist from Marrakesh.*

100 OPPOSITE, TOP CENTRE *Early 20th-century provision bag from the Layoune region south of Goulimime, made of soft leather, dyed, painted and with appliqué embroidery.*

101 OPPOSITE, TOP RIGHT *19th-century* choukara, *a man's fine leather bag; the silk embroidery would have been done by women, one of the few instances when they are involved in leatherwork, an almost exclusively male domain.*

102 OPPOSITE, BOTTOM *19th-century painted leather assortment with camel stick, jewelry boxes and talisman.*

103 ABOVE *Late 18th-century flintlock musket inlaid with ivory, silver and iron, with leather paraphernalia. Weapons were often elaborately decorated, due largely to the fact that it was the wealthy members of society who could afford them, or who required them as a symbol of power and wealth.*

104 RIGHT *Iron grilles are a very common architectural feature in both rural and urban environments; they can be used in balustrades, windows and partitions, with a variety of spiral, foliated scroll and ring designs.*

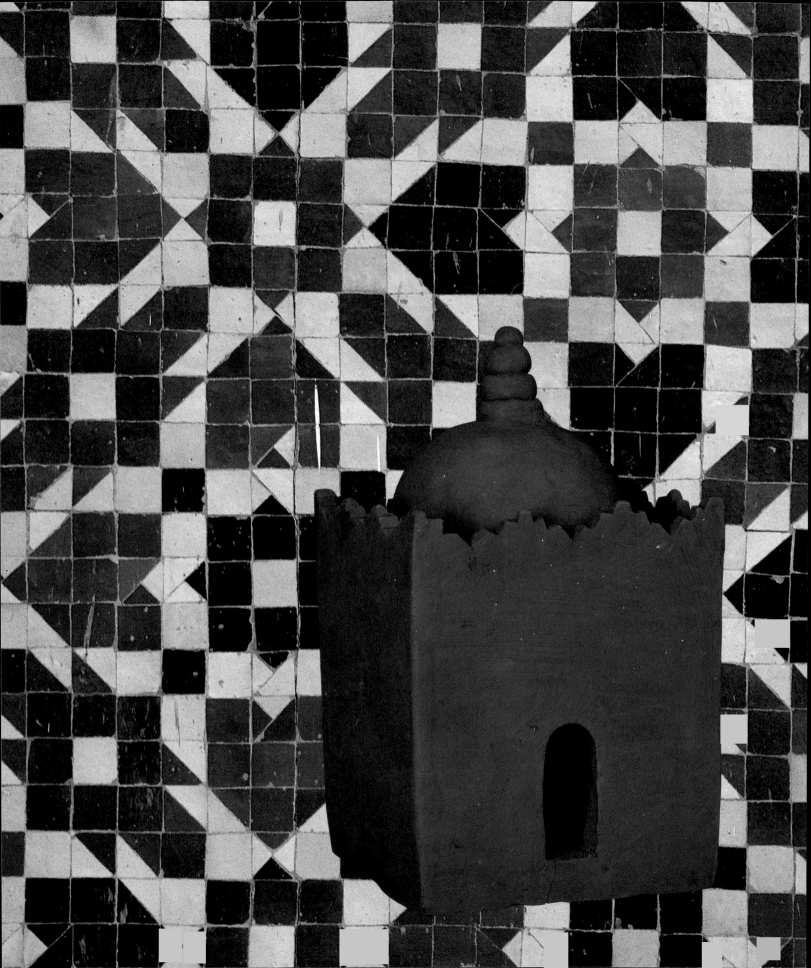

CERAMICS

O water-bearer, from where, from where
Do you carry your earthenware?
O let your glances stray
This way, this way.

Moroccan love song

The art of making vessels and objects from clay is one of the most ancient, and in some cases can be traced back to the beginning of known human civilization. Throughout history, men and women of many different cultures have created seemingly endless shapes and sizes for these vessels, decorating them in as many different ways.

There is ample archaeological evidence to suggest that in Morocco the Berbers shaped clay by the hand-coiling technique, a method common to many parts of the Mediterranean during the neolithic epoch. The Carthaginians revolutionized this tradition when they introduced the use of the wheel to North Africa. Pottery that was turned on the wheel was slowly adopted in many areas, eliminating the old techniques of hand-coiling. This affected much of the Mediterranean, but the Maghreb alone preserved this ancient method, still practised today.

During the Roman era, the use of terra sigillata for making pots with stamped designs and a clear glaze was quite common until the seventh century, when the Byzantine Empire collapsed and the Arabs invaded. Due to little archaeological evidence, it is unclear precisely what happened in ceramic production in Morocco between then and the ninth century; it is certain, however, that the technical expertise and knowledge of glazing with the use of lead oxides, which had grown with the influx of artisans from Moorish Spain and the East, had a great impact on the development of glazed and enamelled earthenware in Morocco. According to Arab accounts, the advent of glazed ceramics in Morocco, at least for culinary use and tableware, occurred after the year 814, which is when Moulay Idris II, son of Idris I and a descendant of Ali and Fatima, the daughter of the Prophet Mohammed, elected to welcome eight thousand families seeking refuge from the Emir of Cordoba in Spain.

The Andalousi immigrants, many of them skilled artisans in pottery and glazed ceramics, were assimilated easily into the Fez populace. From this period until the Almoravid dynasty, during the eleventh and twelfth centuries, there was a great deal of experimentation in the techniques of glazing ceramics, demonstrated by the variety of pieces that have survived from this time.

105 BACKGROUND *19th-century* zillij *(cut tile) mosaic from Meknes. It is thought that this tradition, which continues to thrive today, might originally have been influenced by the stone and glass mosaics of the Byzantines, as well as by techniques from Moorish Spain.*

106 INSET *Contemporary clay folk art* marabout *made in Ourika.*

From the late twelfth century until the fifteenth, a new art form grew in popularity and prolificacy: the making of mosaics from polychrome cut tiles, called zillij. It started in Fez, with artisans specializing in this craft decorating the walls of mosques and the private villas of the Fassi (the wealthy class), and the practice later spread throughout Moorish Spain. There is some dispute over the origins of this kind of mosaic; many scholars agree that it was probably influenced by the stone and glass mosaics of the Byzantines, with the adoption of tiles occurring later. The tradition, which was at its peak between the tenth and the fourteenth centuries, is just one example of the exchange – both technical and artistic – of knowledge between Morocco and Andalusia during this period.

Contemporary zillij from Meknes.

According to one account written in the eleventh century, the Emir Youssef Ben Tachfin, founder of Marrakesh and a great patron of artists, went to the aid of the Emirs of Seville and Granada around the year 1000. They were under threat from the King of Castile; the veiled warriors of the Almoravids defeated the enemy and saved the Spanish Emirs. As payment, Tachfin requested the Andalousi artisans who had made the polychrome sgraffito plates from which he was dining; the Emirs responded by sending these craftsmen and their families to Marrakesh and there are still artists there today who claim to be descendants of this human tribute.

The cultural and artistic exchange between Moorish Spain and Morocco from the twelfth century until the fall of Granada in 1492 fostered a tradition of inventiveness, which has long characterized not only Moroccan ceramic tableware and utensils, but also the ornamentation of religious and domestic architecture.

The rural tradition among the Berbers (like other traditions, distinct from urban practices) produces mainly pottery or unglazed earthenware that serves as vessels and containers for food and liquids. They use the natural clay deposits, which vary in colour from place to place, from brown in the north to red and micaceous clays in the south. The mixing of clays also depends on the quality of the earth in each region; some tribes will typically mix two or more clays together, while others may use only one, as it comes when dug from the ground. Among the Zaer (the semi-nomadic tribes near Rabat), the area in which the clay is found is considered sacred, and no other potters are allowed to take even a little: if they do, it is believed that, on the same night of their theft, all their pots will be broken by evil forces in retribution.

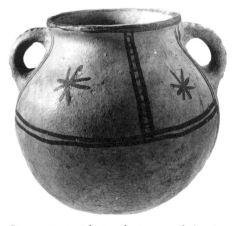

Storage pot with star designs made by the Ait Atta in the southern Oasis region.

The clay is often worked just as it is, or it may be mixed with additives such as straw or ash, to achieve a more standardized body. A series of white slips (clay mixed with water) can be added to the vessel as it is being made, after which it is fired, producing a white pot that can be stunning, especially when painted. This ancient technique is still in use today in the Rif, as well as the

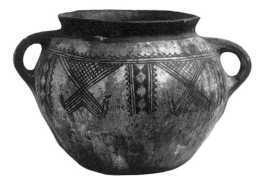

Early 20th-century storage pot from the Tsoul area.

Early 20th-century pitcher from Sless in the Rif region.

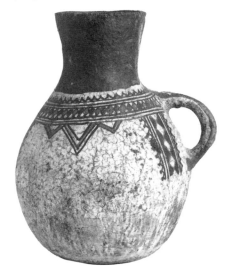

Taza, Zerhoun Massif, Middle Atlas, and the southern regions such as Sous, Dra and Tamgroute.

The Berber tradition was and is still practised primarily by women, who use the hand-coiling technique; the men tend to use a lathe as a wheel, turning it with one hand, while shaping the piece with the other. The techniques for preparing and decorating pottery are the same, however, for both the men and the women. The majority of objects made are utilitarian, but the difference lies in the fact that pots made by women are mainly for use by the family, and those made by men are transported for sale in the city souks. The methods and tools employed are extremely simple: the Berber woman, while sitting in front of her house or tent, cleans, crushes and moistens the clay with water and then adds ash or straw as a temper. An overturned platter is used as a stand upon which the clay is placed and then shaped with simple instruments, such as a flat pebble, wooden comb or a spoon. Once the clay takes shape, and is smoothed by hand, the piece is dried in the sun, then put into an oven, which is usually a bread oven, or simply a pit in the ground. After the first firing, the pots will be decorated with paints made from vegetable dyes, ranging from red to yellow ochre. The second firing of the piece is to fix the colour. The designs used are ancient in origin and similar to those found in other traditions: that is, primarily geometric patterns and zoomorphic symbols, such as tattoos, snakes, hands, eyes, as well as olive pits and seeds, which are familiar motifs in agrarian traditions. In many areas, women will assist the men in the selection of the designs, as their knowledge of occult sciences and magic, and their symbols, is on the whole greater than that of the men. However, the women rarely participate in the actual decoration of pottery produced by men.

There are marked similarities betweeen the pottery of Morocco and that of ancient Greece and Carthage. In fact, the shapes of the vessels made in the Rif look almost exactly like ancient Carthaginian pots. Pieces from the Middle Atlas are even more reminiscent of the shapes of ancient Mediterranean pots, noticeably in the design of the belly, neck and mouth, and in the designs of zigzags, chessboards, rows of triangles and lines with eyelash motifs – designs that can be dated back to the sixth century BC and that are in fact still used by many Berbers. Much of the pottery in the southern regions of Morocco is very similar to that of sub-Saharan Africa, while the pieces found around Tamgroute – pots of a deep brown, with large bellies, wide necks and handles – are reminiscent of pottery styles in Nigeria.

Sheer necessity determines the production of pottery for the Berbers. Their food and tea is heated on a clay brazier and served in clay bowls and plates, with similar containers for liquids. They eat from a large communal vessel, which is cone-shaped with a lid. A typical Moroccan meal, a stew of beef, mutton and vegetables, is known by the name of this dish – *tajine* – in which it

is prepared and from which it is served. Berbers refrigerate their food by putting it in clay vessels that are placed next to jugs containing water in a hole dug in the ground. As the clay is porous, the water seeps out and evaporates, cooling the contents of the food container.

There are a variety of vessels commonly found among Berber tribes. One is a simple butter pot, the *guerba*; milk is poured into it and the pot is then placed on three poles and supported by string, like a sling, and swung back and forth to produce the butter. Other typical vessels are large containers, jugs for oil, grain or dates, drinking cups and milk pitchers. There are also different plates for kneading bread, as well as couscous steamers, oil lamps, incense burners, candlestick-holders and drums (*darboukas* and *guedras*).

Pottery is as integrally involved with the Berbers' beliefs in magic and the supernatural as are other traditions discussed in this book, both in the making and in the function of the object. The designs characteristic of Berber pottery – used for their prophylactic properties – protect both the potter and the pot itself from evil forces. The making of pottery is concerned with the attainment of baraka and the spiritual world from the beginning of the process. The clay is extracted from the earth, where the djoun reside, which, added to the fact that fire and water are used in creating the vessel, induces a certain respect in the artisan. This is because, as among the metalworkers and jewelry-makers, fire is seen as being related to the devils; in fact, most potters were traditionally feared because of these associations with the djoun and the spiritual world. The significance of water is first and foremost its value in a desert environment, but it is also believed to house spirits and djoun in streams and rivers.

For many Berbers, the style of ceramics in urban areas was always considered too gaudy and effeminate for these men of the desert, whose ancestors reputedly praised only two acts: war and the making of pottery. While Berber villagers mainly decorate the wooden shelves in their kitchens with the wares they have made, nineteenth-century examples show that ceramic pieces were bought by the Berbers in the cities and repainted with dots, lines and chevrons over the polychrome designs.

The pots and vessels can often be used for their prophylactic function alone. For example, in the Rif, miniature versions of the plates and bowls of the potters' repertoire are made annually and hung on the wall of village houses to ward off the evil eye and the djoun. Also, in the Middle Atlas, Berbers place a couscous steamer on top of a long tent pole and then push it off. If the vessel breaks into only a few pieces, the year will be good and the fields fertile; if, on the other hand, the piece is pulverized, the winter will be severe and hard times will ensue. In other areas, the breaking of pottery at the door of the house is believed to protect a household from sickness and death. It is also believed that if someone accepts a cracked piece, then he or she will burden the bad luck.

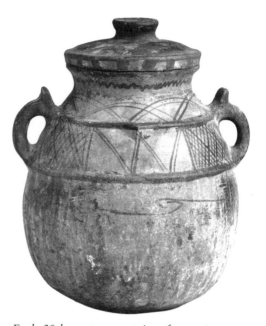

Early 20th-century container for storing water and oil, from the Aghoumi region.

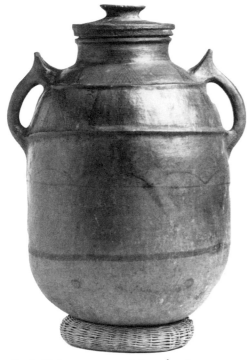

Early 20th-century container for storing water and oil from the Aghoumi region.

For most Berbers, pottery is sacred and their cemeteries are full of many pieces used as markers of the dead. The broken, sharp-edged pieces are thought to protect the deceased from the evil eye, as well as deterring the jackals that roam around these places. In many areas, the oil lamps made of clay and stone also have prophylactic powers, because they are incised with eye symbols to ward off the evil eye. In addition, burning an oil lamp's wick can have uses other than just providing light: it can determine if betrayal in a marriage is near, as well as enhance a marriage union. If the wick goes out, this is thought to signal the end of the relationship, but if it keeps burning, the marriage will last.

In Azzemour, on the northern coast of Morocco, the *darbouka*, an hourglass-shaped clay drum, has always been a sacred instrument and accompanies the magic rituals of many moussems. It was believed that the drum was symbolic of birth, death and every other moment marking the life cycle. There are male and female drums, the former deeper in sound. The membrane covering the top of the drum is the hide of a sheep sacrificed during the great religious festival of Aid-el-Kbir; this celebrates the story of Abraham and Isaac, and the father's obedience to God in his willingness to sacrifice his son. It is a religious holiday for all Moslems and occurs at different times of the year, according to the lunar calendar after Ramadan.

There has been little recognition of the simple elegance of the shapes and designs of Berber pottery in most studies on ceramics. Although pottery is still being made today, many pieces, of the kind featured in this book, are vanishing due to the introduction of new, alternative materials.

CERAMICS

The urban tradition of ceramics – painted and glazed or enamelled ware – is the exclusive province of men. Many of the major ceramic centres can be found within the larger cities of Fez, Meknes, Marrakesh and Safi, or in ceramic ateliers in their environs. There are four main areas of production: the unglazed pottery for domestic, utilitarian use; the plain, monochrome, green-glazed pottery, seen in Tamgroute and Fez and the painted, glazed ceramics used for tableware and architecture, particularly the cut-tile monochrome and polychrome mosaics and glazed roof tiles.

Traditionally, in Fez, the guild of potters produced utilitarian pottery; however, these are now almost obsolete, except for earthenware containers, such as water jugs and cups, which have stippled decorations made with a black resin from the Thuya, a tree found only in Morocco. The resin of this tree has a perfume and taste that repels insects, making such pieces still very much in demand. However, as a result of the general decrease in demand for these vessels, many potters have turned to working for master zillij-makers

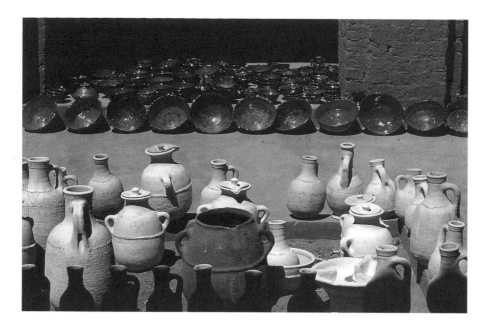

Display of ceramics at Tamgroute.

(*zlayiyyahs*), who are experts in cutting, arranging and laying the cut tiles for the exquisite mosaic patterns one can see throughout Morocco. The zillij-makers' guild (the *hantah*) is under the jurisdiction of the *amin*, as is common in the other guilds for artistic traditions such as leatherwork (see my discussion in Chapter Four). He acts as an administrator and is elected by the maallem and other members of the guild to settle disputes and oversee quality control of the product.

In Fez, the major centre of ceramic production, the guild is comprised of three different kinds of artisan: the *harash*, who makes unglazed pottery, the *zlayiyyah*, the zillij-maker, and the *tallayah*, who produces painted, glazed tableware.

Since the 1940s, some guilds have given way to the cooperative and workshops, which are effectively independent family businesses in areas near the city. In these smaller ateliers, each artisan will probably do a variety of different jobs, but the cooperatives are very much like the old guilds, with each worker specializing in one part of the process. This consists of wedging (working the clay with the feet and hands), throwing it on the wheel, trimming the shape of the pot, mixing glazes, applying the decoration and tending to the kilns. One ceramic pot may pass by several people before it is completed. The traditional artisan, however, works solely on the wheel and creates the form himself, without a mould, and in small quantities.

In all these organizations, tradition has been preserved through the use of the same techniques, forms, artistic vocabulary and marketing. The changes in organization and the demands of the tourist market has also meant that new forms, colours and styles have emerged. Outside Marrakesh, for example, clay sculptures of genre scenes, animals and marabouts are being made alongside the traditional, unglazed water and food containers. Another example of this

trend can be seen at Safi, also an important ceramic centre, where new forms have been created using a combination of Berber geometrical patterns and traditional Islamic designs, with a distinct metallic glaze that gives these pieces a unique quality and character.

The most significant change in the history of Moroccan ceramics in recent times has been caused by the shift to a simpler diet from more elaborate dishes, which were favoured by the richer classes, and which are now nearly obsolete. Much of the tableware, for centuries traditionally used by all classes of people for cooking and for storing food and liquids, is now considered and produced as decorative items only, with innumerable Islamic designs, including geometric, floral, arabesque, paisley and calligraphic patterns. Although they are now rare, they are executed with an overall balance of grace and a meditative spirit that has helped preserve the tradition. Furthermore, the influx from foreign countries of luxurious china and porcelain plates, notably from China, has displaced many traditional domestic ceramics in Morocco.

Some of the more common types of painted ceramics made in the urban tradition are jars, bottles, large soup tureens, butterpots, inkstands and oil lamps. Others include pitchers, plates, honey or storage pots) and the perfume bottles for flower essences.

Traditionally, the Moroccan artist used three base tones of glaze in green, yellow and brown, which were painted on red or buff-brown earthenware after a white slip had been applied. The yellow, from antimony and silica, green, from copper oxide, and the brown, from iron oxide and water, as well as a mixture of minerals with manganese, are used for the glazes. The other coloured glazes were made of lead oxide with an addition of tin or nickel. The appearance of polychrome decoration on a white or brown background was common until the end of the twelfth century. There is documentary evidence of the use of blue in the thirteenth century, which continued until the eighteenth; the blue was added to the palette, but it was of a softer grey-blue (similar to delft blue). By 1853, a cobalt blue with less nickel had appeared, introduced by Fassi merchants living in England, which was much more dramatic in colour than the pale blue of the Merinid dynasty (1269–1465) in earlier pieces, and, although the colour is still used today, the original composition of the blue, from smalt powder, has been lost. The range of colours that can appear when the glazes are applied, and the technique of firing, are not always consistent, and the outcome is often unpredictable.

Many contemporary pieces consist of blue designs on a white background, or motifs, outlined in blue or brown, filled in with yellow and green; they can also have a brown base, with no white slip, and yellow–green designs. Unfortunately, it is difficult to determine precisely the historical origins of older glazes and colours, which can only be done by scientific analysis.

19th-century photograph of a fountain in Fez, showing exquisite zillij designs.

The zillij tradition has probably enjoyed one of the most important advances in the Moroccan ceramic tradition. The quality of execution of these jewelled cut tiles can be seen in the mosques and *medersas* of Morocco, and in the floors, dadoes, columns and fountains of private homes. As I mentioned earlier, the apex of this tradition, with its centre at Fez, probably dates to some time between the twelfth and fifteenth centuries. The earlier form of this mosaic was probably a monochrome tile arranged in geometric patterns. The form practised later in Fez was executed by cutting out curvilinear and rectilinear shapes from a glazed panel; the skill lay in the conception and in the placing of these pieces into the elegant patterns of Islamic design. Another method, practised in Tetouan, and probably Andalousi in origin, is to cut the individual tiles first, and then glaze and fire them. The Moroccan government has helped preserve this tradition by commissioning zillij-makers to decorate public buildings, mosques and the private homes of ministers and royalty with the result that it is now reaching other parts of the Moslem world.

This century has brought many changes to all traditions in Morocco – changes of organization and changes to the function of the objects produced – but the introduction of foreign luxury items and new styles and colours, all of which have had an impact on ceramic production, have not prevented it from being one of the most successful of Morocco's artistic traditions in continuity and creativity.

107 OPPOSITE *Early 20th-century Zaer-Zaine storage container, with necklace design and chin tattoo. In this area, clay is believed to be sacred and forbidden to potters other than those who inhabit the region; the theft of the clay from the earth (where the* djoun *are believed to live) by those unentitled to it will cause their pots to break.*

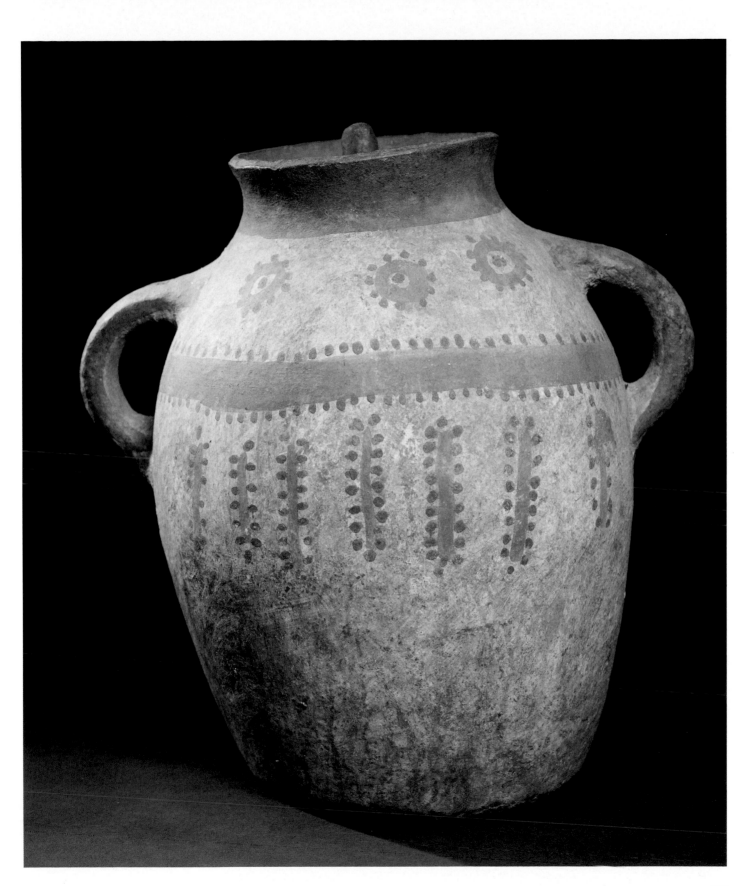

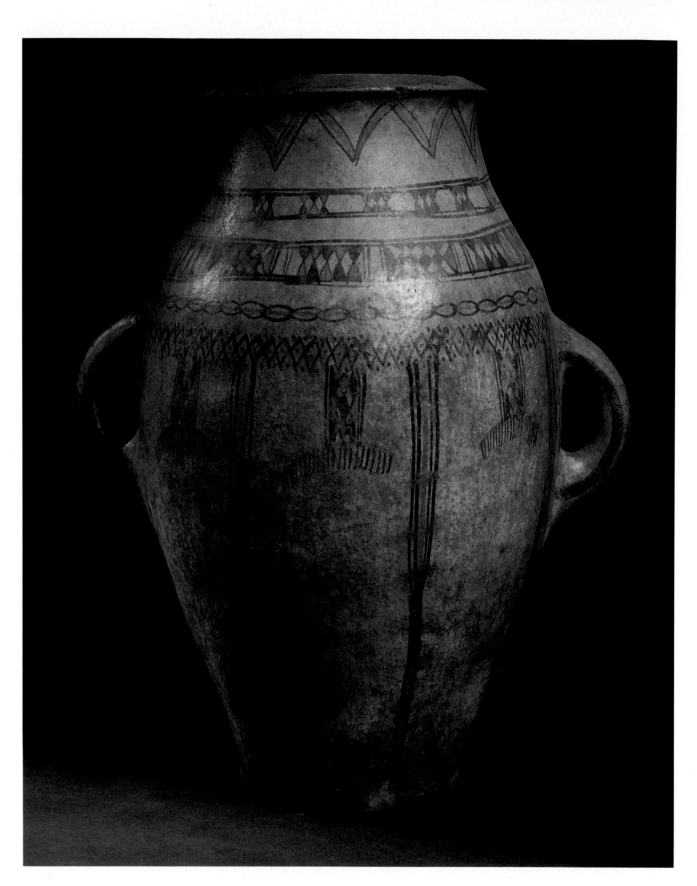

108 LEFT *Late 19th-century oil and water amphora made by the Ait-Bou-Chrik in the Rif region, where ancient methods of pottery have been preserved; the clay can be used just as it is found in the earth, or it can be mixed with another clay, or straw and ash, for a firmer consistency. A series of white slips (clay mixed with water) will be added to the vessel as it is being made, before it is fired.*

109, 110 BELOW AND BELOW RIGHT *Early 20th-century pots by the Beni Mesguilda in the Rif region. Pottery is an essential part of Berber life: their food and drink is heated on braziers made of clay, and served in clay bowls and plates.*

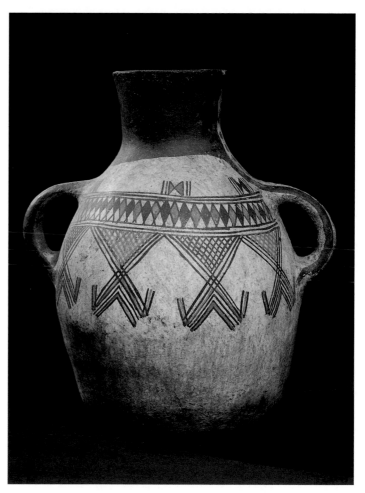

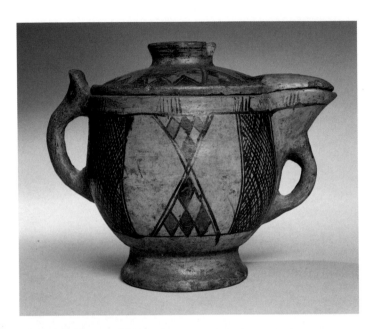

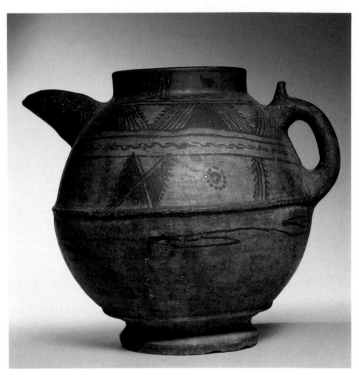

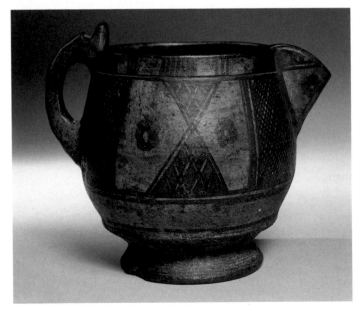

111, 112 LEFT AND LEFT, BELOW *Two late 19th-century Berber micaceous clay milk pitchers from the Tsoul region near Fez.*

113 ABOVE *Late 19th-century large pitcher in micaceous clay from the Foum Zguid region near Ouarzazate.*

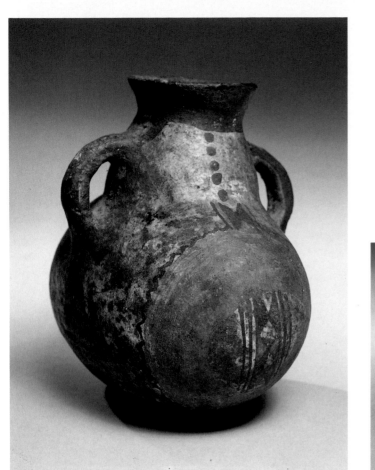

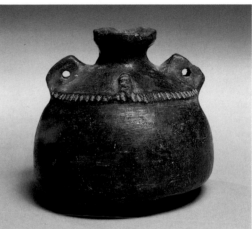

114 ABOVE *Late 19th-century small butter container from Chechaouen in the Rif region (see Plate 124).*

115 ABOVE RIGHT *19th-century inkwell from Tamgroute in the south. Pottery from this area is reminiscent of sub-Saharan African styles, especially Nupe in Nigeria, where vessels tend to be squat and unglazed with wide necks and handles.*

116 RIGHT *Early 20th-century pot made by the Ait-Bou-Chrik in the Rif region.*

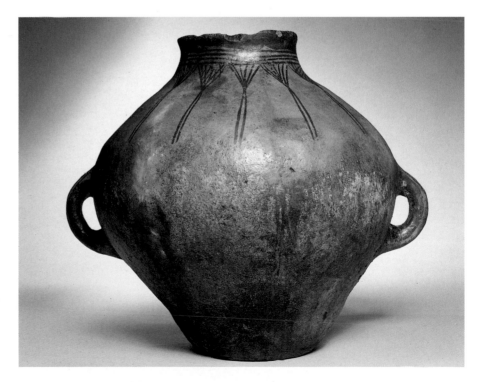

117 RIGHT *Two 19th-century milk pitchers, the left made by the Beni Ouriaghel and the right from the Tsoul area.*

118 RIGHT, BELOW *19th-century storage pot from Zerhoun, an area which, like the Rif region, still uses ancient pottery techniques.*

FACING PAGE *Green is one of the three base tones of glaze used by Moroccan potters, especially in the cities. The others are yellow and brown.*

119 TOP *19th-century pitcher from Tamgroute.*

120 BELOW LEFT *19th-century pot for storing honey.*

121 BELOW RIGHT *18th-century bowl from Fez.*

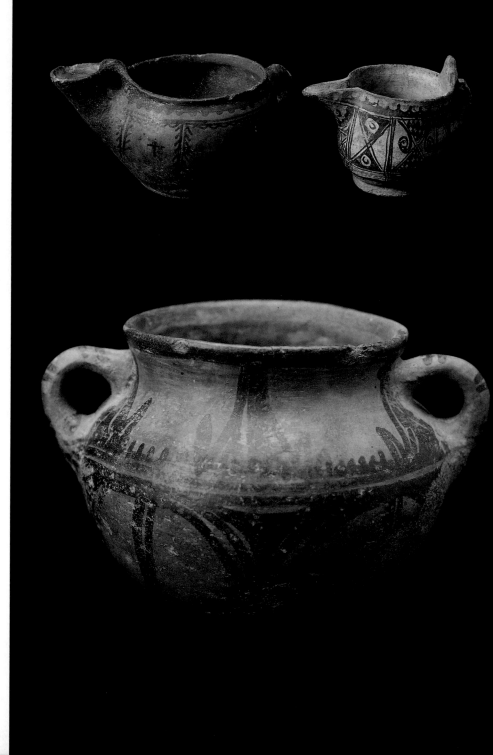

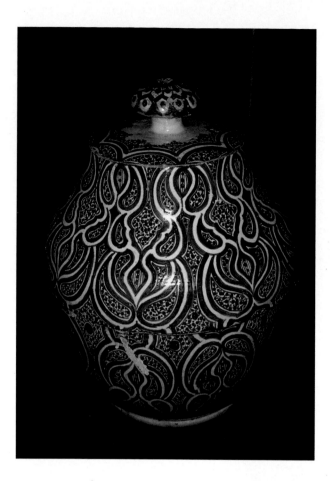

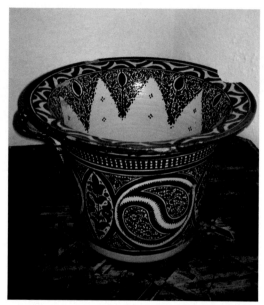

122 LEFT *19th-century soup tureen from Fez, the centre of ceramic production, where the guilds are comprised of three types of artisan: the* harash, *who makes unglazed pottery, the* zlayiyyah *(see Plate 135) and the* tallayah, *who makes painted, glazed tableware.*

123 BELOW *19th-century monochrome bowl.*

124 RIGHT *19th-century* guerba. *This is a pot to make butter: the milk is placed inside the pot, which is then placed on three poles and supported by strings, like a sling, and swung back and forth to produce butter.*

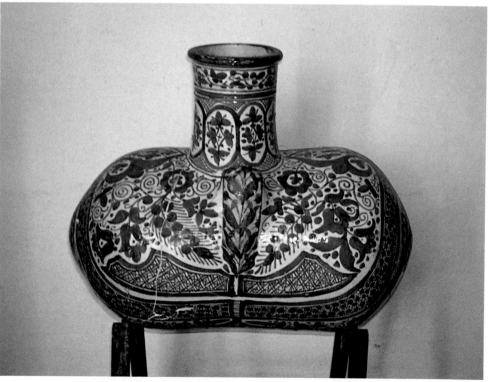

125 FACING PAGE *Shop in Meknes selling contemporary ceramics; the urban pottery tradition – that is, painting, glazing and enamelling – is practised exclusively by men. Nowadays, such highly coloured pots are far more common than the plainer, earthenware pieces made for solely utilitarian purposes.*

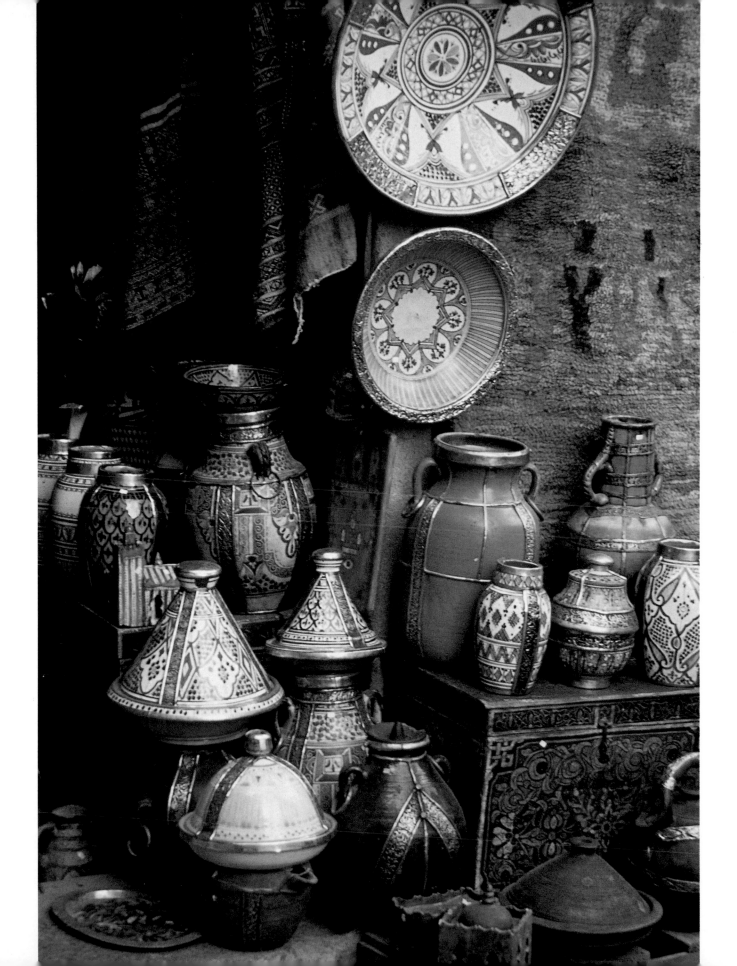

126 BELOW *Potter in Ourika working on the wheel.*

127 RIGHT *Pots on a bench in Zagora, east of the Anti Atlas.*

128 BOTTOM *Potter's atelier in Marrakesh.*

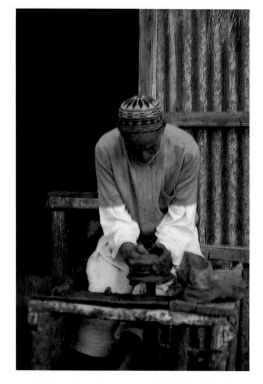

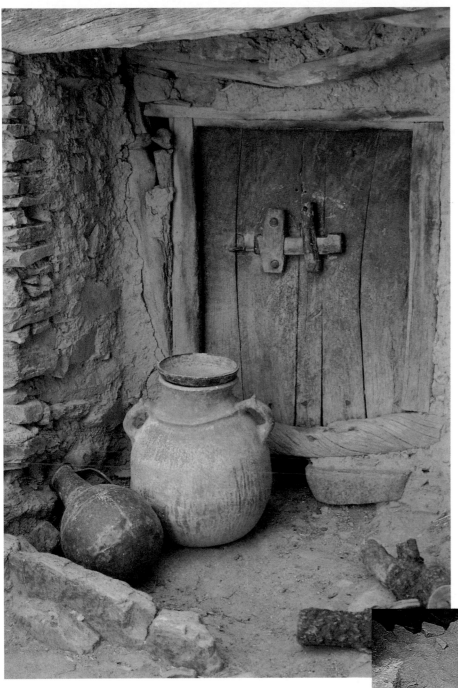

In the pottery guilds of the cities, each member will specialize in one area of the process, whereas the traditional artisan will produce the whole piece himself. In rural areas, the men use the lathe to produce pots for sale in the city souks, while the women, who make pottery for domestic use alone, employ far more basic tools, mixing the clay with water, adding straw or ash for consistency, and shaping the whole with a stone or a wooden spoon.

129 LEFT *Earthenware pots in Tafroute.*

130 BELOW *Front of a potter's house in Taoura, a village in the Anti Atlas.*

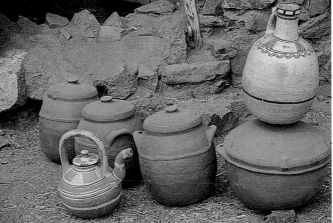

131 LEFT *19th-century polychrome cous-*
cous bowl from Meknes.

132 LEFT, BELOW *19th-century polychrome*
plate from Fez.

133 RIGHT *19th-century polychrome plate*
from Fez.

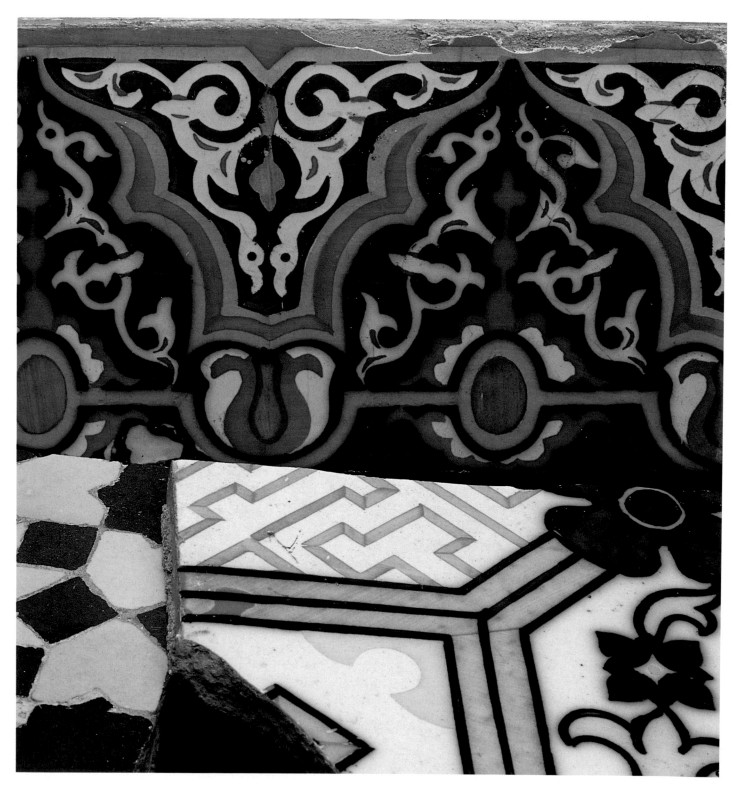

134 LEFT *Tile collage.* TOP *18th-century tiles from Marrakesh.* BOTTOM LEFT *19th-century fragment from Teluet.* BOTTOM RIGHT *Contemporary zillij (cut tile) from Meknes.*

135 RIGHT *Artist working on zillij in Meknes. The pottery tradition is gradually diminishing in Morocco, with the advent of new storage materials, such as plastic. As a result, many artisans who previously worked in pottery have become* zlayiyyahs *(zillij-makers).*

136 BELOW *18th-century zillij panel from Fez.*

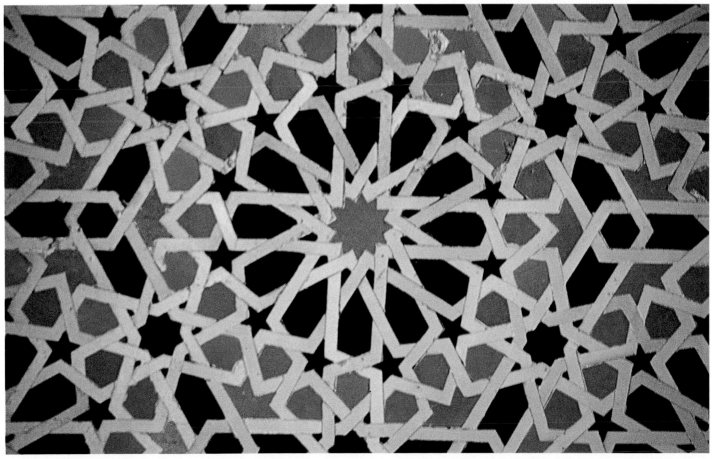

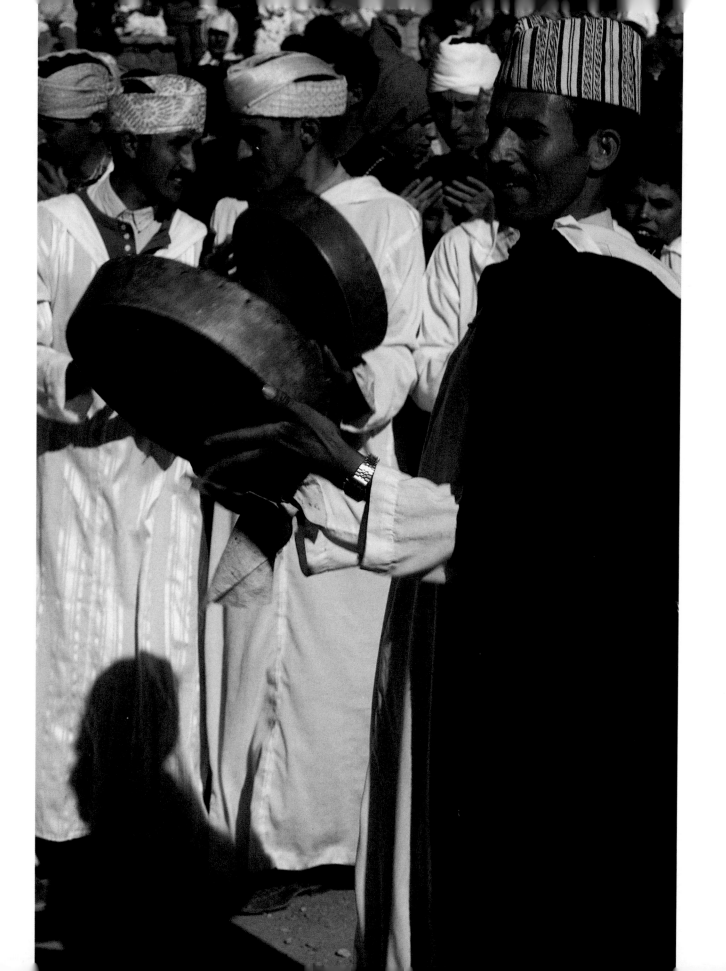

CHAPTER SIX

CEREMONIES AND THE CELEBRATION OF LIFE AND DEATH

Eight yards from us, in an indescribable gesture, all the guns were thrown above our heads. The sun shone on arms, on shoulder belts, on jewels: we could see the transient sheet of fabrics, of embroidered saddles, of gold stirrups and bridles; they flashed past us in a general volley that left us covered with powder and that wrapped them in white smoke.

Fantasia for Moulay Hassan, a Moroccan saint

The artistic traditions of Morocco discussed in this book are seen at their most vibrant in the personal, religious and communal activities displayed at the moussems, the festivals (both spiritual and economic in intent) that are celebrated with music, dancing and special markets where everything from camels to jewelry is sold. These are events showing popular culture at its best. The customs one sees observed at the moussem are based on Sufism, the mystical aspect of Islam that centres around the cult of the saints, the concept of baraka and the practice of rituals intended to cure illnesses and disease. The essence of Sufism is the belief that the individual Moslem is capable of achieving direct and personal communication with God. Through a saintly master, or a marabout (a French word derived from the Arabic *murabit*, meaning 'a man tied to God'), one is able to receive a state of baraka, and transmit it to others.

Sufi brotherhoods were founded by the marabouts and their followers all over Morocco in the twelfth century, since when they have had a strong and continuing sociological, religious and political influence on Morocco. Sufism is especially prevalent in the rural areas, far away from the people of the cities, where the laws of Islam are more strictly enforced. For the Berbers, Sufism offered a richer, more accessible, and new kind of communal experience, and although this cult of the saints was undoubtedly a characteristic of Berber life in pre-Islamic times – their use of magic in healing, for example – it was later incorporated into the more orthodox Islamic tradition.

There are hundreds of saints, both living and dead, venerated by the people of Morocco in the cities and the countryside, as each town and district, and every tribe, is under the protection of a local saint who plays an integral part in

137 *Festival choreographer and men playing the* bendir *(drum) at Azilal in the High Atlas region.*

the life of the people. However, many people attend the festivals purely for commercial reasons, arriving on camels and donkeys laden with vegetables and pots, with textiles and jewelry for sale.

There are tombs right across Morocco that are revered as shrines and places of individual or communal pilgrimage. Almost every tomb is considered a potential location for a moussem, of which there may be twenty to thirty a year in any one area. The sights and sounds of these festivals – the polyrhythmic sound of the musicians, the chants of the bejewelled Berber women, the Andalousi-Arab love songs, the daring feats of horsemanship in the fantasia (the equestrian games), not to mention the spectacular feast of colourful costumes, lavish jewelry, ivory-inlay weapons and exotic musical instruments – are reminiscent of medieval processions in honour of the sultans.

Today's festivals provide a respite from the daily labour of the countryside and an opportunity for people to meet friends and family from other villages, to eat, dance, play music and sing. It is a time to discuss and arrange family matters, agricultural problems and, most importantly, to make pilgrimages to the saints' tombs.

The saints are a means of contacting the evil forces causing illness and death, and are also believed to have a positive power over fertility and creativity. Most people go to the religious brotherhoods and the saints for exorcisms and for repairing the harmful effects that might already have been caused by the evil eye. These rituals are performed during the moussems. The tombs of the saints are usually near freshwater springs, and the remedy may be simply bathing in and drinking the curative waters. Other maladies might be treated with herbs and a host of incenses, amulets and talismans. An individual might also communicate with the saints directly through prayer-induced dreams. Every week, from Thursday night until sunrise on Friday, the dead saints, believed to be merely asleep, are available spiritually through dreams for consultation and healing.

The prayer for cures or related information is called *istikhara*. It is said, in addition to healing, for making important decisions, such as marriage.

The cult of the saints also plays a major role in the realm of the development and practice of artistic traditions, each one of which has a patron saint. Some traditions are protected by the same saint throughout Morocco – for example, all woodworkers revere Sidi Noh – but each artisan will also invoke any number of the local saints in mastering a particular craft. Some Berber women, who spin and weave the wool for rugs and blankets, told me that it is important to acknowledge the local saint in order to receive his help: they pray, 'Spin, spin, my little distaff, God and his envoy watch over thee.' In southern Morocco, the implements used by the spinners are dedicated to Sidi Embarak Derraz. These implements, and the loom itself, are supposed to have been a present from Allah

to Fatima, who is revered as the mythic ancestor of women and a symbol of femininity. Other weavers in Marrakesh are dedicated to Sidi Bel Abbes; they make pilgrimages to his shrine outside the city, where they leave a distaff they have spun as an offering.

For Moroccan women, visiting the marabout for prayer and receiving baraka is a profound religious experience. It is a time to ask questions and meditate upon fertility, health, creative inspiration, or indeed on any problems in their lives. Each woman might take away with her some of the dirt from the shrine, and place it on the rug she is weaving. The marabouts attain their status as holy men by acquiring baraka themselves, or by inheriting it from male ancestors or relatives; they have the same prestige and power whether alive or dead.

It is believed that the living saints in the Sufi brotherhoods receive baraka from Allah and act as his mediators on earth. They are sometimes called *walis* (friends of God). *Sharifs* are the descendants of Mohammed (they include the King of Morocco), and are endowed with sainthood and revered throughout the country as receiving their power directly from their ancestor. Marabouts and *sharifs* are found among both Berber and Arab peoples.

The procession to the marabout, in which the gift is carried to the saint, is an integral part of each moussem. For example, during one of the most elaborate

A marabout at Settat.

festivals, at which Moulay Idriss is worshipped, an enormous carpet is carried above the heads of the religious brotherhood as the gift.

There are accounts of brotherhood rituals that relate the self-infliction of wounds, the inducing of trance states through the playing of hypnotic music, dancing or drumming, in order to get the invoked spirit to speak, as well as reports of tongues and cheeks being pierced with daggers, ordeals by fire and the sword, and the eating of broken glass, serpents and scorpions. The most famous religious brotherhoods are the Aissaoua, Hamatcha, Gnaoua, Jilala and Dergaoua, who travel across the country. Each brotherhood reveres a patron saint: the Aissaoua, for example, revere Sidi Ben Aissa and the Hamatcha worship Sidi Ben Hamadu. Most of the professional snake charmers found in the markets are members of the Aissaoua brotherhood (snakes are greatly revered in Morocco and used in many aspects of magic and healing).

Many moussems are held around the religious holidays, such as the Mouloud (the Prophet Mohammed's birthday), Ramadan, the harvest and other special occasions, such as weddings. The largest moussem reveres Sidi Ben Aissa, and is celebrated on the Mouloud with a spectacular fantasia, music and dancing. It was traditionally the principal gathering of the Aissaoua; however, the Moroccan government has effectively subdued their more extraordinary performances and ordeals.

Ramadan, a thirty-day fast for all Moslems, in which eating and smoking are allowed only between sundown and sunrise, is the time when believers purify their minds and hearts, allowing greater access to Allah's words and blessings. If one observes the fast faithfully, it is believed to be thirty times more beneficial than fasting at any other time of the year. The night of the twenty-seventh day of Ramadan is known as *Laydatel kdar* (the night of fate). This is the moment when the course of the next year of a person's life is determined. It is considered the holiest of nights, but also the night that 'Those Others' – the djoun who have been lurking in their underground habitat – will be released on the earth's surface for a few hours. The women in most Moroccan households take precautions not to let them enter their homes, and the way in which this is effected depends on the believer and the family. The principal means is by fumigating the house with various kinds of incense (myrrh, sandalwood and *djaoui*, a black incense), aloe resin, crystals and seeds, such as coriander and lavender. The women are the most knowledgeable about which incense will repel the djoun and which will be beneficial to humans.

The most famous Berber moussem, where marriages are arranged, is located at Imilchil in the Atlas Mountains, held around late September by the Ait Haddidou and their subclans. In Tan Tan, in the south, the moussem that reveres Sidi Mohamed Mael Ainin involves a pilgrimage with camel sacrifices and *guedra* dances. There are different kinds of harvest moussem in Morocco;

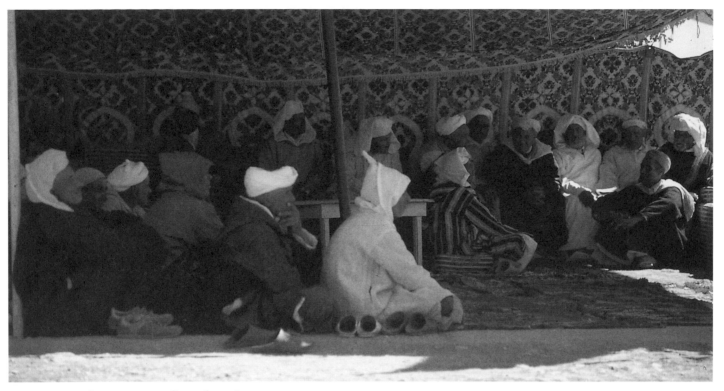

Men sitting under a tent, attending a fantasia for Moulay Hassan at a moussem in Sefrou.

they include the almond blossom festival in Tafroute, the date festival in Erfoud and the rose festival in El Kelaa and M'Gouna, east of Ouarzazate.

The performances of folkloric music and dance are the highlights of these festivals, regardless of their religious or commercial intent. The people of Morocco have always had a keen sense of rhythm that is most powerfully expressed in the songs and dances performed by the locals of the tribe, or by professional musicians (called *imdyazens*) from the Rif and Atlas areas. They can express joy, love, wellbeing and abundance, as well as birth, death, warfare and the reverence of nature in this mingling of long laments, poetic songs and staccato rhythms.

Most music in Morocco can be identified simply as an inheritance of the Arab-Andalousi, Berber and Jewish traditions. Morocco's classical music comes from the Arab-Andalousi tradition, founded in the tenth century by an Arab musician, called Ziyab, living in Moorish Spain. This music went into exile along with the Moors and remained with them in Morocco. Its complex musical form is called *nawba*, a series or suite of songs composed in the same kind of arrangement and grouped together in various movements according to a pre-established order characteristic of Arabo-Moslem music. The movements grow progressively in intensity and length from the middle to the end, similar to the Indian ragas of Asia. The poetry set to Andalousi music is called *muwassaha*, whose sentimental tone and instruments were adapted by the medieval troubadours. Some of the instruments common to the Arab-Andalousi tradition are the lute, flute, oboe, fiddle, violin, tambourine and various drums, such as the *darbouka*, the ceramic hand drum described in Chapter Five. The *rebab* (fiddle) is played by the leader of the orchestra and is

regarded as the most ancient and honourable of instruments. The Jewish tradition preserves songs and ballads from medieval Spain that are performed in the marriage ceremony even to this day.

The musicians are required to follow certain customs peripheral to Islam in every aspect of their performance, even in the handling of their instruments, as some Arabic music (the *nawba* for example) belongs to the djoun. Bahr'sme, once a famous professor of music, is a well-known djinn. Popular legend has it that because of his lax morals and blasphemy he was turned into a pig-headed cat. He is very rarely seen, except on the first Tuesday of the month, but he can manifest his power whenever his music is played at the wrong hour of the day.

Berber music is part of an ancient tradition and has always been more of a communal event, with its various forms of dance heightened by a state of trance. In the northern region, some Berber music has adapted itself to the Arabic musical tradition, while in the southern regions, there is a strong influence from Black Africa. Rural music is more percussive, its myriad rhythms coupled with unique vocals and the common yodelling or *you yous* that are a common expression of Berber women, audible as they work in the fields or wash clothes near the rivers.

Man playing the oboe (ghaita) *at the date festival in Erfoud.*

The most important musical instrument for the Berbers, however, as in so many parts of Africa, is the human body: chanting, singing and clapping, combined with dancing and balletic movements of the feet and hands, are accompanied by very few musical instruments. The dances of the moussem, which can take place any hour of the night and day, are often the highlight of the festival. The *ahidous* is a dance performed throughout the Middle Atlas and by the Chleuh Berbers in the eastern High Atlas. Drums such as the *darbouka* and the *bendir*, as well as the tambourine, oboe and flute, are commonly used. The dancers form a large circle and sway rhythmically in time with the *bendir*. They form simple figures, moving backwards and forwards in response to chanted prayers, which the dancers answer in chorus. This dance, which varies in each region, usually marks the end of the harvest and the beginning of the season, in the autumn, of love and weddings. The *ahouach*, another dance, is performed in the southern areas around Ouarzazate and near Imin Tanout, and usually in the light of great fires, going on until dawn. It requires a large number of dancers, drummers and men singing and beating *bendirs*. The women reply to them in a chorus and move shoulder-to-shoulder backwards and forwards, creating a wave-like motion with their bodies and arms, as they praise the spirits of nature. The dance symbolizes life in the pre-Saharan regions, evoking nostalgia for caravans of camels marching through the desert.

Hand-clapping and chanting, combined with playing the drums (the *guedra*, *bendir* and *deff*) – the *ghaita* (oboe), *tbal* (a large drum played with curved sticks) and *gimbrid* (a long-necked lute), are all characteristic activities in

dances of southern regions of Morocco. One well-known dance performed by women in Goulimime, for example, is the *guedra*, named after the drum. The women sing their love songs to its rhythm and clap their hands in syncopation. In the middle of the circle, one veiled woman kneels and begins sensual movements with her hands and fingers, slowly unveiling herself until she falls finally into a trance.

Music and dance also play a vital role in the healing and curing rituals performed by the religious brotherhoods, as they are thought to bring the performer closer to Allah and to help him achieve a state of mystical and religious ecstasy through a trance-like rhythm. The songs and music are irregular and the chanting by the members of the name of Allah, while holding hands in a circle, slowly reaches a crescendo. One of the most famous of these trance music-forms is the Gnaoua. Of sub-Saharan origin, it was brought to Morocco by the various families of black slaves who accompanied Al-Mansour on his return from his victory over Portuguese Timbuktu in the sixteenth century. The characteristic sound is created by the *gimbri*, similar to lutes found

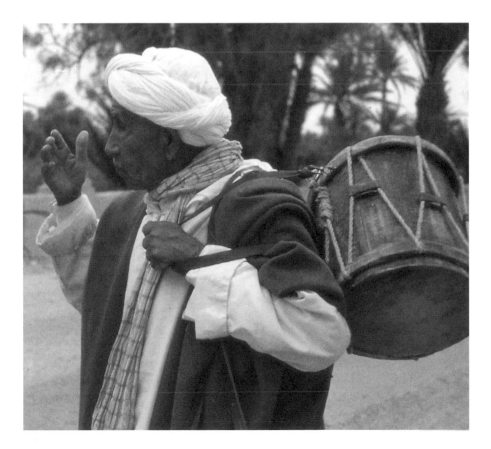

Musician from Ouarzazate holding a tbal, *a large drum played with curved sticks.*

in West Africa, the *qrakach* (a pair of brass or iron clappers played as castanets) and the *tbal*. Most Gnaoua ceremonies involve placating the djoun that have inhabited a person or place, or they can be an attempt to attain baraka from the saint that has been invoked. These rituals are often enacted to cure madness, seizures and scorpion stings.

In Morocco, death is not marked as a sorrowful event, but is celebrated with ancient music and strict rituals. Those who have survived the dead are strengthened by an attitude of confidence about entering Paradise. The Moslem cemetery is not a dreary place: belief in the afterlife has made it a tranquil yet public place. The Moslem communes with the dead by walking freely among them and by sitting on their tombstones; merchants often install braziers in these graveyards and sell tea to passers-by. On Fridays, the holy day, one can see veiled women gather under the olive trees of the cemeteries, talking, laughing and sometimes singing.

At the moment of death, the eyes of the deceased are closed and a few drops of water placed between the lips, a custom born from the belief that a thirsty soul cannot enter Paradise easily. The corpse is then carefully washed, according to set ritual. The Berbers provide a shroud and a pair of trousers, but at the burials of the rich, a complete outfit, including slippers, is used. If the body remains overnight in the house where the person died, scribes are paid to come in and recite the Koran over the body, in order to avert evil spirits from the dead man or woman. The friends and family of the deceased walk behind the funeral procession, singing songs or chants according to each region's traditions. Great care is taken not to come back the same way, and also to prevent the hoes used in digging or filling the grave from touching, as both are thought to disturb the djoun, who might follow them and claim another person for the graveyard. Bunches of wild myrtle are left on the grave and prayers are said by relatives, who eat a meal of bread and dates as they sit around the grave.

Morocco's ceremonial arts of music and dance incorporate many of the other artistic traditions in the celebration of life and death, in both urban and rural environments. The festivals provide a spectacular opportunity to witness at first hand the richness of Morocco's artistic heritage, and its continuing importance in the life of the Moroccan people.

Call for prayer

138 *Musicians from Jajouka.*
Music can play a crucial role in the healing
rituals performed by the religious
brotherhoods, reaching pitches of mystical
and religious ecstasy through the rhythm
and chanting of those taking part.

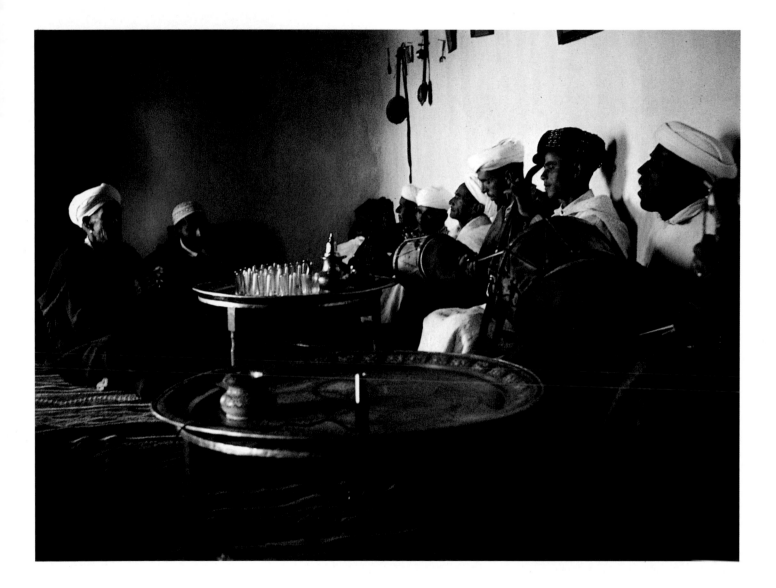

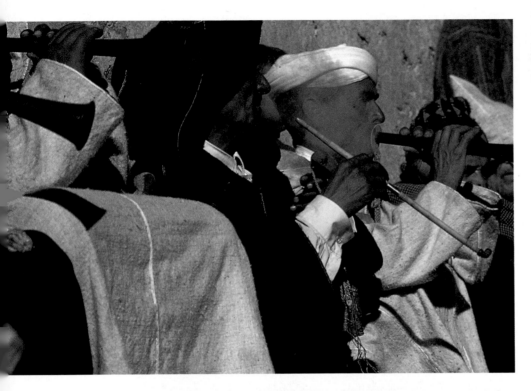

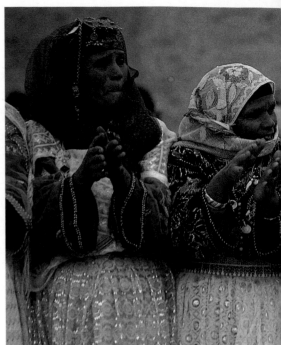

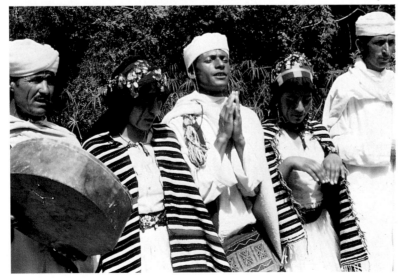

139 LEFT *Musicians in Jajouka.*

140 LEFT, BELOW *People attending an Imilchil (Middle Atlas) moussem, a festival for all Moroccans that is both religious and economic, with music, dancing and souks, where almost anything from camels to carpets can be sold.*

141 ABOVE *People in Ouarzazate performing the* ahaouach. *This is a dance in praise of the spirits of nature and symbolizing life in the pre-Saharan regions: men sing and beat* bendirs, *to which a chorus of women, positioned shoulder-to-shoulder, responds by moving forwards and backwards, making a single, sweeping wave movement.*

142 ABOVE RIGHT *Musicians travelling by bus to the folklore festival at Marrakesh.*

143 RIGHT *A dance troupe in Ouarzazate.*

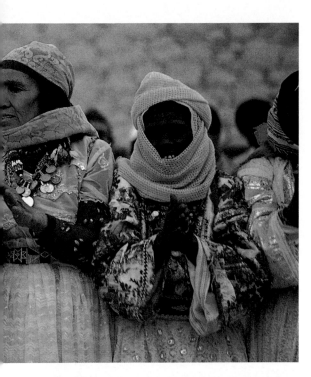

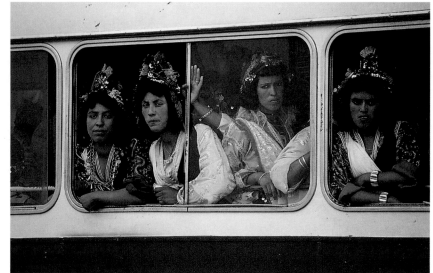

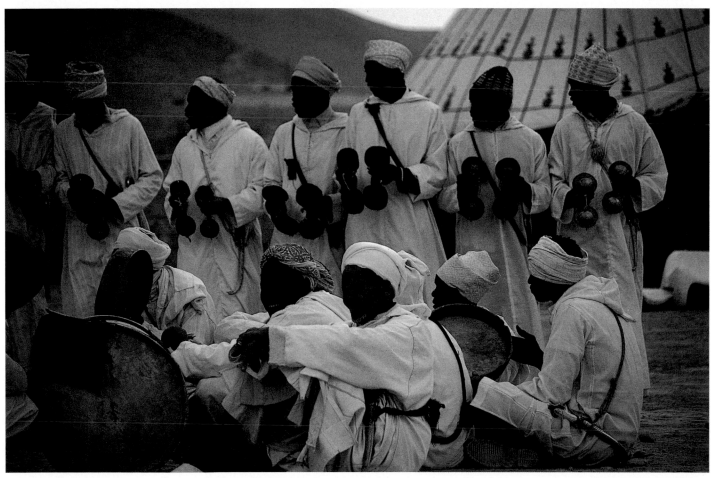

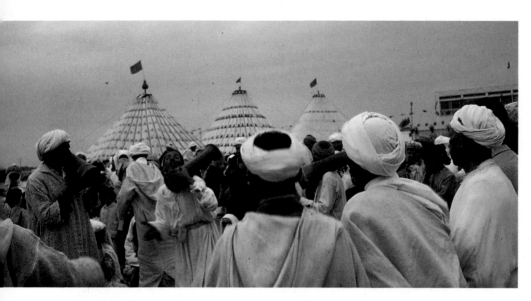

144 LEFT *A* hamadchta (*dance ritual enacted by members of a religious brotherhood in a state of trance*) *in Meknes. The trance is induced through the playing of hypnotic music or drumming, intended to invoke a particular spirit. Other rituals may include the self-infliction of wounds, such as piercing the tongue or cheek with daggers, and eating broken glass, serpents and scorpions.*

145 BELOW *An equestrian fantasia at Sefrou, east of Meknes.*

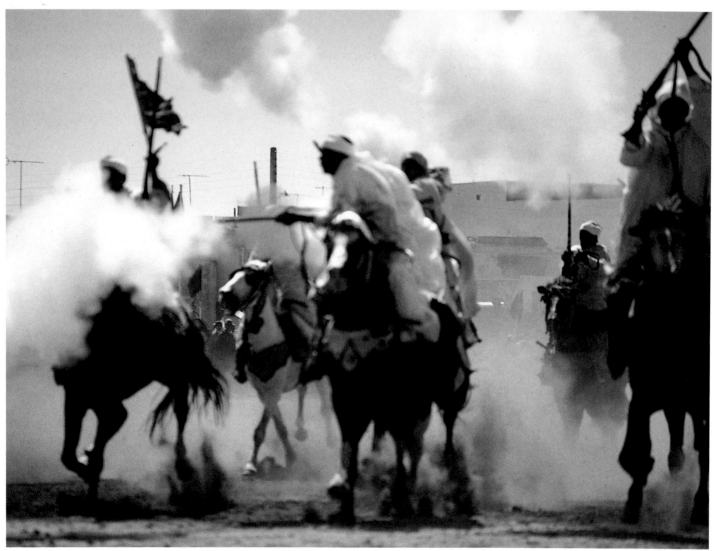

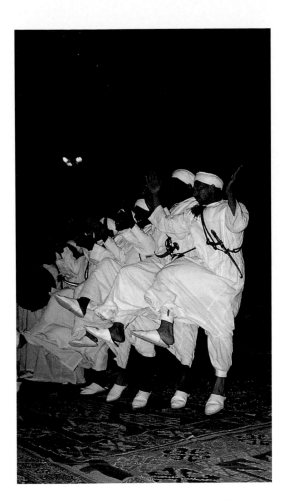

146 ABOVE *Dance troupe at a moussem in Ouarzazate. There can be anything between twenty and thirty such festivals in any one region every year.*

147 RIGHT *The 'maestro', the choreographer of a Khenifra dance troupe in the Middle Atlas.*

148–50 *All three photographs show young women performing at a date festival in Erfoud in the south.*

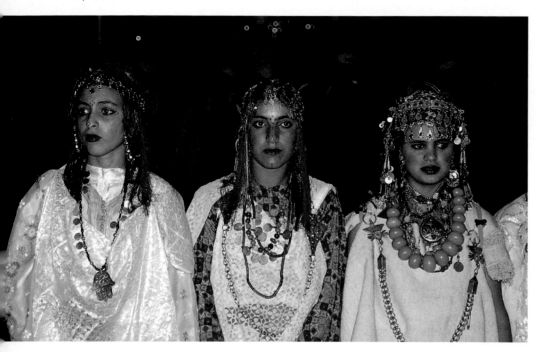

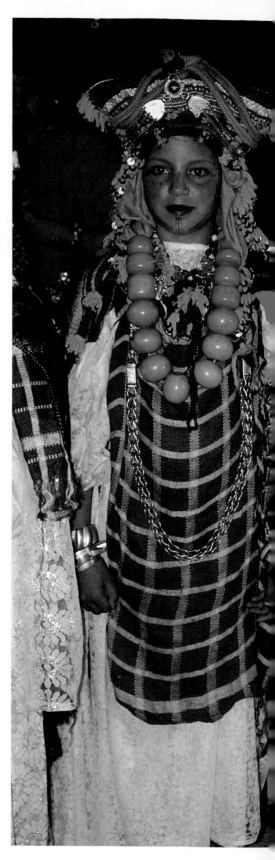

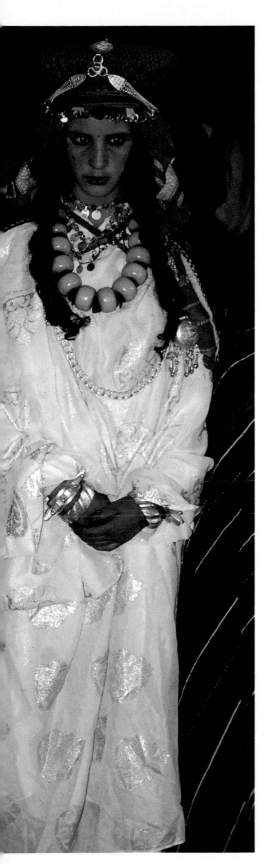

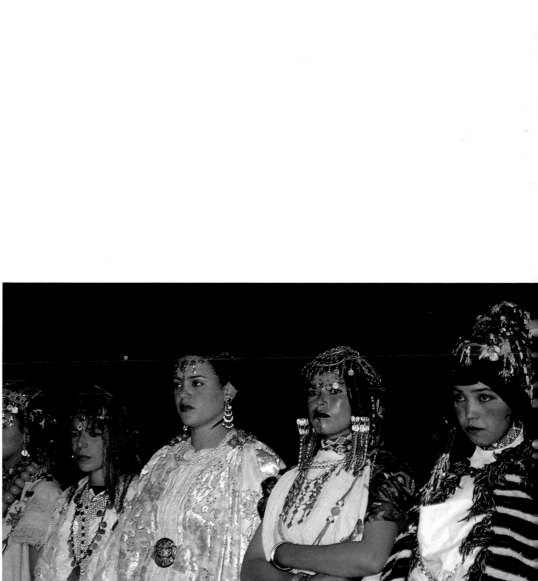

COLLECTING MOROCCAN ARTS AND CRAFTS

I travelled up this road, and I travelled down that,
What have I to show for it? Nothing flat.
All I brought were slippers which I took off and left by the door.
A silly calf ate them, soles and all.

Moroccan saying

In the wider field of African art, the traditions of Morocco have so far been generally overlooked. The main focus of African collections in American and European museums has been on sub-Saharan countries. Even though many museums espouse pan-Africanism, the reality is that the Maghreb is rarely included within the parameters of their attention.

Modernization is fast proceeding in Morocco, as it is in many areas of Africa, and the traditional or antique pieces are vanishing due to changes in social structure, a shift in craft specializations and the demands of the tourist and foreign art markets. There is a positive side, however: Morocco is still very new territory for the collector. It is a country brimming with traditional as well as contemporary work that would enhance and expand any African art collection, as well as enliven an interior as furnishings and decoration.

It was my intention in writing this book not only to illustrate Morocco's unique place in the Moslem world, but to underline the exchange of influences on artistic traditions and belief systems between Morocco – its mixture of animism and Islam – and sub-Saharan and West Africa. Given this exchange, examination of the countries north of the Sahara can provide a rich understanding of the cultural heritage of the whole continent.

In America, there are a few museums that house objects, usually textiles, from the Maghreb. These include the Indianapolis Museum of Art in Indianapolis, Indiana; the Texas Memorial Museum in Austin, Texas; the Smithsonian Museum of Natural History, Washington D.C.; the Textile Museum, Washington D.C.; the Honolulu Academy of Art, Honolulu; the Jewish Museum in New York; the University of Pennsylvania, Philadelphia and the Museum of International Folk Art in Santa Fe, New Mexico.

Many of the collections in museums in Europe and Israel are of note to any serious collector, dealer or visitor to Morocco. The Musée des Arts d'Afrique et d'Océanie in Paris probably has the most representative collection of jewelry, ceramics, woodwork and textiles on display in Europe. The Musée de l'Homme, also in Paris, has a good cross-section of costumes, pottery and some textiles. In London, the Museum of Mankind has some interesting textiles, but only a few pieces of jewelry, and the Victoria and Albert Museum has some ceramics and pottery, although neither has a section devoted solely to Moroccan art. The Linden Museum in Stuttgart has a very extensive collection of Moroccan urban and rural jewelry and the Hetjens Museum in Düsseldorf is the place to look at ceramics and pottery. The ethnology section of the Museum für Völkerkunde in Berlin has a collection of Moroccan pottery, ceramics and weaponry. In Jerusalem, both the L. A. Mayer Memorial Museum of Islamic Art and the Israel Museum have major collections from Morocco in gold and silver jewelry, costumes and textiles.

The best introduction to the culture and artistic traditions of Morocco, however, is of course by viewing the national collections in the country's major cities. These include Tangier's Musée de la Kasbah; the Musée d'Art Populaire Marocain in Tetouan, the Musée des Oudaia and the Musée Archéologique in Rabat, the Musée Dar Jamai et Palais in Meknes, the Musée de Dar Batha in Fez and the Musée de Dar Si Said in Marrakesh. The collections, let alone the architecture of these museums, are the best way of seeing older pieces, of the kind no longer in circulation, as well as receiving an overview of the many different lifestyles and traditions in Morocco. The Musée Archéologique in Rabat, especially, is a must on anyone's itinerary, because the bronze sculptures from Volubilis, excavated at a Roman site north of Meknes, are in its collection.

Once you have become familiarized with some of Morocco's ancient treasures after visiting the museums, the next step is to visit the daily souks that are located in the *medina* of each Moroccan city, as well as the weekly souks in the rural areas. These markets are not only commercial centres, but also places that provide a great opportunity for socializing, with shelter in every weather and season. The throngs of people, the community of merchants and craftsmen, the crowded alleyways, and the vast array of goods, colours, smells and music can give one

a sense of having stepped back in time, as the markets have changed very little since the Middle Ages.

You are bound to be able to find what you are looking for – whether an antique or a contemporary work – at any souk. If you are interested in one particular tradition, such as textiles, it will be easy to find what you want, since the souks are subdivided into the different traditions, organized according to specific manufacturing quarters – rug and embroidery stalls, for example. One can also witness the work in progress, with women weaving in the cooperatives, men tanning hides for their leather goods, and potters working at the lathe.

The organization of the souks makes it conducive to finding a bargain, because all the shops of the same tradition are close enough for the shopper to be able to compare easily prices and materials. One should also try to visit the *fonduks*, or caravanserais, which were once used as inns, but which became the warehouses for the stalls, filled with goods stacked from floor to ceiling and sold in bulk.

I was a tour guide for years, and I found that during the early stages of the tours, most visitors would insist that they were not interested in buying anything. But after the first few days, I would have filled the back of the bus and have roped numerous boxes on top of its roof, with no more room to spare, all with goods that at first no one had had any intention of buying.

As well as experiencing the city souks, one must also venture out to the *bled* (countryside), and visit the markets that take place weekly. Here one can witness the local merchants in tents offering a vast display of items, from perfume, jewelry and teapots, to audiocassettes. The weekly souk is also a good source for either antique or contemporary folk art.

The moussem, the festival discussed in Chapter Six, is also invaluable for collecting. Not only can one observe the music and dance that is integral to the celebrations, but one can also see the jewelry, textiles and costumes worn by participants.

When you have found the object you wish to purchase, be prepared to have to bargain for it: it is a well-known custom in this part of the world. At first, many visitors can get upset or shy of haggling, or they can end up abandoning the sale altogether, because they do not want the bother of bargaining. However, this process is not intended to make one unhappy or angry, but should be thought of as merely a game that can be approached as fun. It may seem to a Western visitor, if this is

his or her first experience of buying at a souk, that the seller cares little about the outcome, because he gives the impression of having all day. The bargaining can sometimes get unruly, and you may have to walk away, but that can usually produce a better outcome in your favour. Despite this apparent hostility between seller and buyer, there are sayings that can always be heard in any souk and that exemplify the ultimately good nature that lies behind this custom of bartering: they are *makayen moushkil,* meaning 'no problem' and *insha Allah,* meaning 'if God wills it'. Mint tea, too, can be a help in buying the desired object: after many glasses have been consumed, one might be amazed at how much the quoted price can drop. The problem for most Westerners is that the price is often so high to being with that it scares off most potential buyers. The rule of thumb to follow seems to be that if you cut the price in half and offer a third of that, it is still too expensive.

The hospitality and generosity of many Moroccans can be astonishing. A deal may end with a *cadeau* of another textile or pillow, and food especially, from mint tea to an invitation to a lavish lunch as part of the bargain. But try not to let this sway you; it is important to focus on the bottom line – that is, how much you like the piece and its design, and how much you are willing to pay for it. Of course, the longer one practises at bargaining, the easier it becomes, and then the fun begins. After many hours, and in many cases days, of bargaining over the years, I have learned not only about the artistic traditions of Morocco, but also about the people and their customs, and some of my most enduring friendships have begun this way.

After exploring the souks and outlying markets for contemporary and traditional art, there are also antique shops and boutiques, usually located in the new part of most Moroccan towns, which offer the visitor or collector new possibilities.

Both new and old Moroccan woodwork that displays very fine workmanship can still be found and the newer painted or carved pieces would fit in with almost any decor or make a welcome addition to a collection. The older doors, windows and chests are usually carved; some newer pieces are painted in the more ornate eighteenth- and nineteenth-century styles, but Berber doors, if carved and painted, are likely to be quite old, and along with other pieces, such as chests, sugar hammers and kohl containers, are a real treasure for most collectors because of the intricate designs of geometric and zoomorphic

symbols on their surfaces. The leather and metal industries continue to thrive and items can easily be commissioned from city and rural artisans.

Pottery is still fairly common in the stalls of the souks, although for the older pieces, one has to look a little harder. The city markets in Marrakesh, Taroudant and Talioune, for example, are probably the best places for collectors to find both old and new pieces, mainly because the potteries are situated nearby. You can find older pieces with tattoo marks or painted symbols that distinguish them from the new pots, as well as pieces that have been made in a variety of clays, from red and white to micaceous, the latter of which makes the pot turn out terra cotta, grey, or sparkling, due to the small residual pieces of mica. The collection of pottery has one considerable advantage in that it is still relatively inexpensive.

Morocco maintains the production of beautiful ceramics that were once only found at Fez, Meknes and Safi. It is possible to find eighteenth- and nineteenth-century bowls, plates and amphorae in the antique shops in Marrakesh, Fez, Tangier, Meknes and Taroudant.

Old and new jewelry is easily found in the souks and in little shops all over Morocco. You can find exquisite pieces in both silver and gold, combined with semi-precious stones. However, it is important to be aware of mediocre pieces made of a low-grade silver. The older pieces are usually stamped by the silver-smith's guild, but sometimes it is not just the material one needs to look at, but the design as well.

The assemblage necklaces are the most interesting items of jewelry; they can be made with coral, amber, silver, glass beads and conus shell whorls, with a vast array of talismans and charms attached to them. Many dealers have restrung some of these necklaces to make them look more European and contemporary. One way to do this is by designing the necklace in one material, for example with just amber, or huge chunks of coral, perhaps accompanied by one little bead of gold. In other words, a very uniform look. In some of the assemblage pieces, there might be green plastic or reconstituted amber beads among the others, which need not mean they are any less worth buying: the assemblage can be just as unique, with an appealing collection of coins and talismans that makes the configuration interesting or attractive, and it can mean that the necklace is believed to have magical properties.

The workmanship devoted to textiles and embroidery is evident as soon as one visits or enters a rug souk or an antique shop. A few hours spent here makes it easy to understand why the artists and designers of the 1920s and 1930s, among them Henri Matisse and Eileen Gray, were so enamoured of Moroccan designs, colours and textures.

There is also a great deal of inexpensive, but interesting folk art and contemporary rugs to be found in the weekly village souks in the rural areas, and one might be lucky enough to find a piece that is unique in design among the more common ones. However, if you want something totally unique, from any of the many traditions, but cannot find it among the ready-made goods, you can commission exactly what you want from an artisan.

The sensation of going back in time, as one goes through the souks and streets of Morocco, was wonderfully summed up by André Chevrillon in his travel book of the 1920s, *Marrakesh dans les Palmes:*

Without doubt, Morocco, with one or two of the Kingdoms of Asia, represents the last surviving example of a civilization of the ancient world. A civilization rich in types and models unchanged for centuries, similar in some of its essential features to the type of culture that used to exist in Europe, in many features older even than Islam and Christianity. One finds here customs, moral and physical aspects of mankind that are eternal, simply because they have never changed. Constantly watching a gesture of prayer or a salutation, a dance, a semi-naked beggar, the way a tailor prepares his cloth, a pilgrim following his donkey across the vast expanse of the *bled*, or looking into the smoky shade of a mill where occasional shafts of light pierce the tangle of beams, we feel we have seen it all before. For all the differences of appearance they recall to us the essential identity of mankind. If such a world, which shares so deeply the spirit of the past had disappeared two thousand years ago, we would have lost a certain understanding of the past and of ourselves, for we could never have recreated it. How many learned tomes would have been written on the subject! But that it has survived until our own times, that we can see it, we can touch it, mix with its people, is a miracle that never ceases to astonish.

GLOSSARY

agadir Granary, where provisions are stored.

ahouach Dance in the south of Morocco, with singers and percussionists.

amin Administrator of a guild who supervises the mallems, the head craftsmen.

Aisha Kandicha Female evil spirit.

attar Travelling salesman and commercial messenger, from whom Berber women would obtain materials for making necklaces.

baraka Beneficent psychic power.

bendir Drum.

burnoose Traditional outer garment with a hood worn by men.

choukara Man's leather bag.

darbouka Hourglass-shaped drum made of clay.

djinn (pl. djoun) Evil male or female animate or inanimate spirit.

fantasia Berber equestrian display.

fonduk Caravanserai or inn.

fqih Holy man versed in the Koran.

ghandoura Silken robe worn by wealthy men.

guedra Drum and dance.

guerba Pot for making butter.

haeti Wall-hanging.

haik Single large piece of cloth – usually white, but sometimes blue and black – draped by urban women to form a veil, cloak and hood.

hammam Public steam baths.

hanbel Flatweave blankets, wall coverings.

handira Blanket-type shawl woven by Berber women and draped over the shoulder.

harash Maker of unglazed pottery.

henna Red dye thought to bring good luck.

ikanaf (plural *akhnif*) Man's cape with red oculus.

izar Long piece of cloth with which Berber women drape themselves.

jellaba Short-sleeved outer garment for men with a woollen hood.

khamsa Hand of Fatima, believed to ward off the evil eye.

kohl Eyeliner, mascara.

maallem (female, *ma'allema*) Master craftsman.

marabout Holy man or holy shrine.

medersa A school for higher Islamic teaching.

medina The older quarter of Moroccan cities.

mellah Jewish quarter of Moroccan cities.

moushrabiya Ornamental screen made of wood in private homes, segregating women from men.

moussem Religious festival.

mushat Weaver's hammer combs, with designs to ward off evil forces.

selham Full-sleeved cloak, with a hood decorated with silk pompoms worn as an outer garment by men.

sharif Descendant of the Prophet Mohammed.

shedwi Flatwoven rug with black and white bands separated by tapestry weave and twining.

souk Marketplace.

taleb Koranic scholar or magician.

tallayah Maker of painted, glazed tableware.

tajine Large serving dish.

talisman Object marked with magical signs, possessing supernatural or protective powers.

tastir Geometrical patterns.

wasm Tribal identity mark.

zaouia Seat of religious brotherhood, comprising a mosque, school and tomb of the saint.

zawwaga Painter of wooden pieces.

zillij Fired and cut glazed tile.

zlayiyyah Zillij-maker.

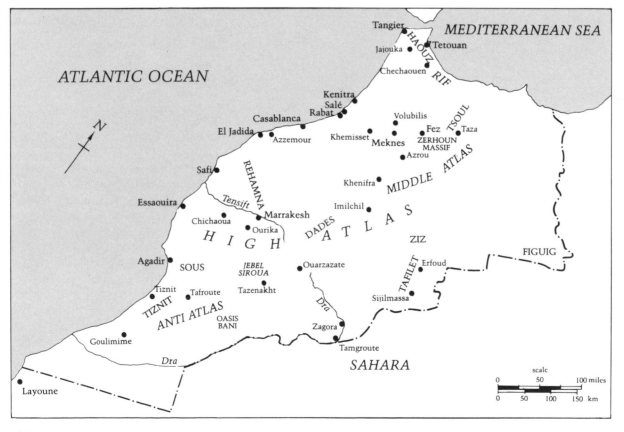

BIBLIOGRAPHY

Abun-Nasr, Jamil, *A History of the Magrib*, Cambridge, 1975

Africanus, Leo, *The History and Description of Africa*, vol. 3, London, 1896

Al-Jadir-Saad, *Arab and Islamic Silver*, London, 1981

Amicis, E. *Morocco*, Milan, 1876

Barbour, Neville, *Morocco*, London, 1965

Barth, Henry, *Travels and Discoveries in North and Central Africa*, vol. 3, New York, 1857–59

Barthelemy, Anne, *Tazra: Tapis & Bijoux Ouarzazate*, Aix-en-Provence, 1990

Bazinet, M., "Corsairs, Commerce, and Cognomens", *Oriental Rug Review*, vol. 2, no. 4, 1991

Beckett, T. H., "Two Pottery Techniques in Morocco", *Man*, no. 58, London, 1958

Bedaux, R., R. Bolland, "Medieval Textiles from Tellem Caves in Central Mali", *Textile Museum Journal*, Washington D.C., 1980

Bel, Alfred, *Les industries de la ceramique à Fes*, Paris, 1918

Ben Jelloun, Tahar, *The Sacred Night*, New York, 1987

—, *Silent Day in Tangier*, London, 1991

Bertrand, André, *Tribus Berbers du Haut Atlas*, Paris, 1977

Besancenot, Jean, *Bijoux Arabes et Berberes du Maroc*, Casablanca, 1939

—, *Costumes et Types du Maroc*, Paris, 1940

Boukobza, André, *La poterie marocaine*, Casablanca, 1974

Bovill, E. W., *The Golden Trade of the Moors*, London, 1968

Bowles, Paul, *Let It Come Down*, New York, 1952

—, *Spiders House*, New York, 1955

—, *Their Heads are Green and Their Hands are Blue*, New York, 1957

—, *Midnight Mass*, Santa Barbara, 1981

—, *Sheltering Sky*, London, 1982

Bravmann, Rene, *Islam and Tribal Art in West Africa*, Cambridge, 1992

Brett, Michael, *The Moors, Islam in the West*, London, 1980

Burckhardt, Titus, *Fez, City of Islam*, Cambridge, 1992

Bynon, J., "Berber Women's Pottery: Is the Decoration Motivated", in J. Picton, *Earthenware of Asia and Africa*, London, 1984

Bushnaq, Inea, *Arab Folk Tales*, New York, 1986

Camps, Gabriel, *Les Berberes*, Errance, 1980

Canetti, Elias, *The Voice of Marrakesh*, New York, 1978

Champault, D. A. R. Verbrugge, *La Main*, Paris, 1965

Chandler, W., "The Moor: Light of Europe's Dark Age", *African Presence in Early Europe*, New Brunswick, 1985

Collingwood, Peter, *The Techniques of Rug Weaving*, New York, 1969

Crapanzano, Vincent, *Tuhami – Portrait of a Moroccan*, Chicago, 1980

Crespi, Gabriele, *The Arabs in Europe*, New York, 1979

Critchlow, Keith, *Islamic Patterns: An Analytical and Cosmological Approach*, London and New York, 1976

Cunningham, Graham, *Moghreb-El-Acksa*, New York, 1930

Daniels, Ger, *Folk Jewelry of the World*, New York, 1989

De l'Empire romain aux villes imperiales, 6000 ans d'art au Maroc, Musée du Petit Palais, Paris, 1990

Dennis, Landt, Lisl Dennis, *Morocco – Design from Casablanca to Marrakesh*, New York, 1992

Deshen, Shlomo, *The Mellah Society*, Chicago, 1989

D'Ucel, Jeanne, *Berber Art*, Norman, Oklahoma, 1952

Dkhissi, Driss, *Tapis du Haut Atlas*, Casablanca, 1984

Doutte, Edmond, *Magie et religion dans l'Afrique du Nord*, Paris, 1984

Dunn, Ross, *The Adventures of Ibn Battuta*, Berkeley, 1984

Eudel, Paul, *Dictionnaire de Bijoux de "l'Afrique du Nord"*, Paris, 1906

Exler Gallery, *Die Hand: Schutz und Schmuick in Nordafrika*, Frankfurt, 1981

Fernea, Elizabeth, *A Street in Marrakesh*, New York, 1975

Fisher, Angela, *Africa Adorned*, London, 1984

Fiske, P., R. Pickering and R. Yohe (eds), *From the Far West: Carpets and and Textiles from Morocco*, Washington, D.C., 1980

Fitzgerald, Sybil, *In the Track of the Moors*, London, 1905

Flint, Bert, *Forme et Symbole dans les Arts du Maroc*, vol. 2, Tangier, 1973

Gabus, Jean, *Au Shara – Arts et Symboles*, Baconniere, 1958

Gallotti, Jean, *Le tapis marocaine*, Paris, 1919

—, *Moorish Houses and Gardens of Morocco*, vol. 2, New York, 1925

—, "Weaving and Dyeing in North Africa", *CIBA Review*, vol. 21, May, 1939

Gellner, Ernest, *Saints of the Atlas*, Chicago, 1969

Gilfoy, Peggy J., *Fabrics in Celebration from the Collection*, Indianapolis, 1983

—, *Patterns of Life, West African Strip Weaving Traditions*, Washington, D.C., 1987

Golvin, Lucien, *Aspects de l'artisanant en Afrique du Nord*, Paris, 1967

Goodwin, Godfrey, *Islamic Spain*, London, 1990

Gruner, Dorothy, *Die Berber Keramik*, Wiesbaden, 1973

Hakenjos, Bernd, *Marokkanische Keramik*, Stuttgart, 1988

Hamri, Mohamed, *Tales of Jajouka*, Santa Barbara, 1975

Harris, Walter, *Tafilet*, London, 1895

—, *Morocco That Was*, Oxford, 1929

Hasson, Rachel, *Later Islamic Jewelry*, L. A. Mayer Memorial Museum for Islamic Art, Jerusalem, 1987

Hedgecoe, John, Salmar Damliyi, *Zillij: The Art of Moroccan Ceramics*, Reading, 1992

Herber, J., "Contribution à l'étude des poteries du Zaer", *Hesperis*, vol. 2, 1922

—, "Technique des poteries rifaines du Zerhoun", *Hesperis*, vol. 2, 1922

Hirschberg, H. Z., *A History of the Jews in North Africa*, vol. 1, Leiden, 1974

Hoffman, Bernard G., *The Structure of Tradi-*

tional Moroccan Society, Den Haag, 1967

Hull, A., J. Wyhowska, *Kilim, The Complete Guide*, London and San Francisco, 1993

Hyde, J., J. Harmer, M. Lorimer, R. Pickering, *Windows on the Maghrib*, Knoxville, 1992

Ilerbare, J. A., *Carthage, Rome and the Berbers*, Ibadan, 1980

Israel Museum, *La Vie Juive au Maroc*, Jerusalem, 1973

Jereb, James, "Tradition, Design and Magic: Moroccan Tribal WEavings", *Hali*, London, August 1990.

—, "Magical Potency in Berber Jewelry", *Ornament*, vol. 13, winter 1989, p. 2

—, Introduction, *Moroccan Carpets*, London, 1994

Kalter, Johannes, *Schmuck aus Nord Afrika*, Stuttgart, 1976

Khaldun, Ibn, *Histoire des Berberes*, trans. Baron de Slane, Paris, 1927

Kiewe, Heinz, E., *Ancient Berber Tapestries and Rugs, and Ancient Moroccan Embroideries*, Oxford 1952

Laroui, Abdallah, *History of the Maghrib*, Princeton, 1977

Leared, Arthur, Morocco and the Moors, London, 1985

Legy, Françoise, *The Folklore of Morocco*, London, 1935

Lewis, Wyndham, *Journey into Barbary*, New York, 1983

Liu, R. K., L. Wataghani, "Moroccan Folk Jewelry", *African Arts*, vol. 8:2, Los Angeles, 1975

Lord, Peter, *A Moorish Calendar*, London, 1978

Loti, Pierre, *Morocco*, London, 1929

Loviconi, Alain, Dalila Belfitah, *Regards sur la faience de Fes*, Aix-en-Provence, 1991

Maloney, C., *The Evil Eye*, New York, 1976

Marcais, G. *Les Arabes en Berberie du XI^e au XIV^e siècle*, Paris, 1913

Mather, Vanessa, *Women and Property in Morocco*, London, 1974

Mayne, Peter, *The Alleys of Marrakesh*, Boston, 1953

Maxwell, Gavin, *Lords of the Atlas*, New York, 1966

Meakin, Budgett, *Life in Morocco*, London, 1905

Meilach, Donna, *Ethnic Jewelry*, New York, 1981

Mernissi, Fatima, *Doing Daily Battle*, London, 1975

Montague, R. *The Berbers*, London, 1973

MorinBarde, M., *Coiffures Feminines du Maroc*, Aix-en-Provence, 1990

Moscafi, Sabatini, *The World of the Phoenicians*, New York, 1965

Neziere, Jean, *La decoration marocaine*, Paris, 1917

Norris, H. T., *The Berbers in Arabic Literature*, London, 1982

Oussaid, Brick, *Mountains Forgotten by God*, Washington, D.C., 1989

Paccard, André, *Traditional Islamic Craft in Moroccan Architecture*, vol. 2, Saint Jorioz, 1979

Paine, Sheila, Embroidered Textiles: Traditional Patterns from Five Continents, London and New York, 1990

Peets, Leonora, *Women of Marrakesh: Record of Secret Sharer, 1930–1970*, London, 1988

Pickering, B., R. Yohe, "Rug Collecting in Morocco", *Oriental Rug Review*, vol. 2, no. 4, 1991

Pickering, B., R. Pickering and R. Yohe, *Moroccan Carpets*, London, 1994

Picton, John, John Mack, *African Textiles*, London, 1979

Prussin, Labelle, *Hautumere: Islamic Design in West Africa*, Berkeley, 1986

Rabinow, Paul, *Reflections on Fieldwork in Morocco*, Berkeley, 1977

Revault, Jackques, *Le Tissage et la tatatouges dans le Moyen Atla*s, Fez, 1933

Reswick, Imtraud, *Traditional Textiles of Tunisia and Related North African Weavings*, Craft and Folk Art Museum, Los Angeles, 1985

Ricard, Prosper, *Corpus de Tapis Marocains*, 1923–34

—, *Tapis de Rabat*, Paris, 1923

—, *Tapis du Moyen Atlas*, Paris, 1926

—, *Tapis de Haut Atlas et du Haouz*, 1927

—, *Haouz De Marrakesh*, Paris, 1927

—, *Tapis Divers*, Paris, 1934

Rouach, David, *Bijoux berberes au Maroc dans la tradition judaeo-arabe*, Casablanca, 1989

Schaffar, J. Jacques, *Tresor et mystere des Berberes du Maroc*, Milan, 1990

Searight, Susan, *The Use and Function of Tattooing on Moroccan Women* ,vol. 3, New Haven, 1984

Sefrioui, Ahmed, *African Costumes and Attire: Morocco*, Rabat, 1982

Sjelmassi, Mohamed, *Les arts traditionnels au Maroc*, Paris, 1974

Spring, Christopher, *African Arms and Armour*, London, 1993

Stanzer, Wilfred, *Berber Tribal Carpets and Weavings from Morocco*, Graz, 1991

Stone, Caroline, *The Embroideries of North Africa*, London, 1985

Terrasse, Henri, J. Hainaut, *Les Arts decoratif au Maroc*, Paris, 1925

Thornton, Philip, *The Voice of the Atlas*, London, 1936

Turnbull, Patrick, *Black Barbary*, London, 1939

Van Gennep, Arnold, *Les Poteries peintes de l'Afrique du Nord*, Boston, 1918

Vicarie, M. "Poteries berberes du Maroc", *Nord-Sud*, 1934

Vossen, Rudiger, W. Ebert, *Marokkanishe Topferei*, Bonn, 1986

Welch, Galbraith, *North African Prelude*, New York, 1949

Westermarck, Edward, Ritual and Belief in Morocco, vol. 2, New York, 1968

Wharton, Edith, *In Morocco*, London, 1984

INDEX

Acknowledgments

Colour illustrations
References are to plate numbers

The author would like to thank the following for kindly allowing objects from their collections to be photographed:

Berdj Achdjian, Paris: 28–30
Julie Ackerman, Baltimore: 75
Keith Barton, Chicago: 89
Marilyn Beddor, Minneapolis: 64
Eric Ceputis, Chicago: 38
Honolulu Academy of Art, Honolulu: 9
Indianapolis Museum of Art, Eliza M. and Sarah Niblack: 50
Jefferson Hyde, Santa Fe: 45
Margot Ladwig: 17 (3rd & 5th from left)
T. R. and Linda Lawrence, Santa Fe: 16 (except fibula), 21 (and front cover), 52, 76, 84 (head bands), 98 (war club), 102–3
Athi Mara Magadi: 17 (far left), 77
Musée de Dar Batha, Fez: 24, 122
Musée de la Kasbah de Tangier: 123, 124
Musée Ethnographie de Tetouan: 10, 26
Musée National des Arts Africains, Paris: 12
Muriel Newman, Chicago: 11
Richar Collection, Chicago: 31
Russell Pickering, Washington D.C.: 55, 57–8
Private Collection, Baltimore: 71
Private Collection, Chicago: 40, 51, 65–6, 70, 74, 81, 85, 90, 108
Private Collection, Los Angeles: 61, 73
Private Collection, Marrakesh: 20, 95, 101
Private Collection, Minneapolis: 106

Private Collection, Naples, Florida: 92
Private Collection, New York: 69
Private Collection, Portland: 79
Private Collection, San Diego; 68, 72
Private Collection, Santa Fe: 84 (1st & 2nd centre ornaments)
Textile Museum, Washington, D.C.: 46, 56
Jean Tyler, Portland: 59, 62, 67
Lucien Viola, New York: 44
Debra Yates, Chicago: 63, 80, 82

The following artefacts are from the author's own collection: 1, 3–5, 14–16 (fibula), 17 (2nd & 4th from left), 23, 33–7, 39, 41–3, 47, 52, 78, 84 (3rd central ornament), 86–7, 91, 96 (except 1st 2 pieces), 97, 98 (except war club), 100–1, 105–7, 109–11, 113–21, 131–4,

The author would like to thank the following photographers:

Frananko Khoury: 46, 56
Robert Liu: 61
Lynn Lown: 1, 3–5, 9, 14–16, 20–1, 23, 33–7, 39, 41, 43, 47, 52, 59, 62–73, 76–82, 84–8, 90–2, 94–100, 103, 105–11, 113–21, 131–4
Athi Mara Magadi: 18, 19, 125
Joel Rubiner: 8, 13, 138–9, 141, 144
Michael Tropea: 11, 31, 38, 40, 42, 74–5,

The author took the following photographs: 6, 7, 10, 22, 24–7, 48, 49, 53–4, 93, 101, 104, 122–4, 127, 129–30, 137, 140–3, 145–50

Black and white photographs
References are to page numbers

The author would like to thank the following for kindly allowing objects from their collection to be photographed:

Musée Ethnographie de Tetouan: 101
Musée de la Kasbah de Tangier: 17, 75
Oudais Museum: 15
Private Collection: 43
Private Collection, Chicago: 76
Private Collection, Tucson, Arizona: 102
Jean Tyler, Portland: 50, 78

The following artefacts are from the author's collection: 43, 44, 49, 74, 77, 103, 114–17

The author would like to thank the following photographers:

Michael Byrne: 114–17
Lynn Lown: 18, 43–4, 49–50, 74, 77–8, 103, 114
Athi Mara Magadi: 9, 20, 55, 143

The author took the following photographs: 6, 17, 19, 46–7, 75–6, 78–80, 100–1, 118, 139, 142

Line drawings by Elaine Feldman and John Kaine.